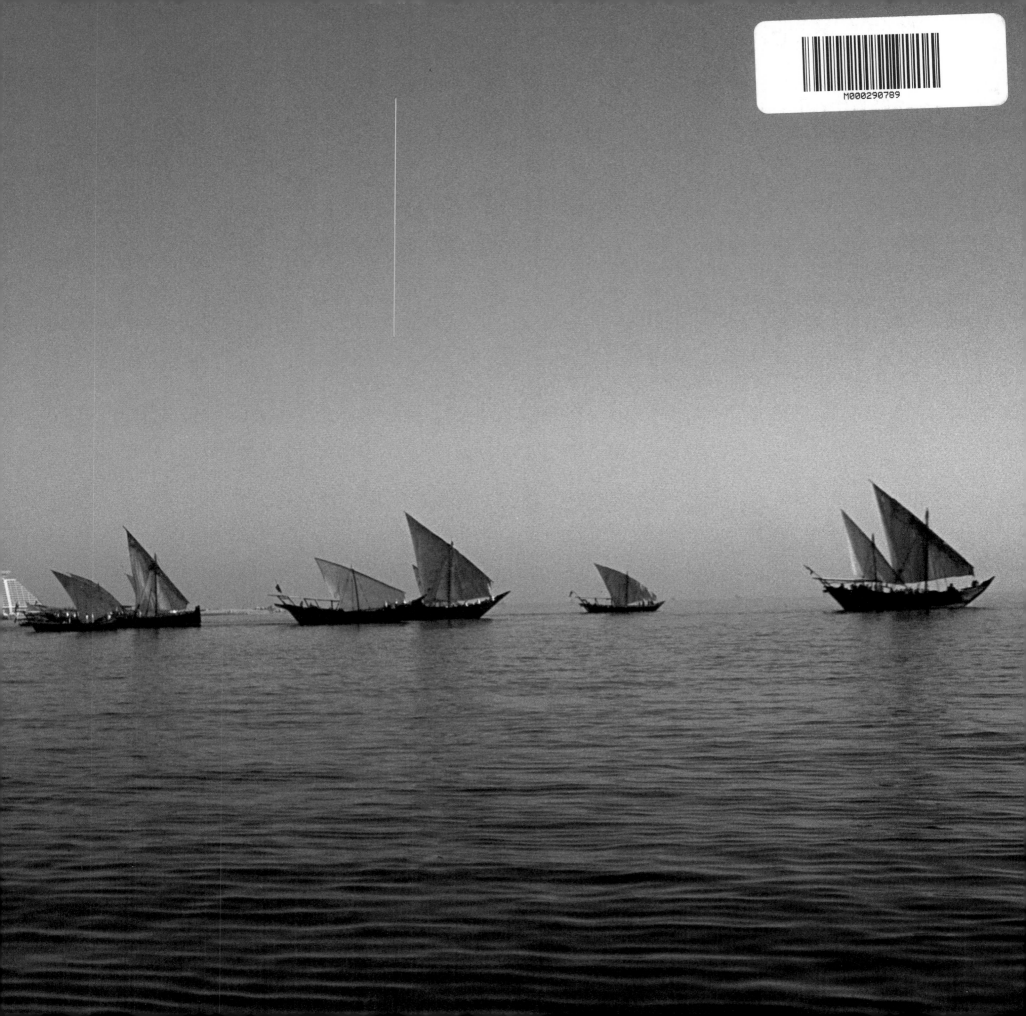

QATAR
SAND, SEA AND SKY

For Quinn and Lisa,
Enjoy this journey to Qatar!
Ri... C. K. Ch...
19 March 2013

bright sky press
HOUSTON, TEXAS

2365 Rice Boulevard, Suite 202,
Houston, Texas 77005

ISBN: 978-1-936474-04-2

10 9 8 7 6 5 4 3 2 1

Library of Congress Cataloging-in-Publication Data on file with publisher.

Editorial Direction, Lucy Chambers
Creative Direction, Ellen Cregan
Design, Wyn Bomar
Photography, Henry Dallal
Printed in China through Asia Pacific Offset

QATAR
SAND, SEA AND SKY

DIANA C. K. UNTERMEYER
PHOTOGRAPHY BY HENRY DALLAL

bright sky press

State of Qatar

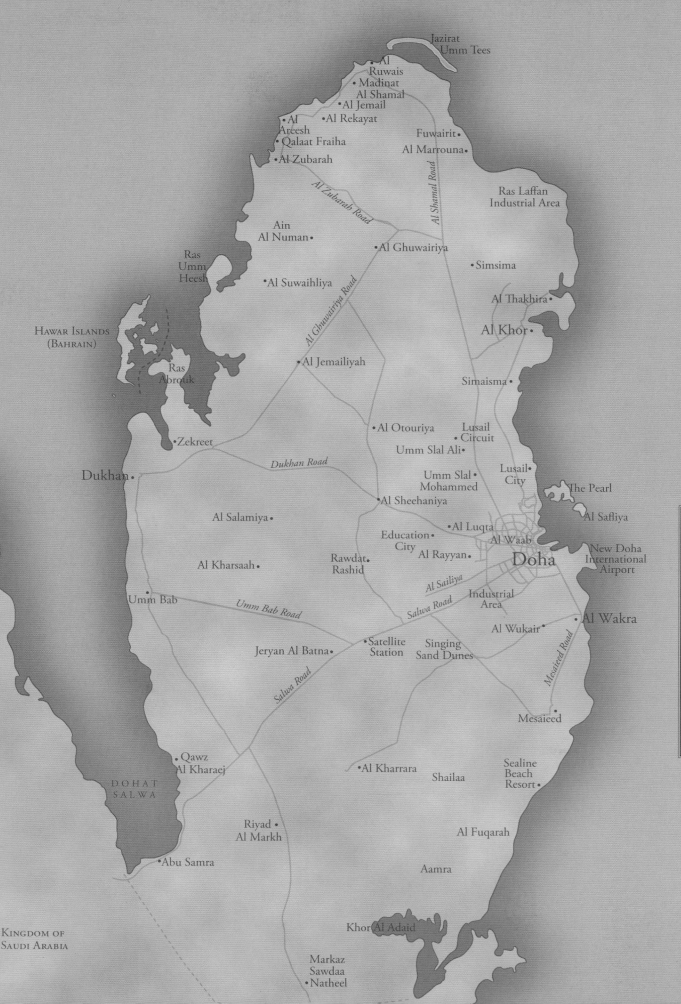

Jazirat
Umm Tees

• Al
Ruwais
• Madinat
Al Shamal
• Al Jemail
• Al Rekayat
• Al
Areesh Fuwairit •
• Qalaat Fraiha Al Marrouna •
• Al Zubarah

Al Zubarah Road *Al Shamal Road* Ras Laffan
Industrial Area

Ain
Al Numan •
 • Al Ghuwairiya • Simsima
Ras
Umm
Heesh • Al Suwaihliya
 Al Thakhira •

Al Ghuwairiya Road Al Khor

HAWAR ISLANDS
(BAHRAIN)
 Ras
 Abrouk • Al Jemailiyah Simaisma •

 • Al Otouriya Lusail
 • Circuit
 • Zekreet Umm Slal Ali •

 Dukhan Road Umm Slal • Lusail •
Dukhan • Mohammed City The Pearl

 • Al Sheehaniya Al Safliya •
 Al Salamiya • • Al Luqta
 Education • Al Waab • New Doha
 City International
 Al Kharsaah • Rawdat Al Rayyan • Doha Airport
 Rashid
 Al Sailiya
 Umm Bab Road *Salwa Road* Industrial
Umm Bab • Area
 • Al Wakra
 Salwa Road Al Wukair •
 Jeryan Al Batna • • Satellite Singing
 Station Sand Dunes *Mesaieed Road*

 Mesaieed •

• Qawz Sealine
Al Kharaej Beach
 • Al Kharrara Shailaa Resort
DOHAT
SALWA
 Riyad • Al Fuqarah
 Al Markh

• Abu Samra Aamra

KINGDOM OF
SAUDI ARABIA Khor Al Adaid

 Markaz
 Sawdaa
 • Natheel

W ——— N ——— E
 S

MILES
0 1.2 2.4 4.9 7.4 9.9

0 2 4 8 12 16
KILOMETERS

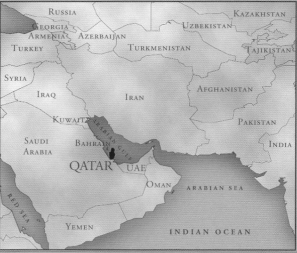

Based on GIS Section, IT Department
Statistics Authority State of Qatar

TABLE OF CONTENTS

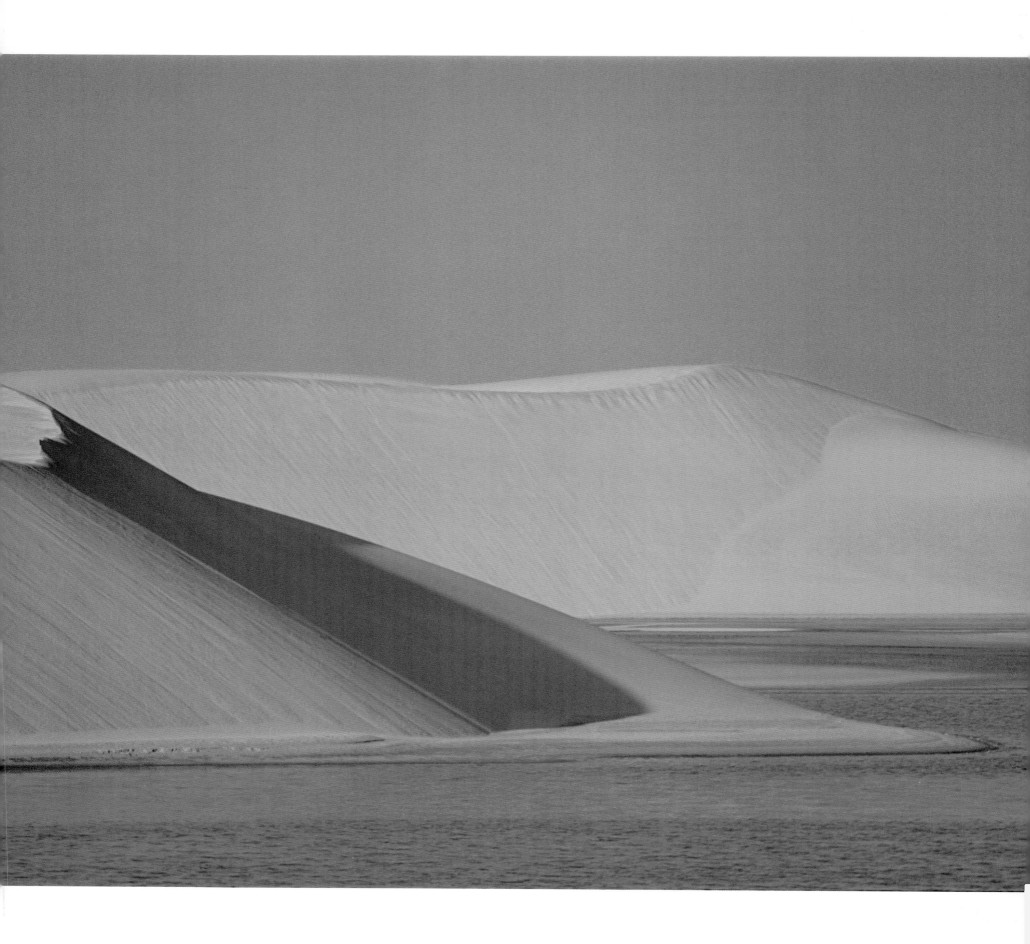

A Special Word of Thanks

Qatar: Sand, Sea and Sky (Qatar: Al Ramel wa Al Bahar wa Al Sama) was brought to life by sponsors who shared our vision to showcase Qatar. These organizations are leaders in supporting community and cultural initiatives in Qatar, and we are proud to be at their side in that endeavor. Alf shukran, a thousand thanks, to:

Ministry of Culture, Arts and Heritage:
Doha 2010 – Capital of Arab Culture

Al Faleh Group

ExxonMobil

Qatar Airways

Qatar Foundation

Qatari Diar and Barwa

Qatar Museums Authority

RasGas Company Limited

I have known Diana since she moved to Doha with her incredibly active husband, Ambassador Chase Untermeyer. Diana is an inspiration to all who meet her. Upon her arrival, she immediately engaged in every community activity—from the horses she loves, to the environment, official engagements and various launches.

The Qataris are privileged to have someone from across the ocean be so dedicated to us, our nation and all that we believe in. Diana has not only been a great ambassador from the U.S. to the region, but she has also been an equally extraordinary ambassador on behalf of Qatar to the rest of the world. Through her numerous activities, she promotes the true colors of our country, and I am honored to be part of this publication. I am grateful for Diana's dedication and contribution, and though I have only recently gotten to know Henry Dallal, I thank him for showcasing Qatar in such beautiful photographs.

2010 proved to be a successful year for Qatar, culminating in the announcement that we will host the World Cup in 2022. To live up to this standard in 2011 would seem like a challenge. But the people of Qatar are prepared to meet that challenge and exceed expectations, not only for the World Cup but also for the long-term wellbeing of our country. *Qatar: Sand, Sea and Sky* highlights our proud history and our vision for the future.

Let me take this opportunity to invite you to explore Qatar in these pages and in person!

Al Mayassa bint Hamad bin Khalifa Al Thani
Doha, December 31, 2010

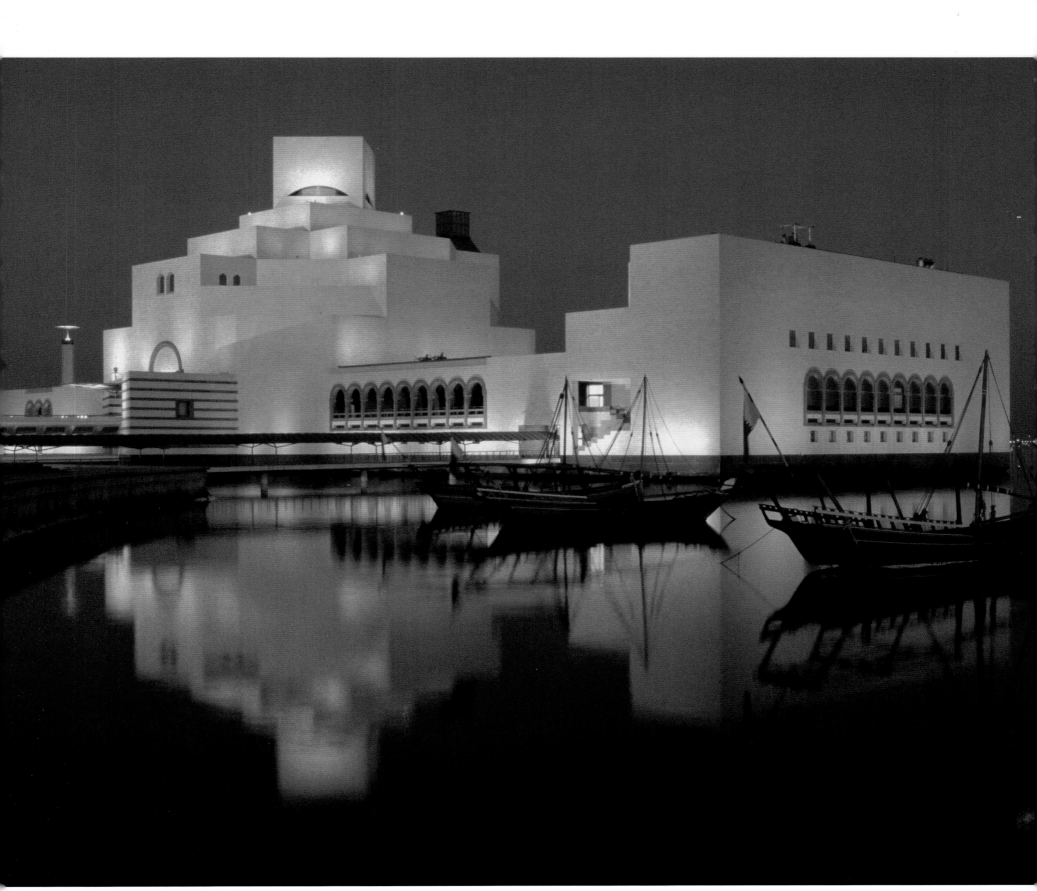

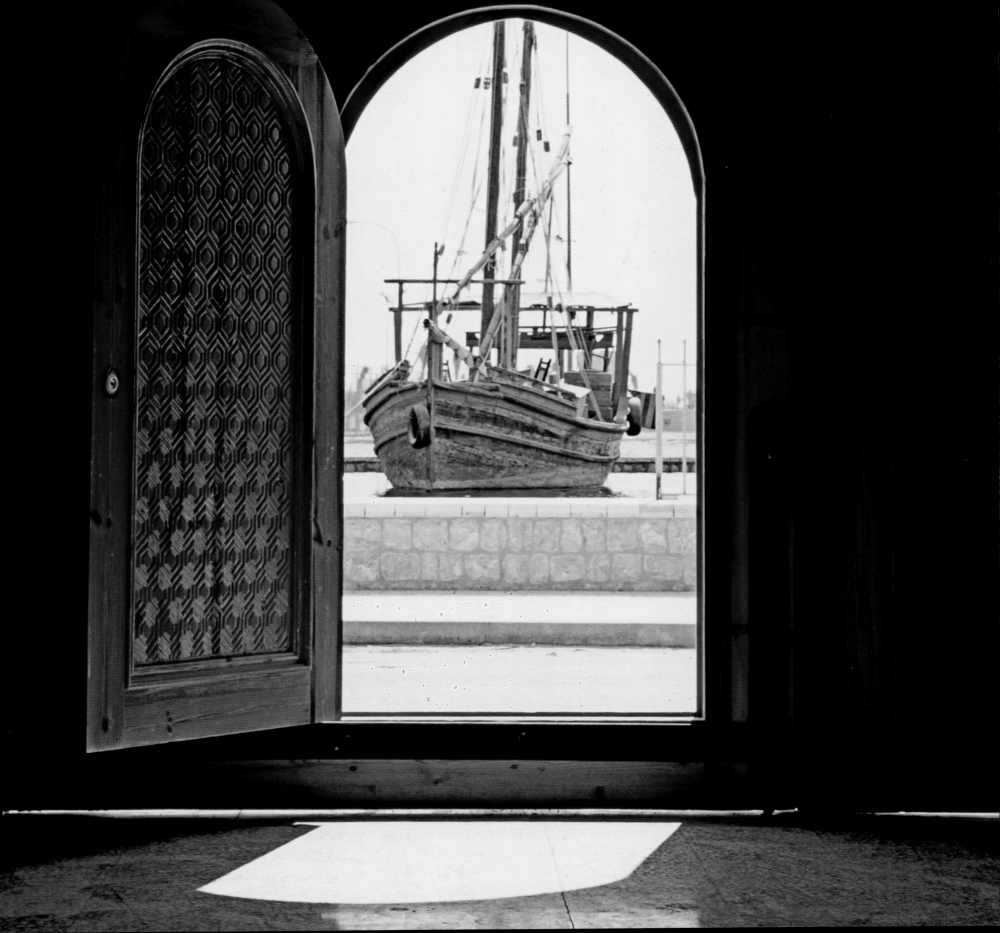

قطر

QATAR

In the creation of the heavens and the earth, and in the alternation of night and day, and the ships which sail through the sea with that which is of use to mankind, and the water which Allah sends down from the sky and makes the earth alive therewith after its death, and the moving creatures of all kinds that He has scattered therein, and in the veering of winds and clouds which are held between the sky and the earth, are indeed proofs for people of understanding.

— Qur'an 2:164, Surah Al-Baqarah

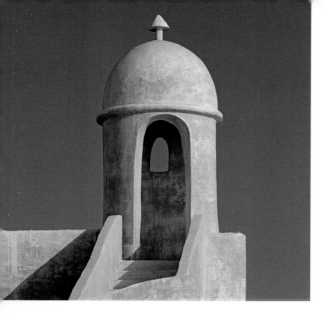

Chapter One: An Introduction to Qatar

The rhythm of our days was set, and we began learning to live in a society where prayer provides the ebb and flow of daily life.

(previous and above)

A dhow visible through a carved doorway at the Sheikh Faisal bin Qassim Al Thani museum; a restored minaret in Al Wakra

Into Arabia | My journey into Arabian nights and days began in April 2004 when my husband received a call from the White House asking him to serve as the U.S. ambassador to Qatar. On August 18 after a presidential appointment and a hurried packing up of the house, Chase, our then eleven-year-old daughter Elly, and I found ourselves flying over the shadowy waters of the Arabian Gulf. Had we arrived by day, we might have seen the entirety of the small Qatari peninsula, but on this clear night only the flaming beacons of the oil and gas industry stood out from the darkness. Shining as brightly as sports stadiums, highways extended from the capital city of Doha like spokes on a wheel, with no seeming destination except small clusters of twinkling lights.

When the door of the airplane opened, we were blanketed by soft, humid heat. Before it became a major international hub flying five-star, Qatari-flagged jets to a staggering list of destinations spanning Europe, Africa, Asia, Australia, and the United States, the old airport was built without jetways. At the bottom of the steps, a phalanx of embassy staff and white-robed bodyguards shepherded us into BMWs for the short ride to the VIP terminal. Little more than a glorified prefabricated cabin at that time, it was nonetheless a refuge from the teeming public terminal. In the lounge, the elegant Qatari chief of protocol greeted us—welcoming with his warm smile, romantic in his flowing robes and headdress encircled by the black rope *igal*.

As we enjoyed fresh juice, U.S. embassy personnel handled immigration formalities before we were whisked to the embassy, where our staff (who would soon be like family) met us with homemade chocolate-chip cookies and brownies. The residence, a split-level home built by a Qatari who had lived in California, was quite worn, but the grounds were lovely with mature trees, flowers and a swimming pool. The residence has since moved to a recently developed West Bay neighborhood. The new residence is more modern, but, alas, the verdant gardens of the old house have been obliterated to make way for eight townhomes.

The next morning we were awakened by a chorus of muffled muezzin and searing light shooting from the edges of blackout curtains. The rhythm of our days was set, and we began learning to live in a society where prayer provides the ebb and flow of daily life. Islam in its pure and peaceful nature flourishes here. It is essentially impossible to consider the Gulf without setting it in a Muslim framework, which informs so much about traditional tribal behavior and governance, as well as the values that guide Qatar's journey into its unique modernity.

Bedouin life had always intrigued me. Having grown up with stories of Arabian horses, I harbored a lifelong dream of galloping through the desert on one of these mythic steeds. What little I knew about the life of the desert nomads also seemed akin to my family's experience as pioneers in Wyoming. My great-grandfather pushed cattle up the trail from Texas, and my grandfather was educated on our dryland ranches by his mother. During breaks from lessons he memorized poetry, and he was an adept storyteller. Into his nineties, he still captivated listeners with tales of the Old West.

From harsh environments like the Middle Eastern desert and the killing winters of America's northern plains, distinctive societies evolved, emphasizing pride, perseverance and hospitality, as well as a strong oral tradition and a thirst for spiritual fulfillment. The corresponding unwritten code of the Bedouin resonates with the cowboy stories I grew up with and even more so with the lives of the American Indians whom early settlers pushed out. It is tempting to be swept up in the illusion that one knows another culture simply because of similarities to one's own, or to fall into the trap of cultural romanticism so common to travelers in the Orient. Outsiders are genuinely welcomed, even honored, in Arabia, yet they rarely become part of it. This applies not only to westerners but even to Arabs not of Gulf origin, who seldom integrate fully into local society. So while I have been flattered to be told, "You are a Qatari!" or, more exotically, to be called Diana of Doha, I never lose sight that some subtlety of culture always awaits discovery, which is why I return often in answer to the desert's siren call.

I have great admiration for the intrepid Western female explorers in Arabia—Lady Ann Blount, Gertrude Bell, Freya Stark and others—but my adventure was different. The Qataris of this century live in towns and cities, not in Bedouin tents or the isolated sea-centered villages of pre-oil days. My time in Qatar coincided with what will surely be known as a pivotal time in its transition to modernity. Learning about the traditions of the past was indispensable to understanding the Qatar of today and tomorrow. The change has been so recent that today's worldly executive may have grown up with parents or grandparents who roamed the desert, traded for goods at a rudimentary market, or combed the sea for fish and pearls.

Journey into Tradition and Modernity | Qatar has a rich cultural heritage and began developing a distinct political identity through centuries-long contacts with Bahrain, the Arabian Peninsula, Persia, India, East Africa, the Ottoman Empire and Great Britain. But because it became a fully independent country only in 1971, Qatar as a nation is still close to its roots. Furthermore, the Emir, His Highness Sheikh Hamad **bin** Khalifa Al Thani, assumed power in 1995, and his wide-reaching plans took some years to bear fruit. Our family experienced this Qatar—a young country with a mighty dream and the petrocurrency to bring that vision to life. Before our eyes, a dynamic city emerged from a modest skyline and a lot of excavation sites topped by building cranes. We lived in a time-lapse world, as twenty-four-hour-a-day work schedules made buildings soar, floor by floor, seemingly overnight.

As recently as the 1980s, amenities like grocery stores and surfaced roads were scarce. When the ziggurat-shaped Sheraton Hotel opened in 1982, it was the first architectural landmark on **Doha**'s crescent-shaped Corniche. It became an instant tourist attraction; locals came in droves to admire the vast, elegant lobby.

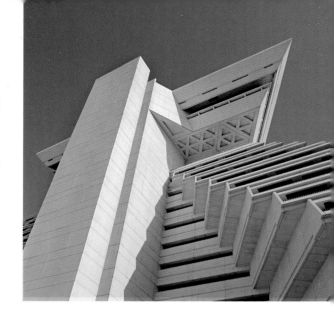

(above and following)
Sharp angles of the
Sheraton Hotel; the State
Mosque inspired by Al Qobaib
mosque commissioned in
1878 by Sheikh Qassim bin
Mohammed, the founder of
Qatar, to memorialize the
death of his father

13

Bin means "son of" while bint means "daughter of." Over coffee one day, a Qatari friend sketched his paternal lineage from memory to his sixteenth grandfather. This "back family" is important to an Arab's sense of self and his place within the tribe.

Doha, dohat in Arabic means bay.

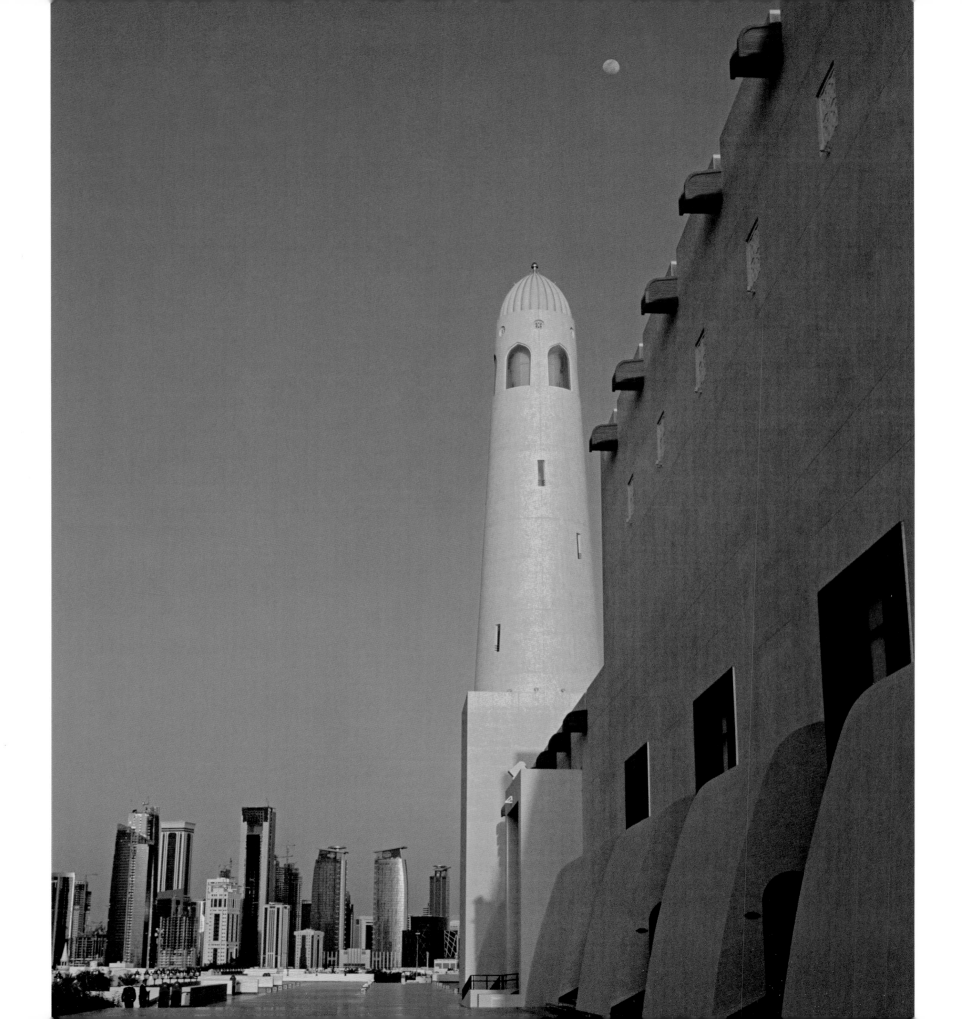

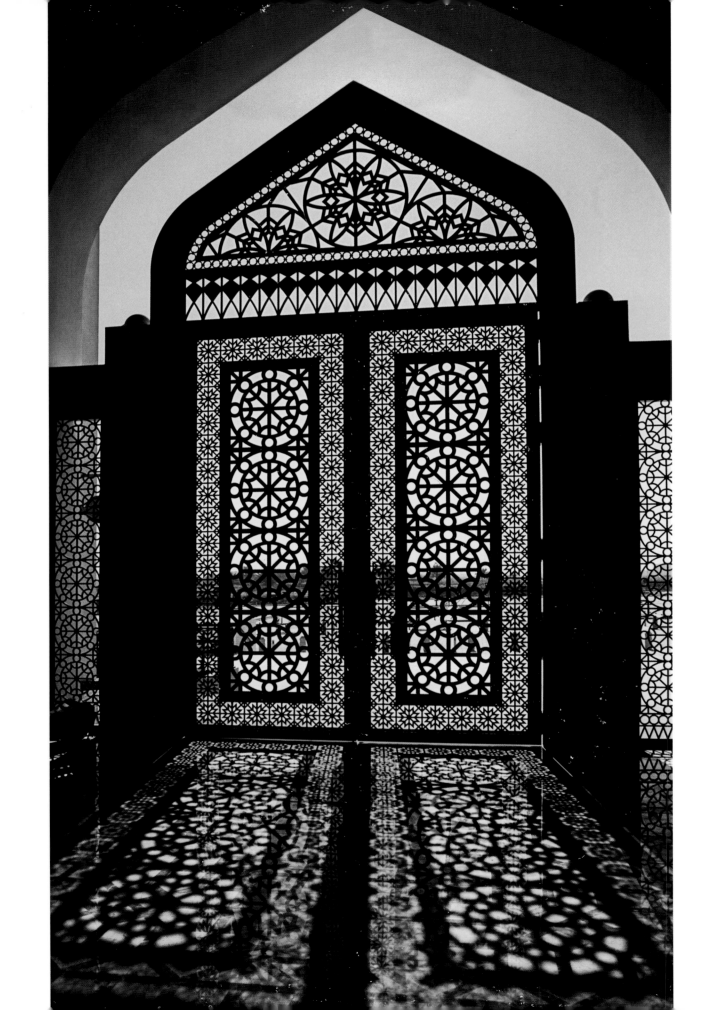

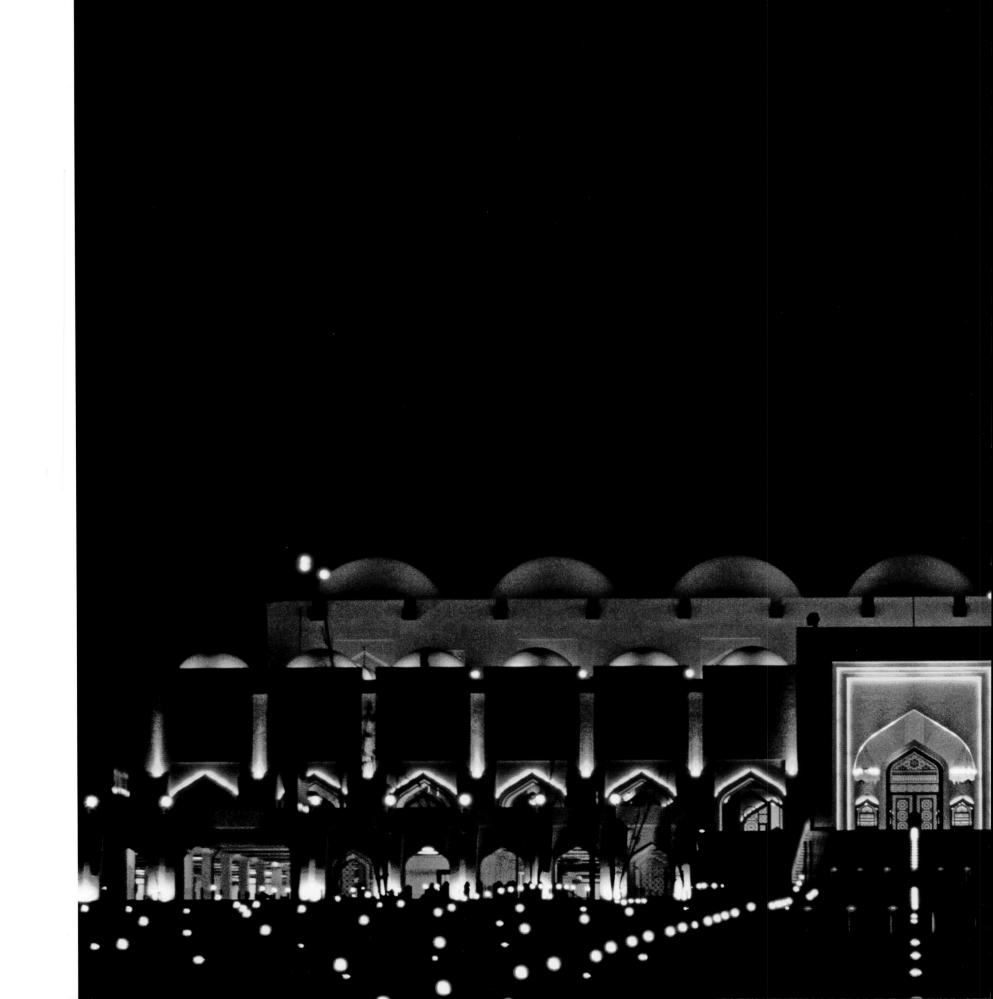

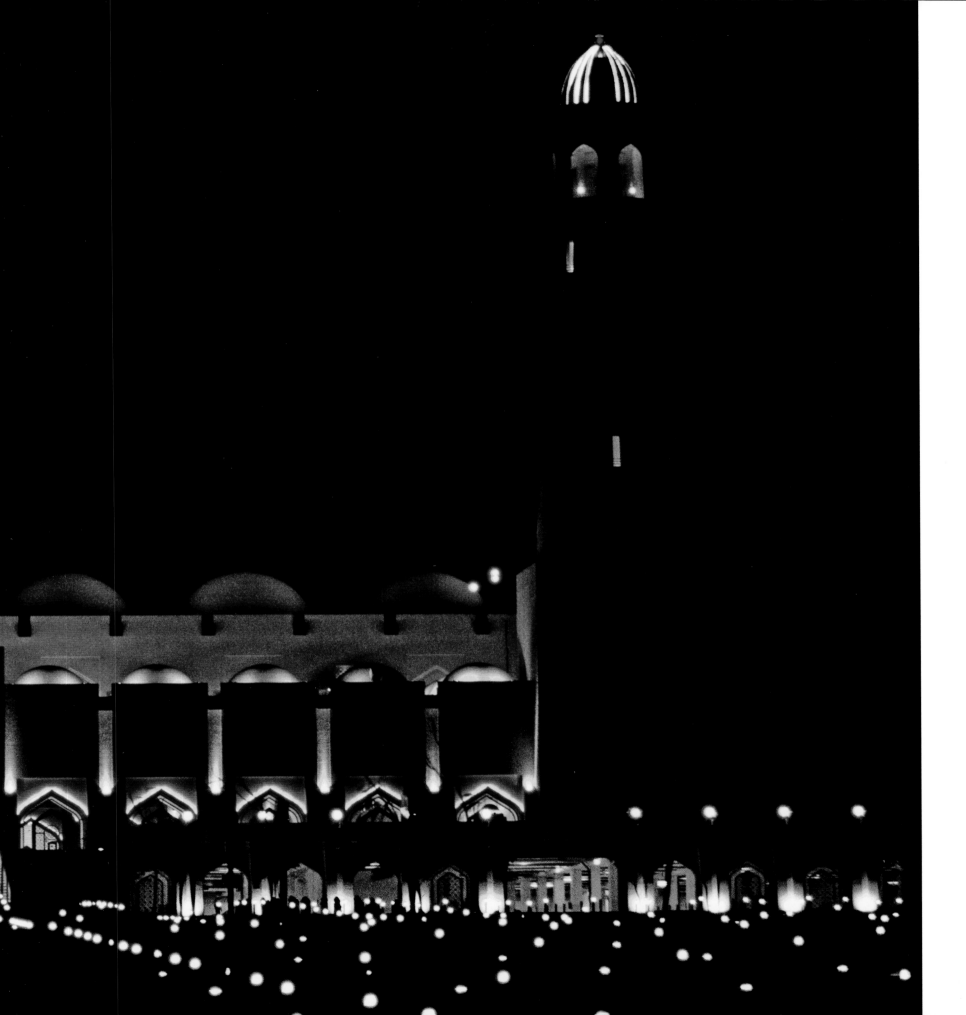

> Now, like a giant sculpture garden, the skyline of downtown Doha intrigues from every vantage point.

The hotel stood alone on a rocky flatland extending to the horizon. Previously, not a tree dotted the landscape where the hotel's popular beach club now nestles in a lush garden. Traveling north of the Sheraton construction site to today's heavily populated West Bay required a four-wheel drive.

Now, like a giant sculpture garden, the skyline of downtown Doha intrigues from every vantage point. Its exotic angles glisten in the sun and engrave the night sky with bold silhouettes. Less flashy but more fundamental, an entirely new infrastructure strives to keep pace with mind-boggling population growth. Roads, schools, industrial complexes, housing, hospitals, a country-wide bus system, a new airport, light rail, water, sewage and desalination systems are just a few of the projects. Locals and expatriates alike grumble about the disruptions caused by the traffic and construction, but given the population explosion, it is difficult to contemplate an alternative.

No formal census data exists before the 1970s, but estimates are available. In 1908, a British observer declared there were 27,000 residents in Qatar. Economic hardship brought on by the collapse of the natural pearl market caused an out-migration, leaving the population at a low of about 16,000 in 1949. With the development of oil resources in the 1950s, the population grew again: A 1970 census reported 111,113 people, of whom more than 40 percent were identified as Qataris. By 1977, that number was 200,000, of whom 65,000 were non-citizens. A high birth rate combined with a robust influx of labor resulted in an estimate of 480,000 in 1992, 744,029 in 2004 and 1,696,563 in 2010. The Qatar Statistics Authority projects the population to grow to 2.5 million by 2020.

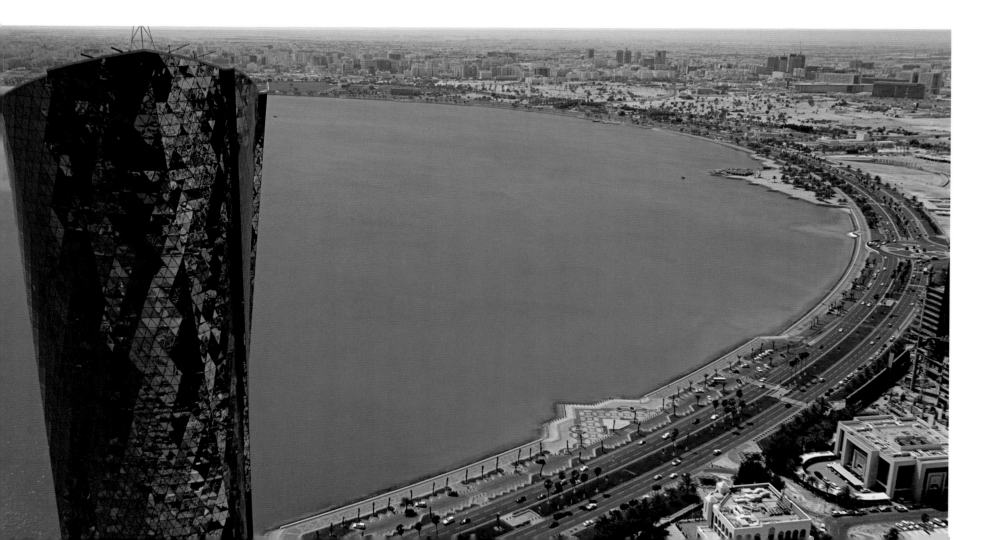

Oil and gas fuel the economic engine that drives Qatar's audacious plan, yet the Emir provides the spark. While he was heir apparent, Sheikh Hamad held many posts which prepared him for future leadership. But more than mere time on task, it has been the Emir's compassionate, pragmatic and confident character that has led Qatar to prominence on the world stage.

This confidence manifests itself in brave decision-making that challenges the political, economic and social status quo. When the Emir acceded to power in 1995, oil income had raised the standard of living in Qatar, but it was still known as a sleepy place relative to its Gulf neighbors. In the face of a depressed global gas market in the 1990s, Sheikh Hamad daringly asserted that soon Qatar would be the largest natural gas exporter in the world. Then, even though it seemed a pipedream to many industry insiders, he took the risk of floating enormous bonds to obtain the working capital to realize this goal. Providentially, the present-day ExxonMobil shared his optimism about Qatar's potential as an industry leader and entered into a joint venture that thrives today alongside many other multinational partnerships.

Using Qataris as cheap labor, a British consortium in the 1930s started developing the oil fields of Dukhan on the west coast. After a hiatus necessitated by World War II, the first oil exportation took place in December 1949 and was celebrated in grand style on February 2, 1950. In subsequent years, Sheikh Khalifa bin Hamad Al Thani, then heir apparent and later Emir, adeptly nationalized mineral rights and abrogated the agreements that gave monopolistic rights to the British. He also became a founding member of the Organization of Petroleum Exporting Countries (OPEC), which demanded fair prices for producing nations. Rather than receiving paltry royalties, Qatar negotiated majority-stake agreements and built downstream industries. The subsequent income led to the first wave of development that included schools, hospitals and basic services like electricity and water distribution.

Currently, the economy benefits from conservative oil price assumptions. Until recently, the assumption was $35 a barrel; in 2010 it was $55 a barrel. This regularly results in fiscal surpluses and the capacity to weather down-years. Surpluses from the hydrocarbon industry, including oil, gas and related petrochemical companies, have grown the sovereign wealth fund to unknown multiples of billions.

This fund, known as the Qatar Investment Authority (QIA), invests in diverse assets on behalf of the state to provide long-term financial security for the country. The QIA board is chaired by His Highness the Heir Apparent Sheikh Tamim bin Hamad Al Thani. The Chief Executive is Sheikh Hamad bin Jassim Al Thani, who is both prime minister and foreign minister. Qatari Diar Real Estate Investment Company and Barwa are two of QIA's dynamic mechanisms for wealth creation and high-quality, socially-responsible real estate development. At this point in Qatar's development, the links between industry, finance and governance are tight; without this powerful and consistent leadership, Qatar might not have the economic might or the social will to accomplish its ambitious goals.

In 1996, when the current Emir's government was newly installed, one of its most far-reaching initiatives was abolishing the Ministry of Information, which had been in charge of censorship, and concurrently creating the Al Jazeera satellite network. Al Jazeera proved an immediate sensation in Arabic and now broadcasts in English

This fund, known as the Qatar Investment Authority (QIA), invests in diverse assets on behalf of the state to provide long-term financial security for the country.

21

(following)

Souq Waqif stables; Al Wakra minaret; timeless horses against a contemporary skyline; fountains and the arabesque-topped Four Seasons towers

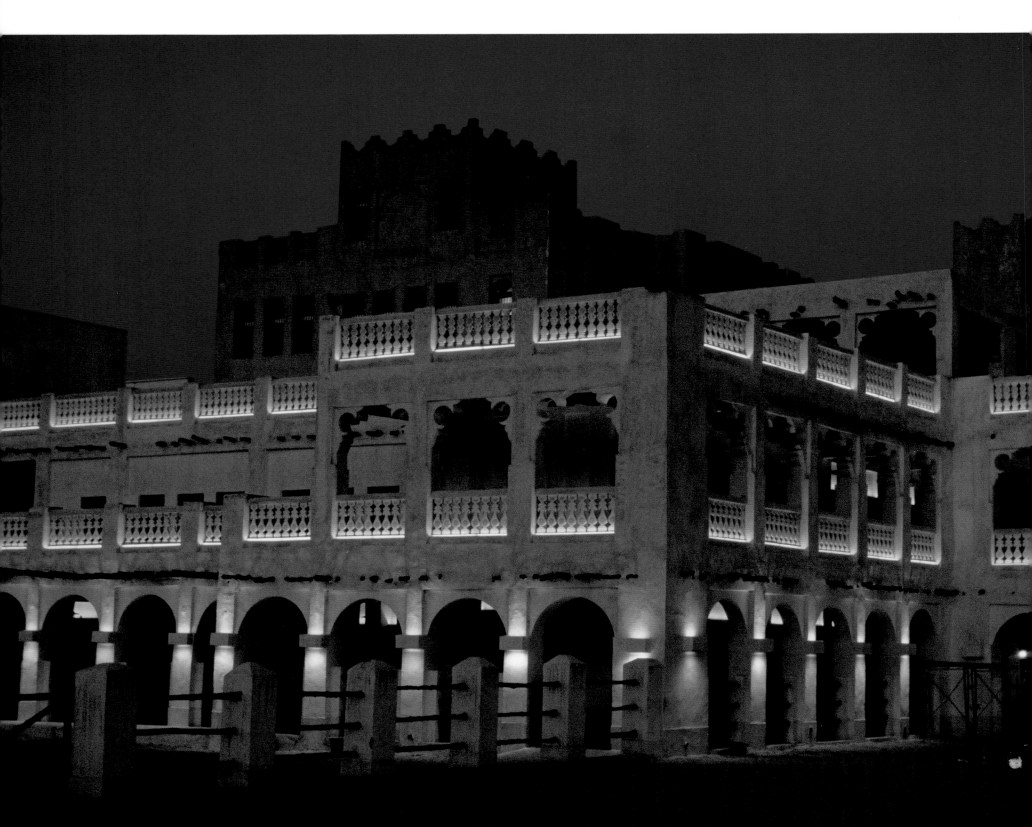

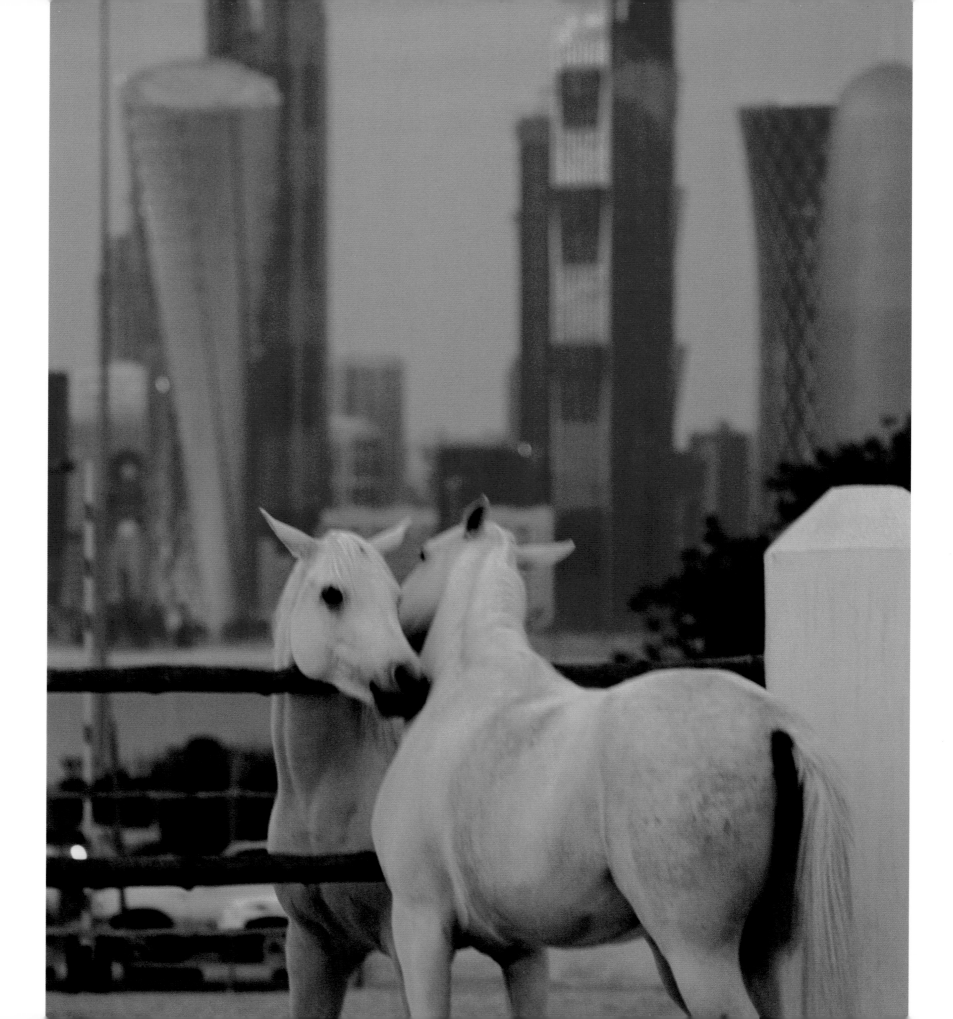

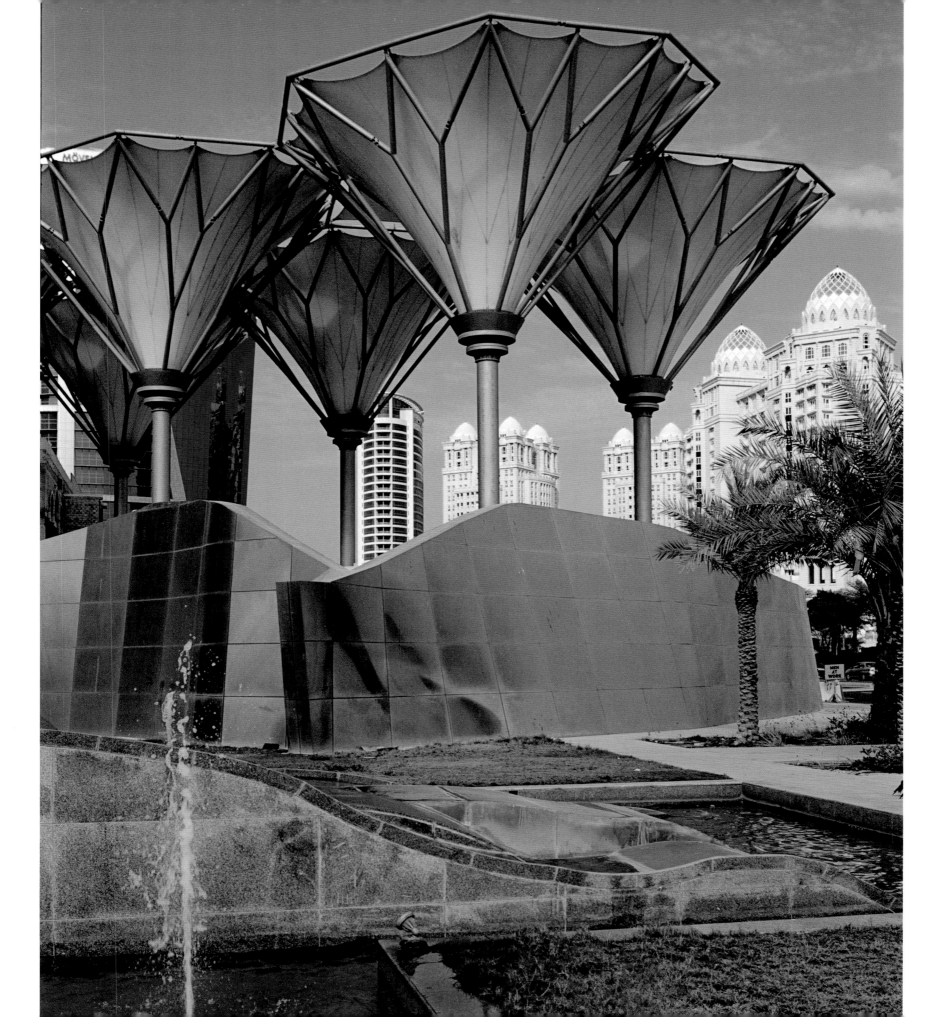

Even with criticism and differences of opinion considered, Al Jazeera has caused a new day of media freedom to dawn over the Middle East.

as well. At a time when many news agencies are closing bureaus, Al Jazeera is expanding at a rapid rate. Never shying away from controversy, Al Jazeera has provoked worldwide ire as it replaced what had passed for television news in the region—chiefly recitations of government press releases and the harangues of maximum leaders—with full and often incendiary coverage of the Afghanistan and Iraq conflicts, criticism of authoritarian regimes, interviews with opposition leaders, live reporting from Israel, and previously unheard-of public debate.

Particularly in the early days, questions arose about Al Jazeera's journalistic professionalism. Critics note that events in Qatar are rarely broadcast on Al Jazeera. Network managers respond to this by saying Al Jazeera is an international station: What happens right outside their doors rarely is important enough to report. Certainly, the network gave extensive coverage to the only anti-western terrorist incident in Doha to date, a suicide bombing in 2005 that killed one innocent person. Even with criticism and differences of opinion considered, Al Jazeera has caused a new day of media freedom to dawn over the Middle East.

Continuing the groundbreaking reform, Sheikh Hamad recognized that, given the needs of a country of less than 200,000 citizens, women should and must be equal partners in the future. The Emir confronted the cultural norms of the male-dominated region and put women on a public par with men. In 1995 when the Emir appointed his consort, Her Highness Sheikha Moza bint Nasser, as chairperson of the Qatar Foundation, women rarely if ever held official positions. In this role, Sheikha Moza launched a campaign to transform education from one of rote learning to one that stresses critical thinking and problem solving. The cornerstone for all the country's aspirations is education; placing this critical reform in the hands of a woman demonstrated the Emir's deep commitment to utilize the best talent available, regardless of gender.

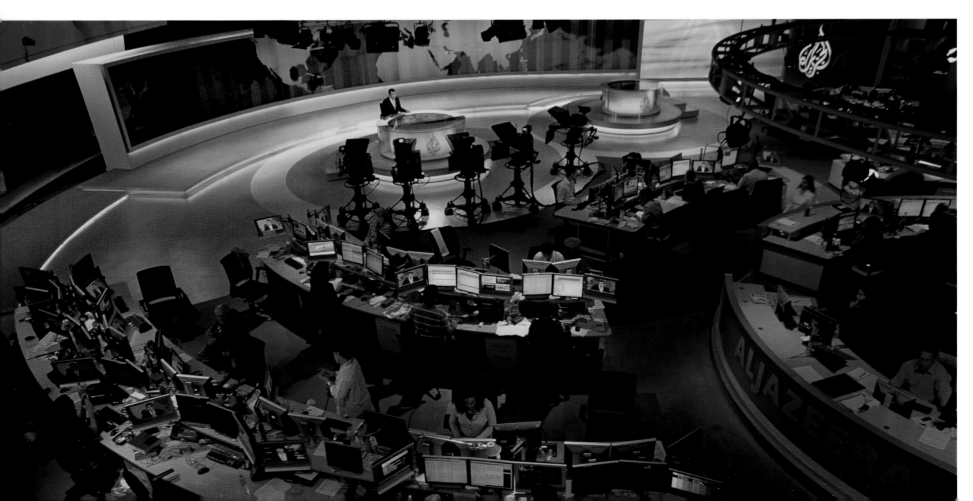

After a mere decade and a half, Qatar Foundation's Education City houses a collection of world-class degree-granting institutions, all with co-educational classes and instruction in English. Currently, these institutions and their academic fields are: Virginia Commonwealth University, design; Texas A&M, engineering; Carnegie-Mellon, computer science and business; Northwestern University, communications and journalism; University College of London, archaeology and museum studies; Weill-Cornell, medicine; Georgetown University, international affairs; and the Qatar Faculty of Islamic Studies. More are coming. While many students, including an increasing number of women, still go overseas to study, Education City provides important options.

Other alternatives for higher education include Qatar University (QU); University of Calgary-Qatar Nursing School; the Community College of Qatar, developed in partnership with the Houston Community College system; and the College of the North Atlantic-Qatar. QU, Sheikha Moza's alma mater, has separate campuses for men and women. The College of the North Atlantic is a junior college that provides extensive vocational training ranging from business and emergency medical training to machine tooling. To prepare students for these rigorous programs, education reform extends into the elementary and secondary levels of instruction. English is now mandatory and course work focuses on problem-solving rather than memorization.

Qatar Foundation also oversees a multi-billion dollar endowment to bring business and research together at the Qatar Science and Technology Park located adjacent to Education City. Fully 2.8 percent of the Qatari gross domestic product is set aside for research each year. Attracting high-profile partners to commercialize technology is part of a strategic plan to develop a sustainable economy based on brainpower, not just hydrocarbons. Other projects include an impressive convention center and hospital, both of which will be magnets for entrepreneurs, research and development.

Sheikha Moza's commitment to education led her to participate in a televised appearance at the groundbreaking of the Weill-Cornell Medical School in Doha in October 2003. This was the first time she and the Emir attended a public event together. A small number of female newscasters and professional women like physicians and educators began appearing in news stories in the 1970s; however, this was the first time the First Lady was broadcast on television. Only strong leaders surround themselves with talented people, and within the strictures of the Middle East, the latitude given to Sheikha Moza to succeed is even more profound. She is an inspiration, particularly for women wishing to excel academically and professionally. As young people race to be diplomats, petroleum engineers, brain surgeons, designers, or whatever career they choose, nothing now seems out of reach.

In the political realm, the Emir not only extended the vote to women in first-ever elections for a municipal council in 1999, but he also encouraged them to stand as candidates, forestalling debate over universal suffrage. While none of the eight female candidates triumphed in that initial democratic experience, a woman won a seat in a subsequent election. At the same time, newly empowered women took to the roads behind the wheels of their own cars and continue to do so in exponentially-increasing numbers. While I know a **sheikha** who learned to drive in her forties, teenage girls today start lobbying their parents for cars and drivers licenses much like their peers abroad. Some women still prefer the convenience of a driver, however.

(previous, above and following) Al Jazeera newsroom; Qatar Foundation's Education City: shade structure at Qatar Academy, Ceremonial Court designed by Arata Isozaki, Weill-Cornell Medical School, nighttime graduation celebrated with Her Highness Sheikha Moza

27

Any female member of the ruling Al Thani family is a sheikha; the male equivalent is a sheikh. Respected religious scholars often receive the honorific of sheikh as well.

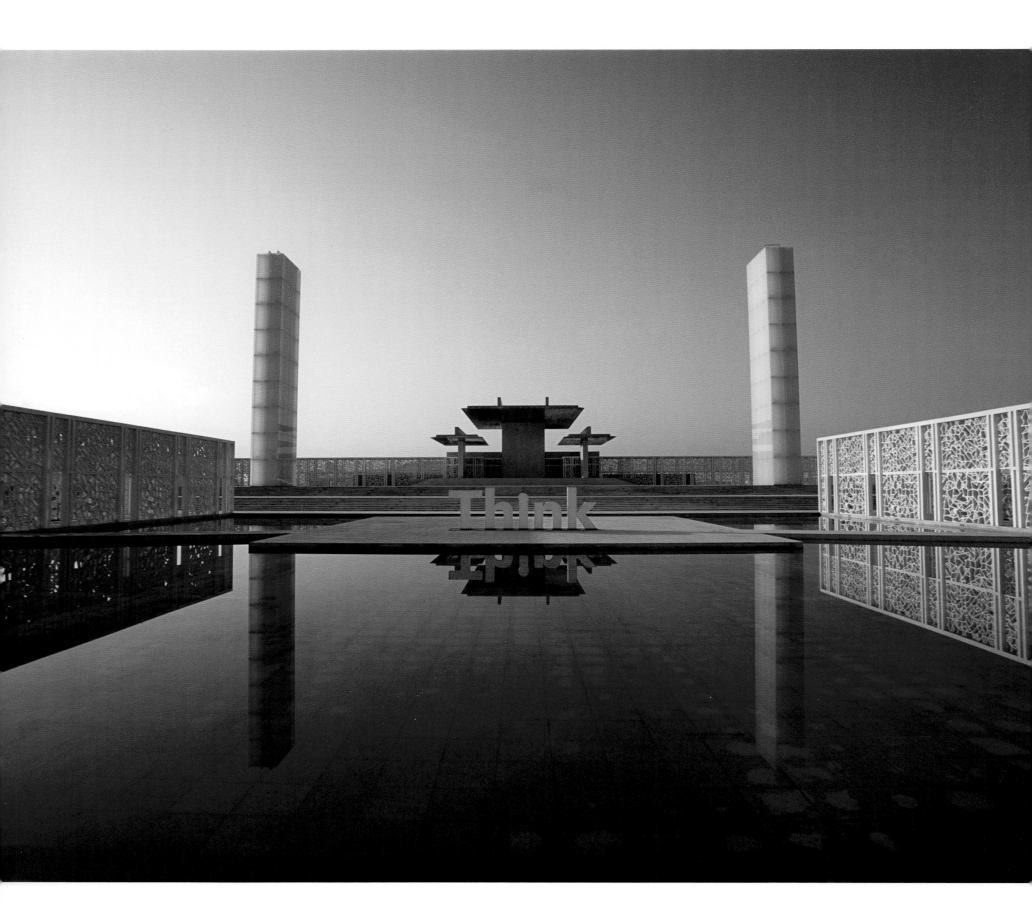

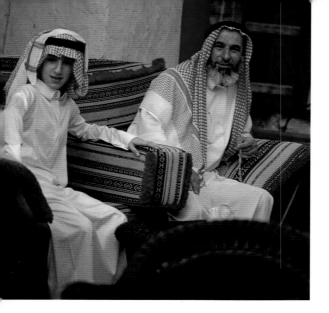

(above, opposite and following)
Faces in Souq Waqif: a father
fingering a *misbaha*, prayer
beads, sits with his son;
a Persian worker who pushes
shoppers' purchases in a wheel-
barrow; the Emiri Diwan houses
official reception rooms and
offices for the Emir and his staff

The challenge is
immeasurable:
To transform within
one generation a
conservative, hard-
scrabble subsistence
society into one
with the highest per-
capita income in the
world, without losing
desirable traditions and
ethics in the process.

Paradoxically, the empowerment of women is not new. Current reforms return them to the central role they played in the pre-oil era. With the exception of women in a few wealthy merchant families, idleness was not an option. Bedouin women—and children, for that matter—worked hard around camp, caring for livestock, weaving, cooking, packing up heavy woolen tents, and bartering their handicrafts in the market for grain, rice and dates. Women held the family together. Whether they lived in a tent, a simple adobe-like house or a palm frond hut, they cared for their children and conspicuously took full responsibility for the family during the pearling season, when many of the men were gone for months at a time. Modern women are mostly professionals, but there is also a lively fine art scene, and programs at the social development center inspire new artisans.

Focusing on the people of Qatar—roughly 200,000 citizens and more than 1.5 million expatriate workers —is the hallmark of the Emir's reign. It marks the inception of a new Qatar, one that honors tradition while building a superhighway to the future. The goal of modernity is not Westernization. Instead, it is to use best practices to compete in the global economy while nurturing the country's core values of family, faith and tradition.

A thumb-shaped peninsula—smaller than Connecticut and larger than Cyprus—jutting north into the Arabian Gulf, Qatar has forged an assertive foreign policy that has won global attention despite the country's small population and modest size. Qatar made both history and headlines when it became the first Gulf nation to establish overt ties with Israel. Political and religious leaders from both Israel and the Jewish diaspora have participated in Doha's frequent global conferences and interfaith dialogues alongside their international peers. In another unprecedented move, the Qatari government donated land for the construction of Christian churches in Qatar. The first of these, a Roman Catholic church, opened on Easter Sunday in 2008.

Both the Emir and Sheikh Hamad bin Jassim Al Thani, the prime minister and foreign minister, are known for intercontinental diplomacy. Qatar sought and won the so-called "Arab seat" on the UN Security Council, and in so doing had to withstand the inevitable storms that result from casting on-the-record votes during the two-year term (2006-2007). Its pursuit of open relationships with countries and groups of such widely different views as Iran, Israel, Hamas, Hezbollah, Syria, Cuba, Venezuela, China, Europe and the United States has, unsurprisingly, caused disquiet on all sides. Qatar believes that such ties both protect its interests and allow it to influence regional and even global politics as an international conflict mediator, notably in Lebanon, Darfur, Yemen and Gaza.

Engaging with Iran and Arab political movements while hosting the U.S. military headquarters responsible for operations in Iraq and Afghanistan is a tightrope act that is scrutinized and criticized by all sides. Political factors, as well as a practical budgetary decision to expend wealth on education and development rather than on weapons, led Qatar to construct the Al Udeid air base outside Doha in 1995. As Qatar hoped, Al Udeid attracted the interest of the United States, which began using it in 1996 after agreeing with Riyadh that American forces should leave Saudi soil. While Al Udeid may be a potential target, it also acts as a deterrent to aggression.

To date, Qatar has resolved all border disputes. But with Saudi Arabia on its southern border and a potentially nuclear-armed Iran across the narrow Gulf, it remains a small and extremely rich country sandwiched between powerful neighbors. In this position, foreign policy places a premium on building alliances. Strong regional

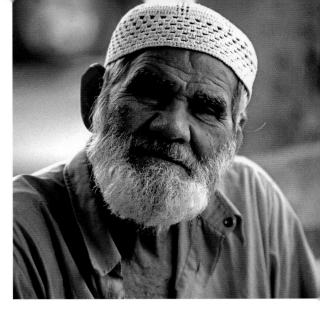

ties are built unilaterally as well as through the Cooperation Council for the Arab States of the Gulf, also known as the GCC. In March 2011, Qatar complied with the Arab League's call for action against Libyan leader Muammar Gadhafi by sending fighter jets to enforce a U.N. no-fly zone. At the same time, Qatar Petroleum arranged to sell Libyan petroleum to give anti-Gadhafi forces vitally-needed funds.

When not pursuing his comprehensive agenda, the Emir enjoys walking through projects like Souq Waqif, the redesigned old market, and talking with whomever he encounters. Born into the traditional tribal structure in which sheikhs listened to petitioners and decided individual claims, Sheikh Hamad has built modern governmental and legal structures to handle disputes equitably and efficiently. In this time of striving and adjustment, governance is less about emiri decrees and more about providing incentives for Qataris to take advantage of opportunities in education and the professions—all precursors to their country's transition into a working democracy.

The challenge is immeasurable: To transform within one generation a conservative, hard-scrabble subsistence society into one with the highest per-capita income in the world, without losing desirable traditions and ethics in the process. Wealth is an extraordinary blessing, *al humdulillah*, thanks be to God. But just as in stories about lottery winners, it can also be a bane. Wildfire change can cause social upheaval. While community responsibility is part of the culture of both Islam and the desert, wealth and opportunity have flooded the country so fast that it has been a struggle to catch up with existing realities. And, comprising less than one-seventh of total residents, Qataris are a minority in their own country.

Only a generation or two ago, Qataris lived either as nomads—the *bedu* or Bedouin—or as traders, coastal fishermen and pearl fishers—known as *hadher* or settled. This small group must learn to balance having wealth with the obligation to care for the legions of foreign workers who are opening businesses, managing and manning projects, practicing professions, digging holes, cleaning houses and playing a significant role in raising children. The rights of immigrant laborers clash with a sponsorship system which requires expatriates to have a citizen sponsor who controls significant aspects of daily life—like traveling overseas and working for another employer. The National Human Rights Committee offers complainants a voice, and other initiatives provide low-cost housing and healthcare and more systematic enforcement of the existing labor laws.

With such a tiny population, Qatar must protect both its unique character and its resources. Thus new citizenship is limited. While Qataris may be a demographic minority in their country, they are still its cultural majority, and they want to keep it that way. On the other hand, the ongoing need for foreigners—from the backbone skills of migrant laborers to the expertise of professionals —necessitates the development of rational systems to incorporate expatriates into the fabric of national life.

These complex legal and humanitarian issues differ vastly from those faced in the recent past. A Qatari born in 1950 may well remember not having enough to eat, or watching fathers and brothers leave to take manual jobs in the new oil fields in Dukhan. Running water and electricity were virtually unknown, except for scattered generators at the sheikh's palace and the houses of a very few affluent merchants. Donkeys, camels or a man with a wooden yoke balancing two pails hauled water from local wells.

Born into the traditional tribal structure in which sheikhs listened to petitioners and decided individual claims, Sheikh Hamad has built modern governmental and legal structures to handle disputes equitably and efficiently.

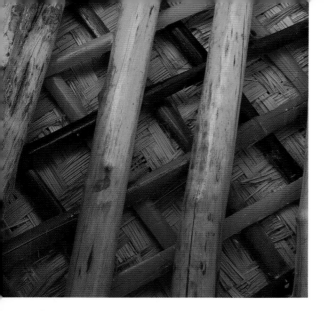

(above, opposite and following)
Ceiling lattice commonly used in
traditional Gulf construction;
Qatar University's architecture
reflects the traditional wind
tower which provides natural
ventilation; wind tower and
door detail at the Sheikh Ghanim
bin Abdulrahman Al Thani
house in Al Wakra

Greetings in the Gulf
are still a dance of
words as ritualistic
exchanges of peace and
the ubiquitous query,
"*Esh alakhbar,*" literally,
"What is the news?"
carry tradition up
through the centuries.

Qatar's economic low point was caused by the arrival of Japan's cultured pearls on the world market in the 1920s. The new, less expensive cultured pearl crushed the demand for Qatar's primary export commodity, natural pearls, and World War II delayed the development of newly-discovered oil reserves. As the population was reduced to dismal poverty, men and even entire families and tribes migrated to Bahrain, Saudi Arabia and Iran to eke out a living and keep their children from starving. Qatar now has an enviable GDP with modern hospitals and entire school systems springing up in outlying towns as well as in the capital city of Doha.

This dramatic rise in the standard of living has had the unintended consequences of inflation and a new culture of consumption that leaves many prosperous people feeling poor as society puts a premium on material goods. Young men worry about being able to pay the dowry required for marriage—including elaborate weddings, housing, cars and a driver—as well as the possibility of having to care for aging parents. Lack of financial management skills can lead to squandering government-provided financial resources or taking bank loans for luxury items that lead to long-term debt.

In contrast, consider that in 1952, there was only one school in Qatar, an elementary school for boys with about 240 students and six teachers. The first school for girls opened in 1955. Before then, some students, primarily boys living in or around small towns and villages, might learn basics like reading and writing from a local Qur'anic scholar. A friend born in the early 1960s recalls piling into the back of a pickup truck with other boys from his north coast village to bounce over rough roads to a small school. At that time, many Bedouin were still living a nomadic life, and illiteracy was the rule. But even without much formal education, Qatari *bedu* produced beautiful and complex poetry and transmitted it by word of mouth, the timeless medium of desert travelers. Greetings in the Gulf are still a dance of words as ritualistic exchanges of peace and the ubiquitous query, "*Esh alakhbar,*" literally, "What is the news?" carry tradition up through the centuries, from times when meeting a fellow wanderer of the desert was an occasion for hospitality and a gathering of information.

The lives of parents and grandparents were simple, measured in necessities—food, shelter and protection of families. Life was basic, physical. Tribal laws held sway. Complex rules of protection and retribution were part of an unwritten code. Currently, civil codes and court systems are replacing the traditional justice of families and sheikhs. Basic math and reading skills were for reading the Qur'an and keeping merchant accounts, whereas education today is valued as the fundamental building block for a successful life.

Qatar National Vision 2030, launched in October 2008, focuses on four pillars of development—human, social, economic and environmental—that together articulate Qatar's clear intent to be a modern nation. The plan pays special attention to the social contract with its own citizens addressing questions such as "What is a fair distribution of wealth from the hydrocarbon windfall?" In the distant past, even the leading families had relatively small fortunes, and everyone else was on a par, basically subsistence-level. Those who could afford to share practiced *zakat*, the mandatory annual giving to the poor amounting to about 2.5 percent of one's wealth and *sadaqah*, voluntary charity above that level. They provided fundamentals like clothes, bags of rice and sugar to the less fortunate. In the early oil years, however, the society became increasingly stratified as a few Qataris profited disproportionately. Thus, a conscious effort is being made to implement a policy that guarantees that every citizen in perpetuity will benefit from the economic boom.

The goal is to develop a productive middle class. But because of the robust per-capita income, Qatar is well above customary measures. For example, by international standards, no Qataris live in poverty; instead, Qatar has identified a relative poverty line to ensure a dignified and equitable life for all citizens. Providing meaningful jobs is an essential part of this process, and "Qatarization" is a government policy to encourage companies to hire local citizens. Excellence in education is the means to achieve this goal, because the skills needed to keep Qatar in the hands of Qataris are technical, intellectual and managerial. Work is focused not in the home but in office buildings, laboratories and industrial sites.

Change of this magnitude usually evolves over centuries. In Qatar, it comes quickly and relatively seamlessly. Naturally, not everyone is of one mind. There is both nostalgia for the simple, unhurried life of decades past and religious concern that society is moving away from its conservative fundamentals. The *fereej*—neighborhoods delineated by families or tribes and usually bearing their names—are still prevalent. Yet, as the population grows and land gets scarcer and more expensive, families are living farther apart, often in single-family dwellings rather than with extended families. Faced with busy lives and congested streets, families who once gathered daily must now carefully set aside a day or a meal per week to get together. New standards of education also put a strain on families as they see their children pressured to succeed in rigorous new school and university programs. As English becomes the dominant language of instruction and business, Qataris worry that **Arabic** fluency is in decline.

There is a difference between spoken, colloquial Arabic and literary or classical Arabic, which is very difficult to master. Classical Arabic is revered as the language of the Qur'an and is used for newspapers and provides commonality across the multicultural Arab world.

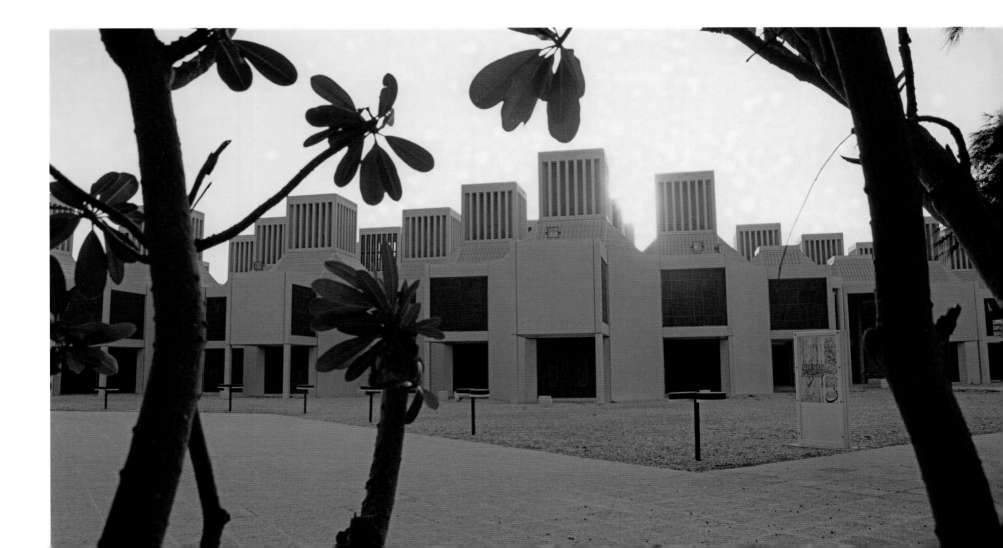

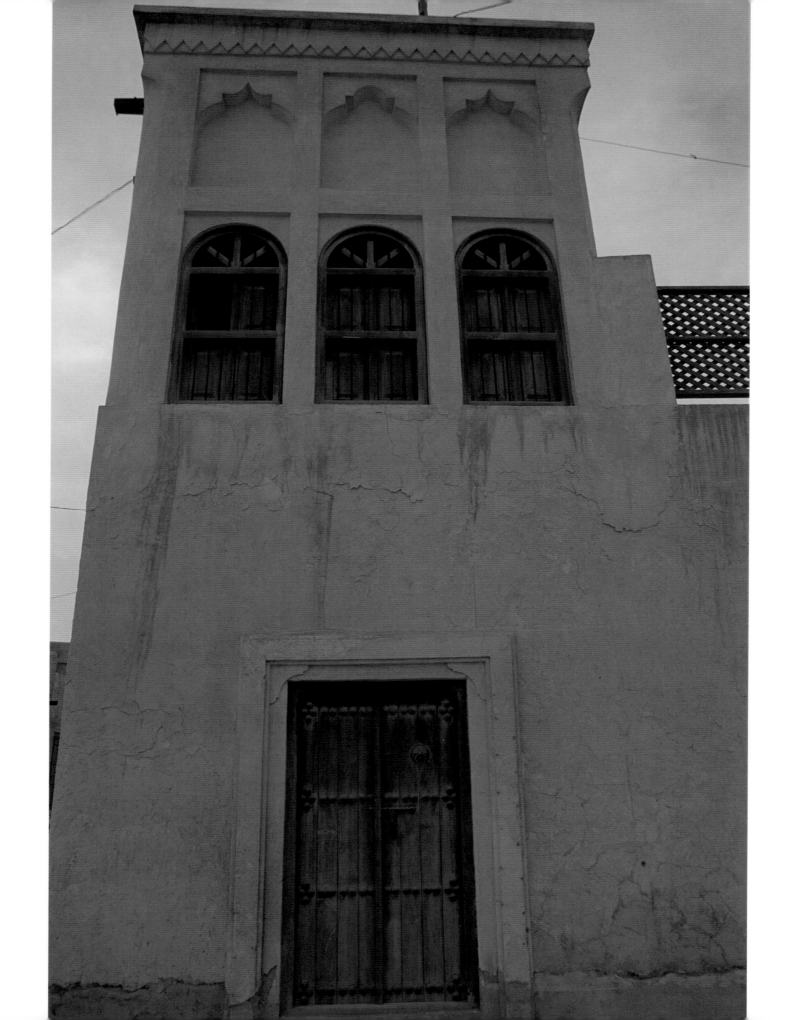

Modest dress—
the graceful, floor-
sweeping robe called
an *abaya* and the
matching headscarf,
the *shayla*—derives
from religion;
the black color,
from tradition.

(above, opposite and following)
The sleeve of a colorful *abaya*,
a member of the women's
show jumping team; a *batoola*-
clad woman shopping at the
wholesale vegetable market;
a photographer with henna-
patterned hands at a National
Day parade; enjoying fresh
bread in Souq Waqif

Land use debates create another source of tension. Substantial development projects and urban enhancements like major parks were not anticipated in early city plans and have required large sections of land to be taken by eminent domain. Landholders are generously compensated, but this can seem like small consolation when their homes go under the wrecking ball or when land held in the same family for generations is taken. Evolution of this magnitude does not happen in a vacuum.

A recent study suggests that consanguinity—or cousin-marriage—with consequent congenital abnormalities, is on the rise, perhaps as a stress response to the rapid fracturing of social ties, a way to circle the wagons and protect what is dearest, family. Genetic information is broadly disseminated in the press, which is note-worthy because until recently private issues of this sort were not addressed publicly. To date, Qatar has not forbidden cousin-marriage; but as of 2009, genetic testing is required, and couples are advised to follow their doctor's advice.

The decision not to mandate this personal decision fits well within international practice, as no laws forbid cousin-marriage in most of the world, including in the European Union. Only twenty-five states in the U.S. prohibit it under all conditions. The primary reason for close marriages is that people within the same family trust each other. Since cousin-marriage is an ancient practice in a region proud of its lineage, an attempt to mandate change would likely meet significant resistance. Rather, Qatar has created both a major new genetic research hospital and a public information campaign to enable prospective couples to make educated choices.

Tough issues face young people, particularly women, who are both the primary beneficiaries and the ones most affected by the rate of change. The question, "Are women oppressed?" inevitably arises when Middle Eastern countries are discussed. As in any country, there is a continuum and room for improvement, but for the most part Qatari women have opportunities most women elsewhere only dream about, such as free education through the university level and beyond if they are qualified. Women have the right to equality in education and employ-ment, as well as the right to drive, vote and hold office.

Qatarias are active in claiming their prerogatives. For example, until recently women did not receive housing allowances, as did their male counterparts, since it was assumed they would be living either with their fathers or husbands. Only recently entering most professions, Qatari women will soon be tapping on the glass ceiling, and only the future will tell how successful they will be at cracking through.

In public forums, some female students express a desire to study overseas, which they say their families will not allow without a chaperone. This can be impossible due to the expense and difficulty of finding a family member who wants to spend an extended time abroad. Sometimes these young women compare themselves to their American peers who the Qatarias have been told can do whatever they want after age eighteen. Legally, this may be true, but in reality the situation is similar since many western parents exert great influence over their college-aged children's decisions, in addition to financing their education. The main discrepancy is that Qatari males face fewer familial restrictions on overseas travel and employment.

Women fill the halls of academia and the workforce. Their enrollment numbers in higher education exceed that of males and their achievement outstrips many of their male classmates as well, demonstrating that Qatari women have been quick to take advantage of the opportunities made available in the last two decades. Many have the luxury of maids, nannies and drivers who provide them the freedom to pursue a career. Still, the social impact of Qatari children being raised by foreign, often non-Arabic-speaking, caregivers is vigorously debated in the media and in mosques. Fundamentally, Qatari women shoulder the same burden as modern women the world over, balancing home and office. Add to this the desire to protect traditional values like cohesive families while enjoying the empowerment allowed by an increasingly open society and personal income, and the circumstances Qatari women face grow even more challenging.

Modest dress—the graceful, floor-sweeping robe called an *abaya* and the matching headscarf, the *shayla*—derives from religion; the black color, from tradition. No laws mandate veiling. *Abaya* are frequently form-fitting and so elaborately embellished with silks, beading and embroidery that their beauty and expense rival the finest evening gowns. The *abaya* and *shayla* are essentially national dress, just as the *thobe*, a long robe usually of white cotton but of darker wools in winter; the *ghutra*, a white or red-checkered head covering; and the *igal*, a double black rope ring around the ghutra, are for men.

The *niqab* is a black cloth face-covering. Some women wear it; most do not. Perhaps because it is such an arresting image, evoking thoughts of women coerced to cover in countries controlled by fundamentalists, it receives inordinate attention, as does the *batoola*, a metallic-looking linen mask that is still seen occasionally, primarily on older women. Not all women who cover their faces in Qatar are Qatari. Many are from other countries, such as Egypt, Sudan or Algeria, and even some American women married to Qatari men choose to wear the *niqab*.

Some families want women to cover their faces, and some women choose to cover for reasons of privacy, because in this small-town-sized population it increases their freedom of movement. There are a few men who wish their wives would leave their faces uncovered and accompany them to restaurants and other public places more frequently. More important than the degree to which women cover is the extent to which they are given freedom to pursue personal goals like education and careers. By that measure, Qatari women are not oppressed but quite liberated.

If mores in dress are complex social barometers, multiple marriages also raise multifaceted issues. Muslim men are allowed four concurrent wives, although the Qur'an and the **Prophet Mohammed** discouraged this practice. In reality, most Qataris are in monogamous relationships for a variety of reasons. Some believe monogamy is better, and others cannot afford more than one household even if they want more. *Sharia* law allows women to put whatever provisions they want in their marriage contracts, including those allowing them to continue their education after marriage and to get a divorce if their husband takes another wife. There is a gender disparity, since polyandry—a woman having multiple spouses—is forbidden, and wives face the possibility that a husband may try to take another wife. But Qatari women are not forced into polygamous marriages.

Muslims often include "Peace be upon him" (PBUH) after all prophets' names, including the Prophets Abraham, Jesus and Mohammed. This notation will not be included in this book but may be assumed. The Qur'an 4:3 states that a man should marry only one wife if he doubts that he can treat more than one equally. While not a complete prohibition, many interpret this surah to forbid polygamy since no mere mortal could pass the equal treatment test.

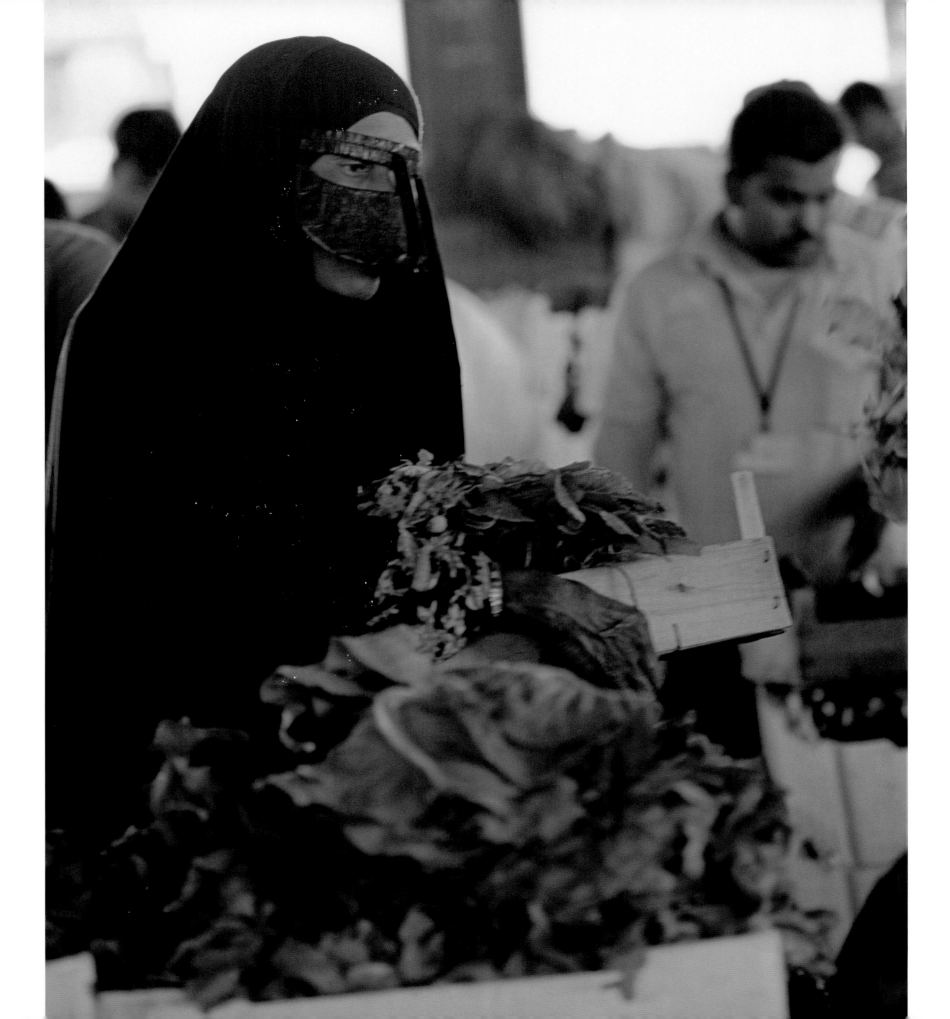

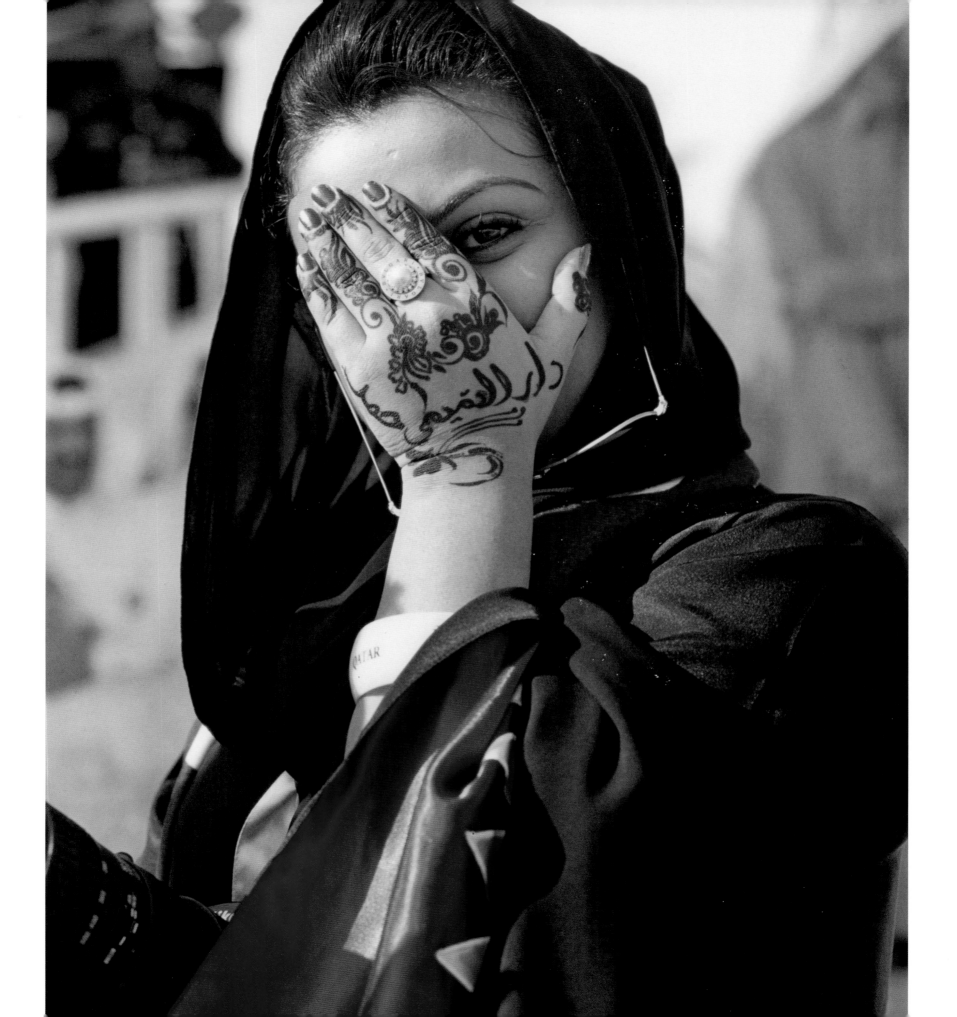

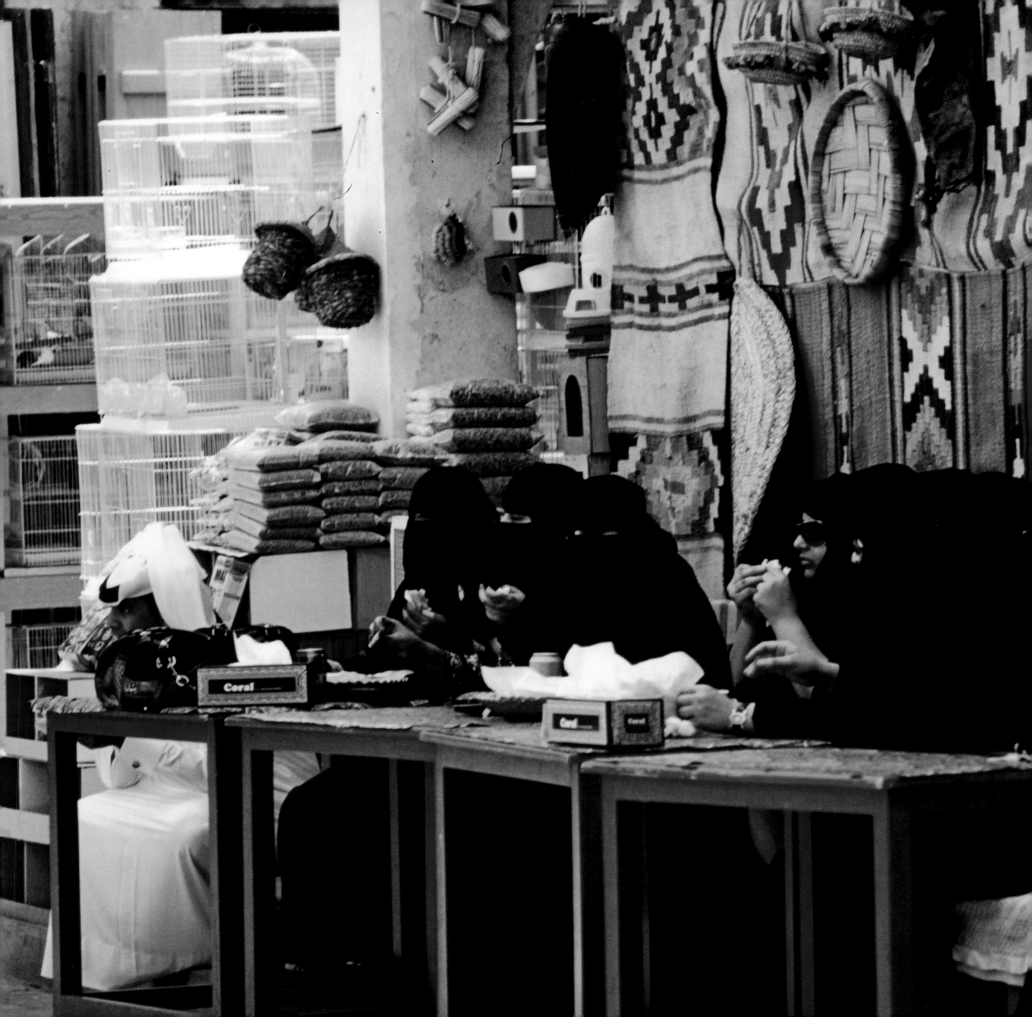

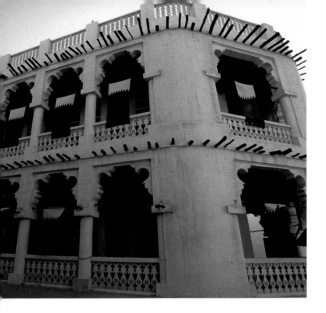

In the Gulf, "to sit" is an active verb. Sitting means sharing each other's time and food. It means sharing profound grief at a condolence call and glorying in the joy and splendor of a wedding party.

Indeed, there are women who willingly become a second, third or fourth wife in order to have children, or because they are in love or want a better standard of living. In some cases, particularly in the case of close family marriages, there can be a de facto separation without an official divorce. So while a woman may be a second wife, she may not be sharing a husband. Qatar has not seen combat on its soil recently, but in war-torn countries like Iraq and Afghanistan the huge loss of young men has meant that many women desiring a husband and children have few options other than accepting a polygamous marriage.

Undoubtedly, profound choice and change confront women in Qatar. Many young women express a desire to obtain more freedom without losing the benefits of their traditional life. Some of that tradition has to do with close family ties and the subservience of the individual to the group. Most women do not want to discard the protection and love of the family to achieve unfettered freedom, particularly since the grassroots and the political leadership already provide them with such rapidly expanding opportunity.

The world focuses on the status of Qatari women, but young men also face challenges. Men hold the vast majority of senior positions in Qatar, in which they (like the women) are proud to contribute to its development. At the same time, with few restrictions and ready access to cars and cash, many young men fall into an idle life. If women achieve more and young men less, there may eventually be more than a loss of productivity: A social rift could develop in which young people cannot find marriage partners with similar aspirations.

In a more immediately tragic situation, young men are dying in high numbers on the roads. High speeds and reckless driving once ranked Qatar as worst in the world for traffic deaths. Just as in other countries, making laws is not the challenge; enforcement is. In recent years, a public-private partnership has made visible headway, including increased professionalism of the traffic police, education and awareness campaigns, numerous radar cameras and a rigorous regulation of industrial vehicles. The focus on road safety is a visible example of Qatar's commitment to hold its citizens accountable for the well-being of the entire community.

Community is the essence of Qatar, and loyalty to family and tribe makes community, not the individual, the building block of society. For centuries, Arab tribes in Qatar co-existed in loose confederation, migrating regularly both by sea and land from Kuwait, Bahrain, Oman, eastern Arabia and Persia. These nomadic tribes moved in and out, following elusive fodder for their camels and livestock and seeking or escaping tribal alliances and disputes. Settled coastal areas also organized along family and tribal lines, at times banding together to repulse intruding tribes from as far away as Oman or to make naval sorties along the Arabian coast and the islands of present-day Bahrain in order to control trade routes and pearl beds.

Tribal chiefs governed towns such as Al Zubarah, Al Thakira, Al Wakra, Fuwairet and Al Bidda (part of present-day Doha). Centralized governance and Gulf Arab dynasties evolved during the time the British sought to abolish piracy, maritime warfare and the slave trade. The British wanted peace in order to further their trade interests, and to do so they had to identify the most likely leaders with whom to negotiate. The Al Thani tribe emerged politically in the mid-nineteenth century when the British political resident (domiciled in Persia) began corresponding with Sheikh Mohammad bin Thani, identifying him as the "Bidda Chief". His position as the political leader of Qatar was reinforced when he signed a treaty with Great Britain in 1868 that ended hostilities between Qatar and Bahrain.

The 1868 treaty also recognized the other leading tribes, whose leaders continued to exercise power within their territories, but Sheikh Mohammed acted for them on external matters. Al Thani hegemony solidified during the Ottoman occupation of 1871-1915. Sheikh Mohammed's son, Sheikh Qassim (or Jassim) bin Mohammed al Thani, acted as a deputy governor for the Ottomans while concurrently appealing to the British for a treaty of protection. Sheikh Qassim is credited with unifying Qatar, and December 18th, the date in 1878 on which he succeeded his father, is now celebrated as National Day. Before 2007, the national day was September 3, the date in 1971 on which Qatar became an independent country, nullifying its 1916 protection treaty with Great Britain. The change of date emphasizes Qatar's "Arabness" and makes the point that it was never a colony. Nationality is like another layer of history added to desert pride and is demonstrated annually with enthusiastic displays of the flag and folkloric dress.

Though Qatar has a strong national identity, its families and tribes still define the social order. Tribes proudly relate their histories and tell tales of the land or towns they used to control—but discreetly, so as not to revive old animosities. On celebration days, such as the marriage of the heir apparent and on national day, many of the tribes set up huge tents on empty lots scattered around Doha. There the men celebrate with *ardah*, sword dancing, and enormous feasts. Generosity was and is a primary measure of individual and tribal pride, so any passerby may drop in and be welcomed with traditional coffee and a place around the common platters of food.

Finding My Way | I clearly benefitted from my husband's status as the American ambassador, partly because people were curious about me and partly because their concept of an ambassador's wife differed so greatly from who I actually am. The general expectation was that I would be aloof, socializing only with a small elite of Qataris and the expatriate community. In truth, I wanted to take part in local life. I handed out my card unreservedly and went everywhere I was invited. Expatriates can get the impression that Qataris don't want to know them, because Qataris can seem reserved. This perception results not from a "clash of civilizations" but from what I call "a clash of shyness", a mutual misunderstanding of cultural norms.

In close-knit Qatari society, introducing yourself is rarely necessary. You either already know someone or a mutual friend will tell you who the person is before you meet him or her. Qataris shake hands and exchange pleasantries, but serious conversation waits until later, perhaps while seated over coffee. Westerners in Qatar may feel rebuffed when they give their names and get little or no response, such that they may never move beyond that initial reaction to any type of intimacy.

In the Gulf, "to sit" is an active verb. Sitting means sharing each other's time and food. It means sharing profound grief at a condolence call and glorying in the joy and splendor of a wedding party. It means kneeling around a heaping platter of rice and roasted lamb or waiting past exhaustion for your host to let you go home. Sitting means spending time together, the pathway to trust and affection.

Qatar is small enough that word travels quickly, and it seems my daily routine disarmed many, notably the pre-dawn dashes I made to farms to ride horses before the withering heat set in. While my husband zoomed around in traditional ambassadorial style in a three-car motorcade outfitted with lots of armor and firepower,

Nationality is like another layer of history added to desert pride and is demonstrated annually with enthusiastic displays of the flag and folkloric dress.

53

(opposite, above and following) Souq Waqif adorned with Qatari colors; *ardah*, sword dancing; pouring *qahwa*, a universal sign of hospitality in the Gulf; feast in a woven *bait al sha'ar*

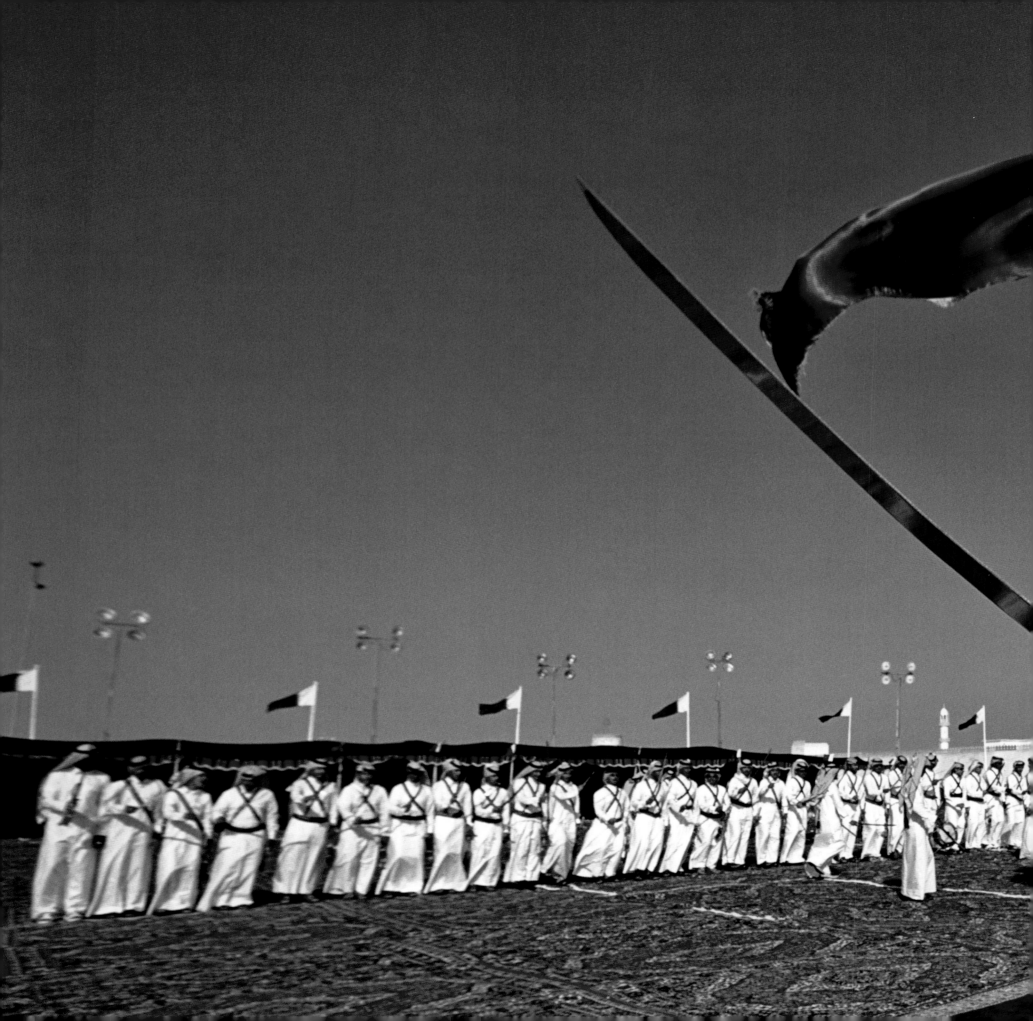

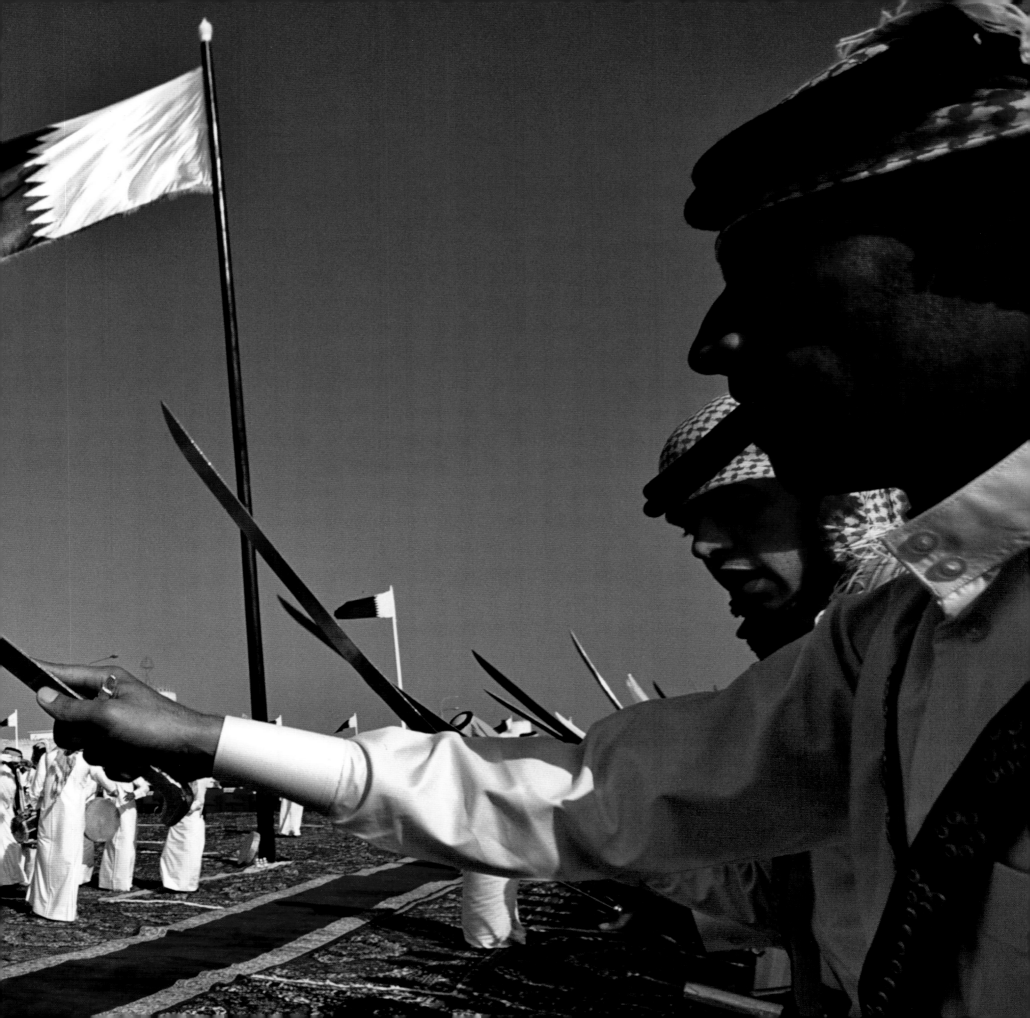

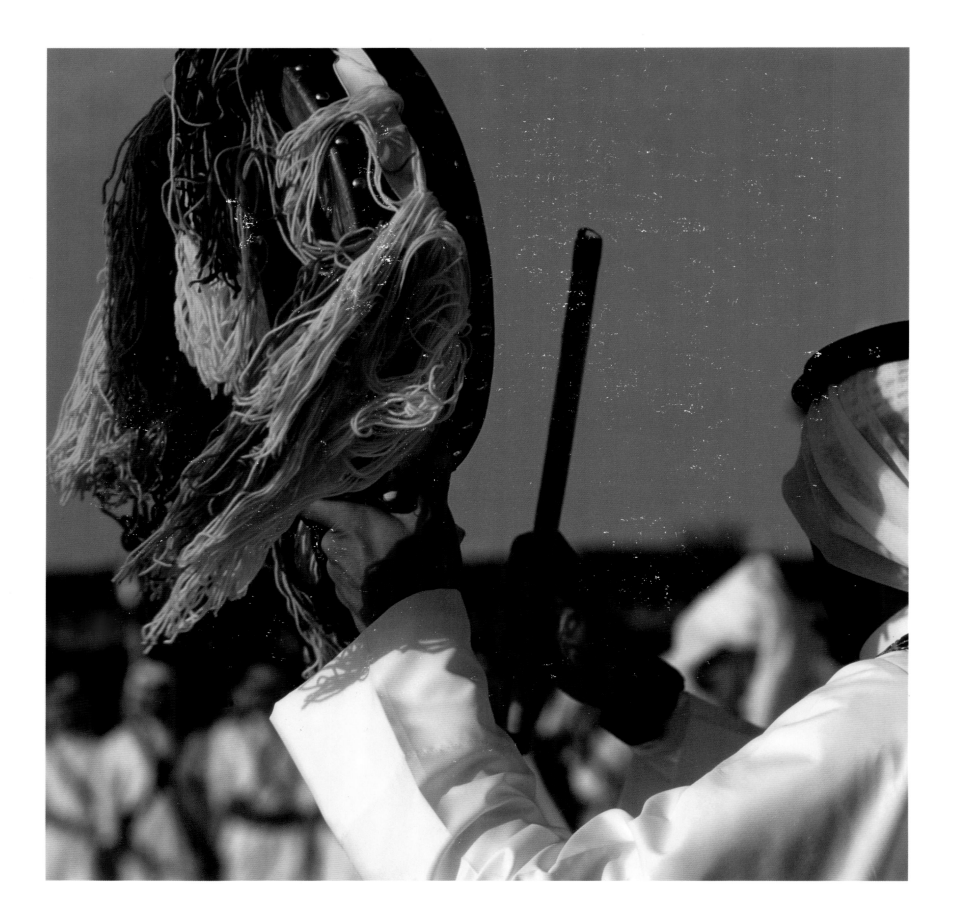

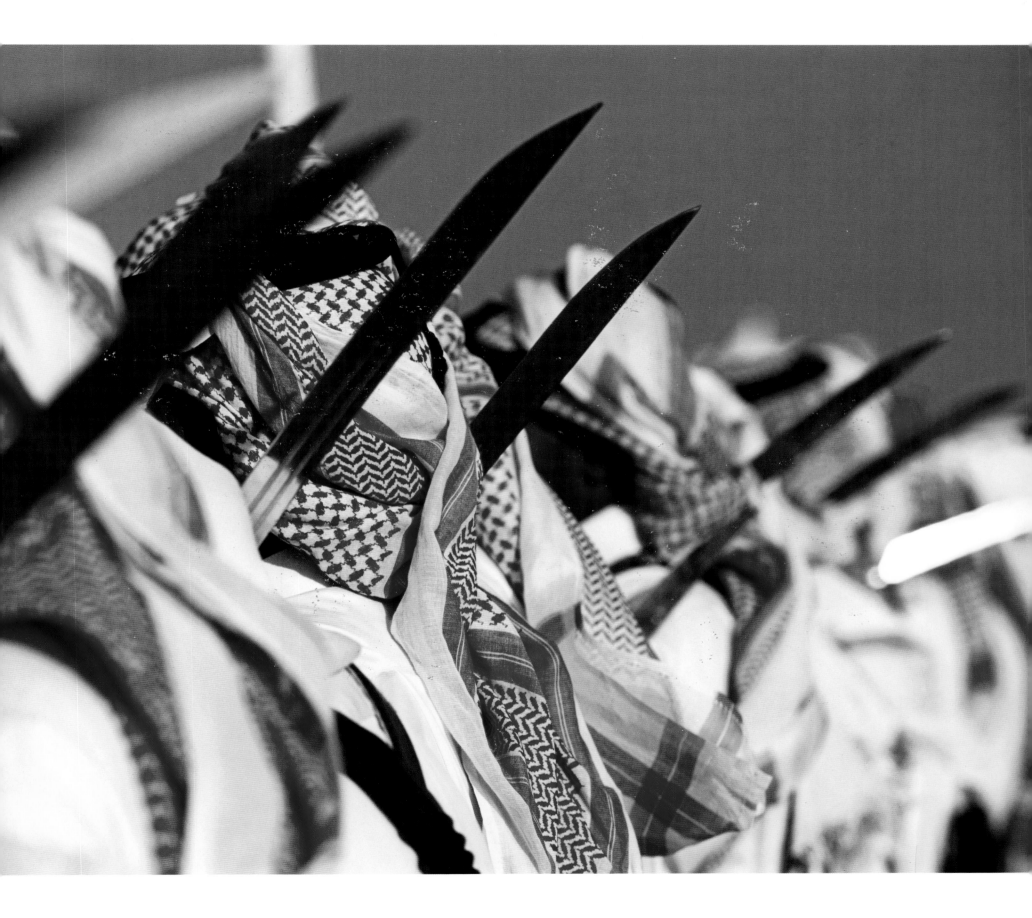

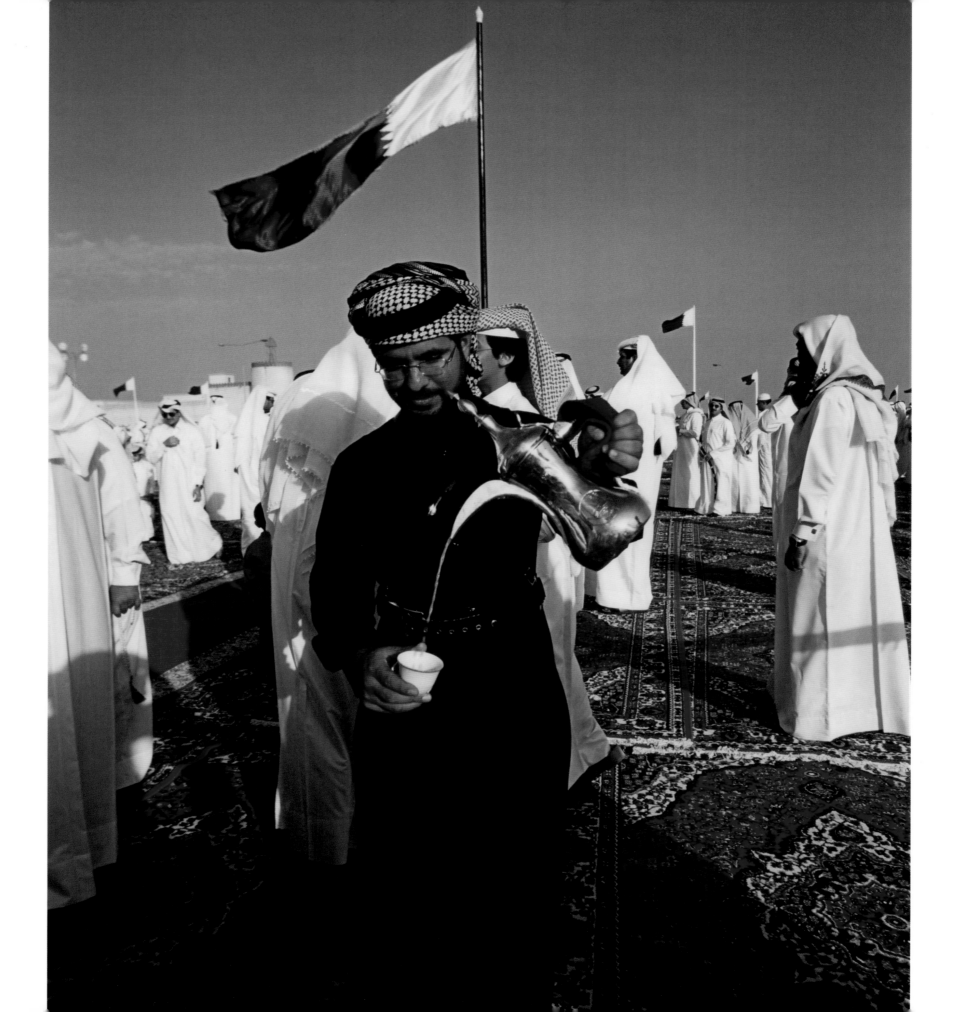

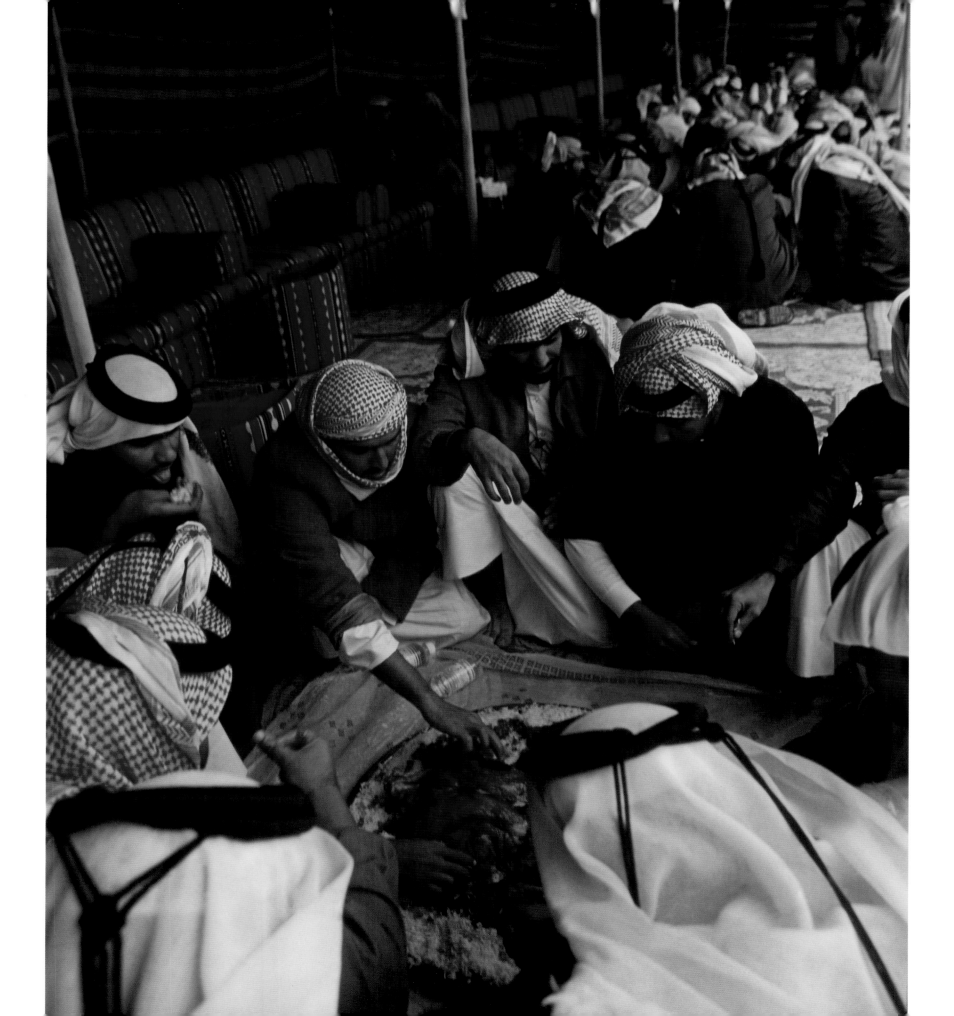

I drove myself in the family car and treated his youthful entourage of Qatari bodyguards as though they were my sons. I feel that my acceptance into Qatari society came in part because I put aside the rank and privilege associated with being an ambassador's wife and entered fully into the community, including fasting during Ramadan, which gave me a spiritual bond with my neighbors.

Qatar 2022 will be the first time the football championship has been awarded to a country in the Middle East. Qatar's visionary plan includes carbon-neutral, modular stadium construction that will eventually provide 22 stadiums in developing countries.

I also volunteered actively, even luring my family into the desert to pick up trash from scorpion-infested brush and to the coast to plant mangroves. During the 2006 Doha Asian Games, one of the world's largest athletic events, I sported a bright yellow, blue and maroon uniform along with thousands of other volunteers and worked twelve-hour days to help make the Games a success. Qatar uses sports as a medium for international engagement and on December 2, 2010, won an historic bid to host the **World Cup** in 2022. The World Cup will bring hope and pride to the region as well as concrete economic activity as billions are spent on preparations. Building on the success of the Asian Games, the World Cup will bolster volunteerism and community action—key aspects of an effective civil society.

In the Asian Games I worked on the equestrian events, and it was perhaps my love for horses that contributed most to my relationships with local families. I had longed for Arabian horses since childhood, when my stepfather brought home Dorcus, a leggy, dark dapple-gray filly. She pranced and floated over green pastureland, her proud head and flashing eyes the legacy of a thousand years in the stark desert. The Qatari horse world provided a natural home for me. From the equestrian club to makeshift stalls in the desert, I shared a bond of horsemanship with many Qataris that allowed us to relate intimately, transcending age and gender. Our horses climbed dunes and followed glistening paths of moonlight through the salty Gulf along the shallow flats of the coastline. My husband called it "equine diplomacy," and to many in the horse world he was known as "the husband of the wife of the American ambassador".

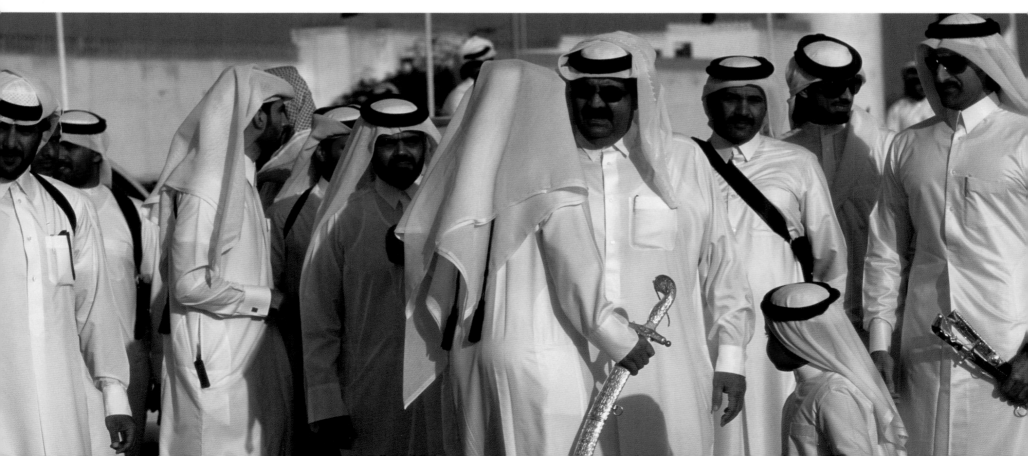

Majlis Sitting | Outside the family quarters where ladies usually entertain, the *majlis* provides the setting

for most social interaction. The *majlis* is several things: a place, an occasion and a type of governance. Literally a sitting-down, or an assembly, the *majlis* can take place in a formal hall with chairs lining the walls, in a living room, or in a *bait al sha'ar*—house of hair—which is the Bedouin wool and goat hair tent woven in wide swaths of earthy browns and beige. While the nomadic life belongs to a bygone era, many Qataris still yearn for the desert and set up *bait al sha'ar* for winter camping and weekend outings. During Ramadan, when the country slows down and deliberately embraces old ways, our embassy set up a tent in our front yard where we entertained large groups, ranging from government officials to students to ladies only. This *majlis* setting was embraced enthusiastically, and I still receive messages during Ramadan from friends who fondly recall those gatherings.

A *majlis* is open to all. One Bedouin friend told me that if a visitor arrives, you must not ask why they came for three days. While this extreme deference is probably rare today, it speaks to the obligation of hospitality born out of a ruthless environment. For a traveler in the desert, life and death could depend on the generosity of a chance encounter. Desert protocol respects relationships above all else; it is a matter of honor to give one's utmost to a guest.

Personal courtesy is not reserved only for guests; it showers every meeting—however mundane—with the blessings of God. The greeting *Salaam alaykum* (peace be upon you) and the response *Wa'alaykum salaam* (and upon you be peace) is exchanged when entering a home or *majlis* as well as when entering a shop or an office, or approaching an information counter.

The *majlis* is also important to interpersonal relationships. Here, both personal and governmental business is done and favors are granted. People who are blessed with possessions have an obligation to share. In fact, in the traditional system, a leader's failure to provide for his people is reason enough for them to throw their support to another who will. In the past, Arab leaders were known not for the wealth they amassed but for how much of it they gave away. Even today, "stingy" is a biting criticism.

But, more than anything else, the *majlis* is about socializing. Whether the gathering is at a house or in a desert tent, the host offers tea, fresh fruit juices, and especially *qahwa*, a fragrant Arabic coffee made from lightly roasted beans and cardamom. Those of Bedouin lineage typically serve coffee first, while some *hadher* or town people serve the coffee at the end of a visit. Later, a censer is passed, wafting smoke of an earthy incense called *oud*. The highest quality of *oud* is agarwood, and this rare incense is sometimes burned in combination with valuable resins like frankincense and myrrh. Ladies often burn perfumed *bakhoor*, wood chips infused with fragrant oils. The aromatic smoke is waved into tresses of hair and the folds of robes. There is a saying that there is "no sitting after the *oud*." In other words, the visit is over after the incense is passed. An exception to this is at a large celebration like a wedding, when censers will be circulated periodically throughout the evening.

The World Cup will bring hope and pride to the region as well as concrete economic activity as billions are spent on preparations.

(opposite and following)
The Emir is received at a tribal celebration with a kiss on the shoulder, a sign of respect; World Cup bid slogan, "Expect Amazing"; Aspire Zone hotel, The Torch Doha; people celebrate until dawn after Qatar wins the bid to host the World Cup 2022

61

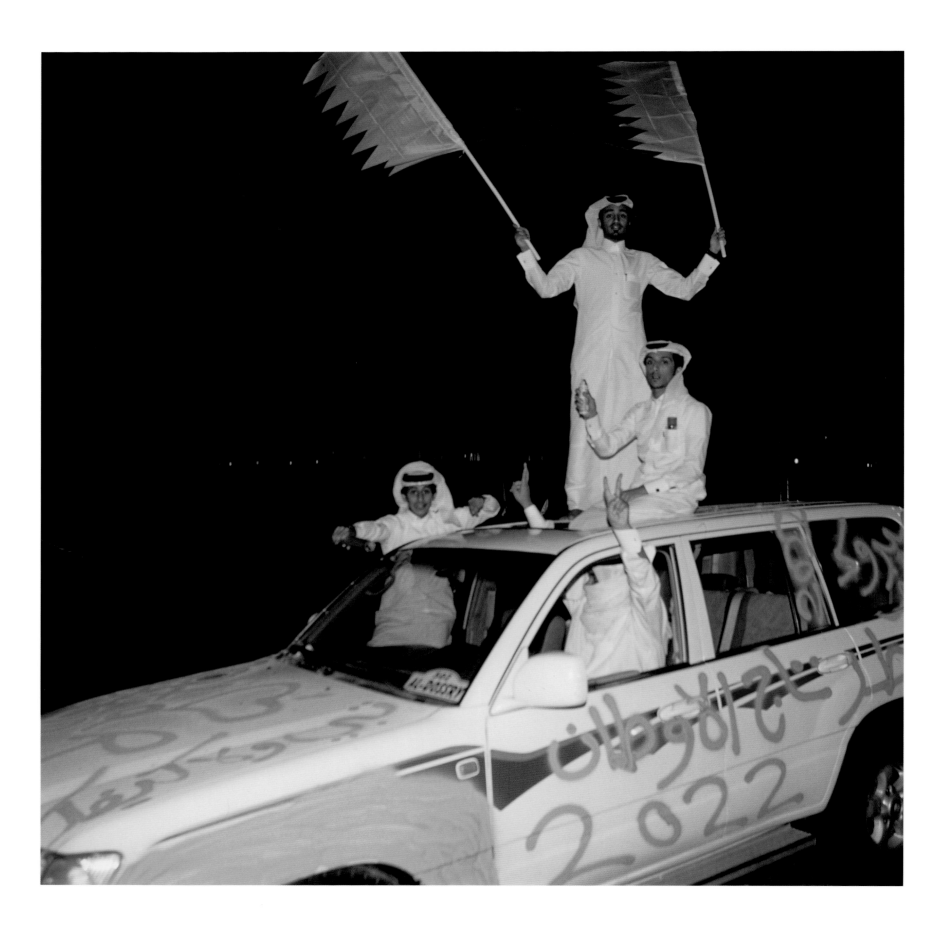

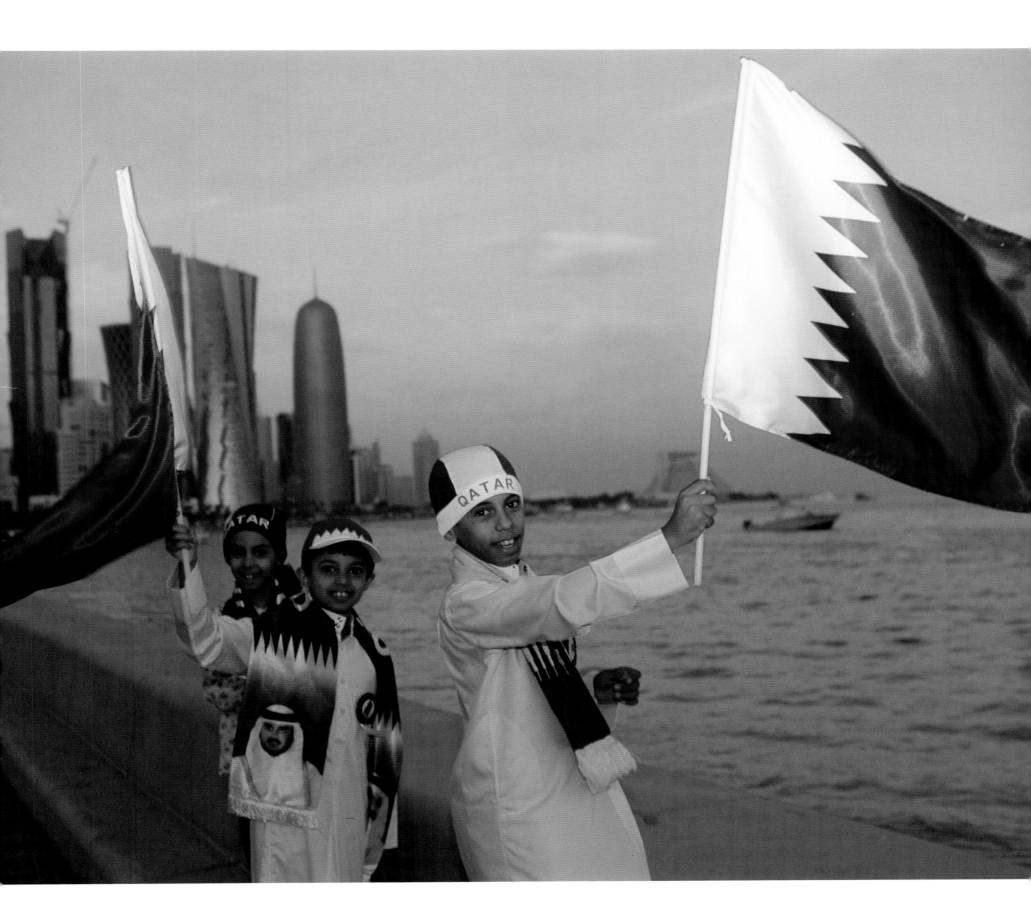

66

Carpets cover tent floors, and low upholstered cushions in bright, predominantly red and black Bedouin patterns provide seating. In the depths of winter, robes of camel hair or canvas lined with lambskin warm visitors huddled around the fire, known as the fruit of winter.

Carpets cover tent floors, and low upholstered cushions in bright, predominantly red and black Bedouin patterns provide seating. In the depths of winter, robes of camel hair or canvas lined with lambskin warm visitors huddled around the fire, known as the fruit of winter. Hot, sweetened camel's milk or warm cow's milk infused with ginger fend off the cold from the inside.

A prominent Qatari will "have his *majlis*" on a given day at a given time. But all that is needed to indicate a *majlis* is in session is to leave the gate open. Men participate in these open-invitation *majlis*, while women tend to invite their guests for more defined occasions. My agenda was not to break gender barriers, but in the course of events, I started visiting some men's *majlis*—at times with my husband and at others with male riders or other friends. A few non-Arab women achieve a sort of gender-neutral status, allowing them to move easily between male and female society. Certainly, the chance to make friends and learn from both sides of the house was a blessing, because while the public side of Qatari life is fully integrated, socially the gender division largely remains.

I enjoyed the distinct character of masculine and feminine, and it would be a mistake to assume women are trapped in dour circumstances. The ladies have fun. When I was with them, we danced, laughed, talked about anything and everything, and shared sumptuous meals. Children abound, and the intermingling of generations keeps families united. Few Qataris express dissatisfaction with gender segregation in private life, although many women would like their husbands to participate more in the life of the family rather than going out so often with their friends.

Some young people hope to establish new norms for relationships. In a society in which boys and girls don't interact socially after about age twelve except in some co-ed classrooms and work places, and in which marriages are typically arranged, romantic love is complicated. The term "arranged" is used loosely, since most Qataris do not consider the current match-making process to be arranged marriage, which is one made without the couple's prior consent. In the past, the bride in particular had little or no say in her choice of partner. Women have told me they were outside playing in the dirt with their siblings and cousins when called inside to be told they were to be a bride. A woman born in the early seventies told me she probably would be one of the last brides never even to see a photograph of her husband before the wedding celebration.

Most commonly now, a young man asks his mother and sisters to look for a wife for him. Mother and sisters then consider young women from within their circle of family and friends or someone they see at a wedding. They discreetly inquire about the young woman and describe her to the prospective groom; sometimes at this point or later in the process, photographs are available. If the young man accepts, his mother, often accompanied by his sisters, will visit the girl's family to determine her availability. Traditionally, if the families do not know each other, the visiting mother asks for a glass of water as a pretext to enter, but both sides know what the true purpose of the visit is, so marriage-age daughters would likely make an appearance.

Since courtesy and saving face is paramount, if the young woman is not interested in a proposal she will make a polite excuse like the need to finish school or pursue a career, avoiding an outright refusal. If both sides agree, a chaperoned meeting is arranged where the prospective couple can see each other and perhaps have a conver

sation. And if the families decide to proceed, a contract is negotiated, stipulating the dowry to be paid by the groom to the bride as well as any provision the couple might want.

Officially, the couple is married when the contract is signed. In practice, an engagement period follows the contract, extending to a few months or even a year. During this time before the wedding celebration, the couple often speak to each other by phone or have chaperoned meetings. Many unions end during the engagement period. This is technically a divorce, a factor which causes the divorce statistics to look abnormally high. As long as one does not make a series of broken engagements, however, little stigma is attached to them.

In addition to the traditional path to matrimony, many dream of more contemporary relationships developed through knowing someone at school or work. Others utilize social networking technologies like Facebook to make contact with those they have seen at university or the mall. Another such method is Bluetooth, which allows electronic devices like mobile phones and PDAs to communicate wirelessly at short distances. If you are at a mall with Bluetooth enabled on your mobile, sooner rather than later you are likely to get an electronic ping from another device close by. As you look down at your phone, the other person will have a good idea whom he/she has pinged and may try to strike up a text conversation.

Unfortunately, relationships remain a challenge, and divorce is not uncommon in the younger generation, both in love matches and arranged marriages. But divorced men and women often remarry and lead happily settled lives. Another sign of changing social mores is that it is now possible to see young married Qataris lightly holding hands in the mall, an unheard-of display of affection when we arrived in 2004.

On the Public Side | Qatar combines capitalism with a generous welfare system. Utilities are free. Citizens receive free land and either a liberal subsidy to build a house or an interest-free loan. Government jobs are readily available. Over 80% of jobs are in the public sector, although some of those employees also run private businesses. Initial Public Offerings (IPOs) on the local stock exchange (bourse) are offered to citizens on easy terms. These quickly transfer public wealth into private hands without giving direct handouts. Individuals become responsible for their wealth rather than looking to the government for it. From infants to seniors, all Qataris have a stake in the market. A Qatari businessman estimated in 2010 that with good management, a family of five should have realized five million Qatar riyals (US$986,000) since 2002 when the IPO program began.

At the same time, there have been growing pains as the population adjusts to the angst of market fluctuations. Some fall prey to the lure of the fast profit and overextend in speculation. Particularly after the first IPOs, when stock prices jumped overnight, a number of inexperienced investors thought that stock prices would continue to surge and so borrowed money against land, houses and cars. When prices on the bourse dropped as any market can, the losses were devastating to many. Others squander money on fast cars, designer clothes and luxury vacations. Distributing the common wealth is imperative, but the challenge is to do it while teaching financial competence and without destroying self-reliance.

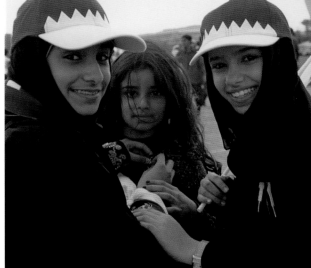

(above and following)

Sisters at a national day parade; bumping noses, a traditional desert greeting; horses in Arabian regalia; *ardah*; warming drums; Deputy Prime Minister and then-Energy Minister Abdullah bin Hamad Al Attiyah and the Armed Services Chief of Staff General Hamad bin Ali Al Attiyah

67

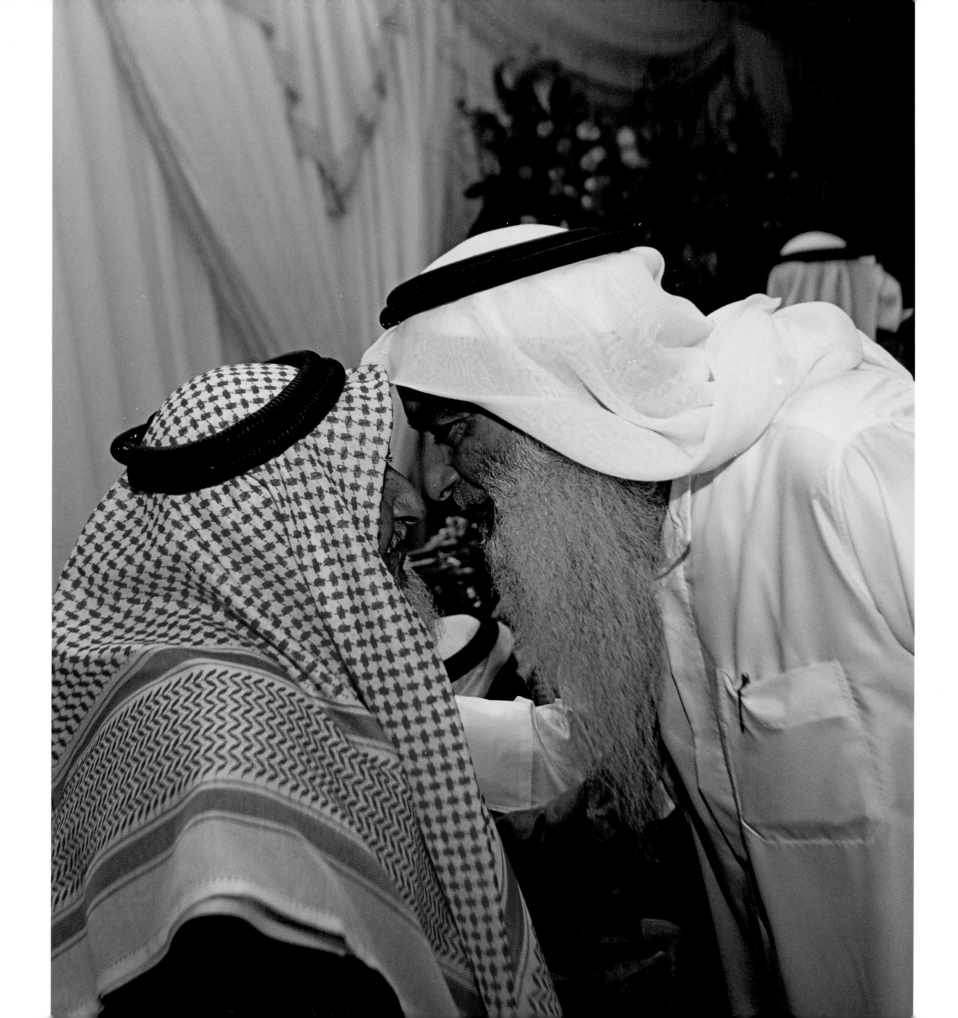

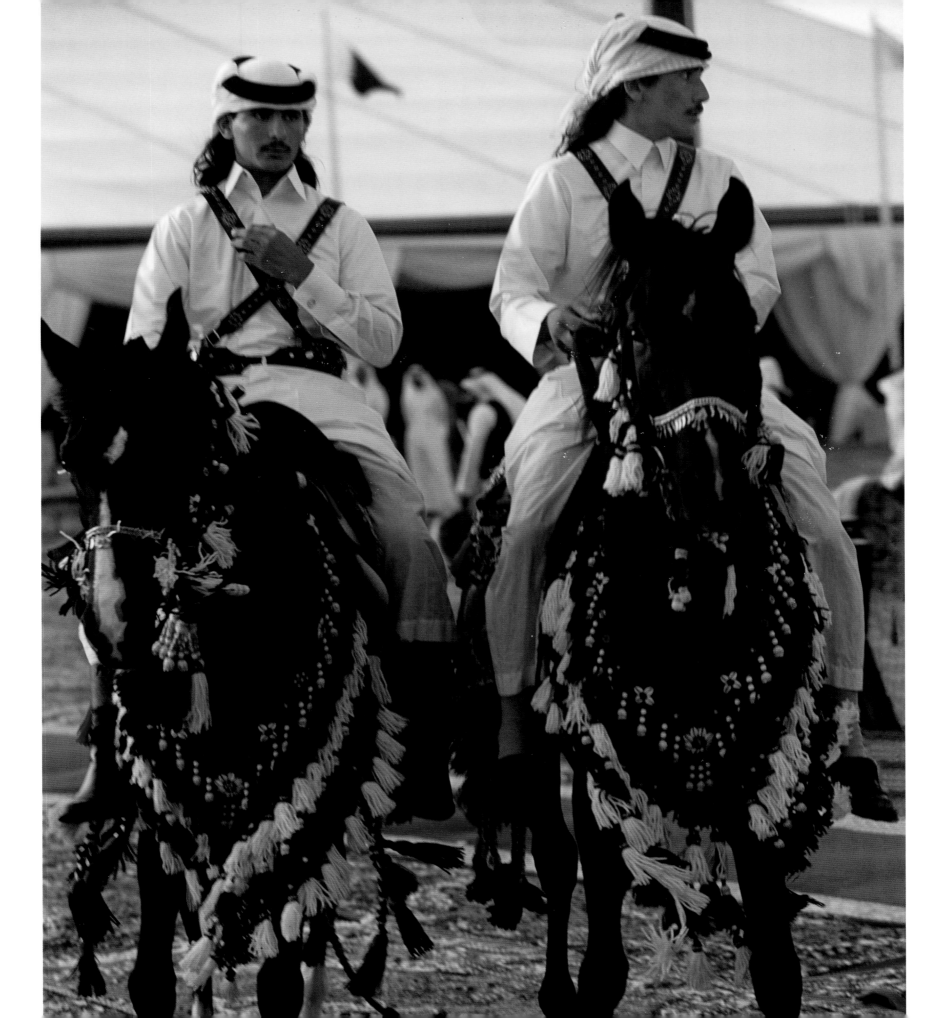

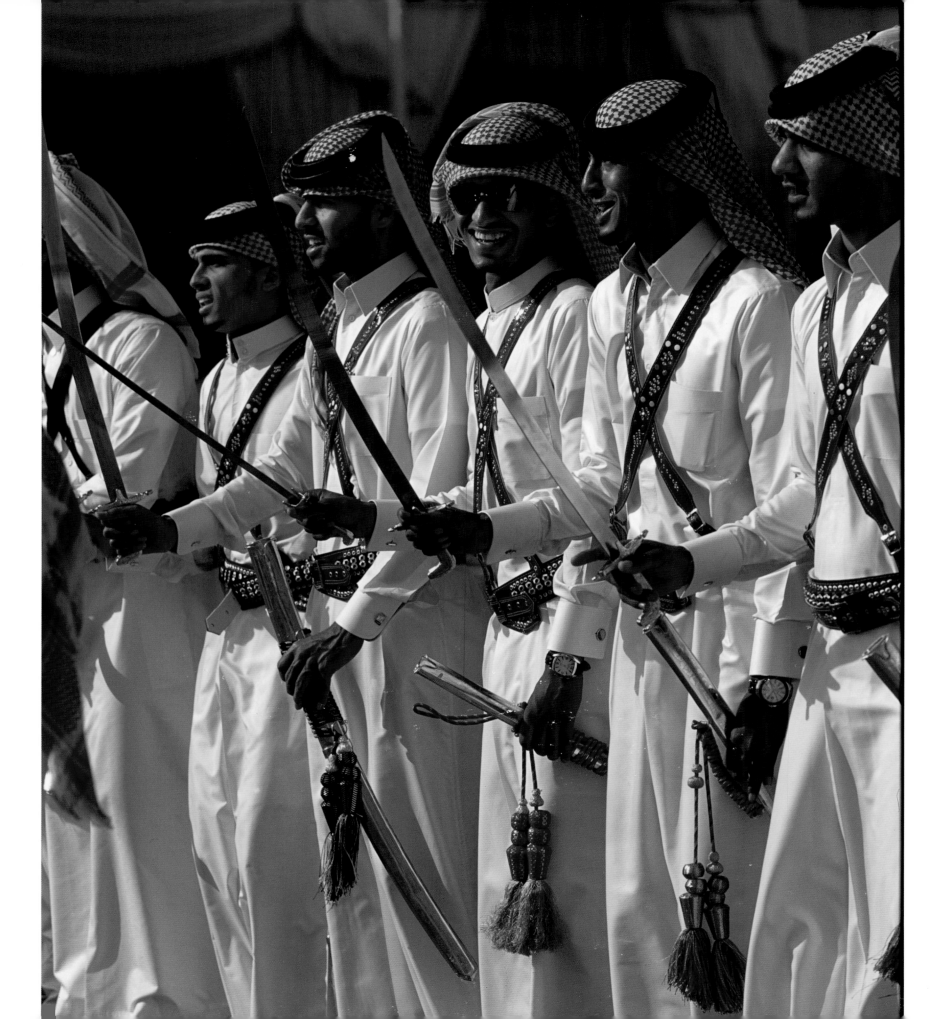

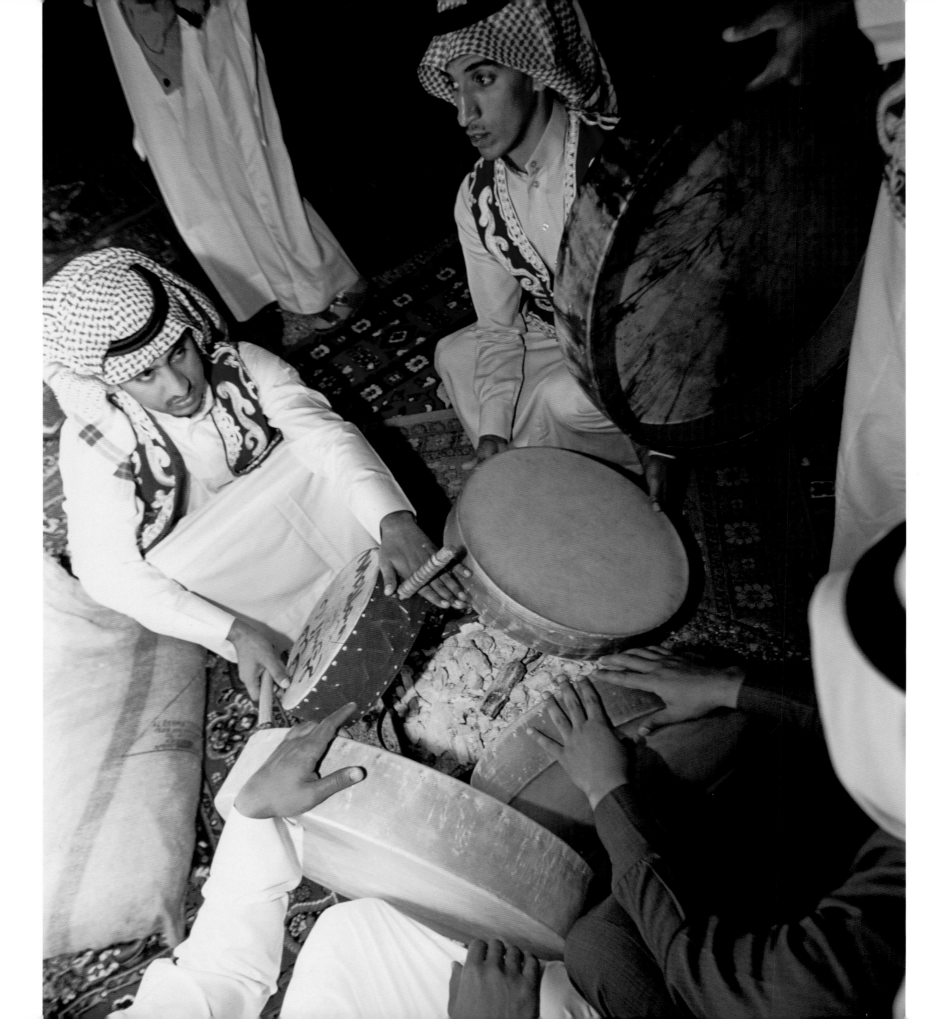

Education reform goes beyond schooling. The process has been so sweeping that education has become a primary method of socialization and a means to introduce democratic principles and transparency.

Mahram are close kin whom one cannot marry, such as father, sons and uncles.

Just as in the rest of the world, the haves and the have-nots in Qatar soon will be defined by who is educated and who is not, because education will determine who prospers. Education reform goes beyond schooling. The process has been so sweeping that education has become a primary method of socialization and a means to introduce democratic principles and transparency. The government decided to make a rapid and aggressive transition to a new system rather to do it gradually. The result will produce a stronger graduate, but many people are caught in the transitional vacuum, unable to compete in the new system because the old system did not adequately prepare them. For example, some parents who only speak Arabic cannot help their children as English becomes the primary language of instruction. Some talented students with only limited exposure to English cannot pass entry exams at universities where English is required. Academic bridge programs and a new community college system established in 2010 are trying to keep young people from falling through such cracks.

This restructuring has taken place with unprecedented openness. Arab media typically report only positive news, and Qataris were not used to seeing their leadership criticize itself. Yet the government publicly acknowledged the failings of the old system, in particular that Qatari students had scored near the bottom of all countries on international standardized tests. It then addressed the anxiety created by the transition to the new schooling system by having educational and political leaders appear in public forums to answer questions and receive criticism. And in another dramatic departure from the norm, parents are encouraged to make active decisions in their children's education by choosing amongst the new independent schools (similar to charter schools), which have virtually replaced government schools.

Education is contributing to social changes as well. Men and women interact more and more, particularly in the workplace and at official events where women are taking active roles in public life. Often different standards dictate interaction with foreigners than with other Gulf residents, and gender relations can seem like shifting sands. A Qatari woman who might shake hands with a Westerner often just politely nods at a fellow countryman. A Muslim man's willingness to shake hands may vary depending on whether he has performed his ablutions in preparation for prayer. The polite gesture of placing the right hand over the heart substitutes for a handshake. Kissing on the cheek is as common between men as it is between women, which can come as a surprise to a foreign man who is unexpectedly honored by this sign of friendship. Arab men commonly link fingers lightly with their male friends too.

One situation that commonly confounds Westerners is the notion that touching a woman renders a man "unclean." The origin of this religious taboo against touching by non-*mahram* is misinterpreted in our modern time. But during the Prophet Mohammad's time, unprotected women were easy targets for unwanted advances. Thus the taboo was more of a command for men to act respectfully than a derogatory judgment against women. With any religious text it is possible for both liberal and conservative thinkers to isolate passages that support their positions. In contrast to conventional Western thought, however, the Qur'an in the seventh century codified rights for women—like property ownership—which women in the West did not acquire until many centuries later.

All Things from God

Muslims from America to Indonesia, from Morocco to Mindanao all stress that Islam is more than a religion; it is a way of life. Islam is such a central feature of Qatar that it is impossible to give an accurate picture of the country without addressing it. Even Westerners quickly start using common Islamic expressions that are in everyday (sometimes every-minute) parlance in the Middle East. *Inshallah* (God willing) acknowledges that any worldly arrangement is subject to divine intervention. The ever-present refrain *al humdulillah* (thanks be to God) is used in the Gulf to give thanks whenever something good happens, after a meal or a sneeze, and even after a tragedy, because Islam believes that everything comes from Allah. As with most religions, Islam teaches that mere humans cannot discern the cosmic plan, so we should be thankful for all things that happen in our earthly existence. This acceptance of the works of God's hand brings peace in the face of hardship as well as a deep appreciation of blessings.

It is challenging to reconcile this pure practice of Islam with the extremism too often portrayed in the media. Many abuses committed in the name of Islam are based more on culture, tradition and politics than on a precise reading of the Qur'an. Fortunately, Qatar's wealth and enlightened approach to education, employment and women's rights have exempted it from much of this experience, but few governments operate in a vacuum that excludes the sacred. The United States, a bastion of secular democracy, has been swayed by tides of revivalism since before its founding. China, officially atheist, is buffeted by renewed popular interest in Buddhism, Islam and Christianity. And each Middle Eastern country has its distinctive dialectic between the mosque and state.

A comparison of holy texts and subsequent interpretations illuminates the common compassionate core of the three great monotheistic faiths—Judaism, Christianity and Islam. All issue a divine call for *salaam*, *shalom*, peace while also glorifying those who protect their faith. Militant jihadists believe they are defending Islam and that if they give their lives in the course of a suicide mission they will go straight to heaven as martyrs. This is not a uniquely Islamic point of view; the medieval Christian Crusaders likewise believed they would go to heaven if they died fighting for their faith. Yet it is crucial to recognize that the majority of Muslims define jihad not as a call to arms but as an individual obligation to refrain from doing wrong and to seek peace, understanding and knowledge.

A dynamic leader, Qatar forges a productive and progressive Islamic society at home and tries to create concrete opportunity among the less affluent abroad. Desperation leads to desperate actions. Many countries in the Middle East and North Africa have been beset by corruption, poverty, a lack of democracy, and a modernity that primarily benefits the elite and leaves the majority feeling confused, betrayed and voiceless. This has opened the doors to demagogues. Violence has become one way some people deal with a feeling of powerlessness. While no amount of desperation justifies terrorism, it is clearly a reason why so many young people are attracted to these movements. No nation is exempt from this scourge, and by energetically creating opportunity Qatar attempts to provide a positive alternative and a wellspring of hope.

House of Wisdom

Sheikha Moza once told me that Qatar has no excuse not to succeed because of its small size and vast resources. But Qatar not only focuses on internal success; it also shares its wealth with other nations in countless ways. The charitable foundation, Reach Out to Asia (ROTA), founded by the Emir and Sheikha Moza's daughter Sheikha Al Mayassa bint Hamad bin Khalifa Al Thani, builds schools from Gaza

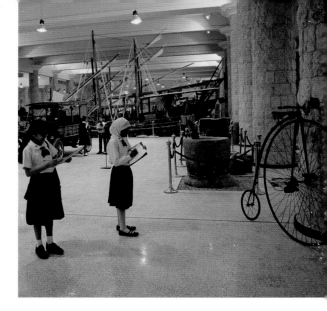

(above and following)
Students at the Sheikh Faisal bin Qassim Al Thani museum on his farm near Al Sheehaniya; Arabian orxy on the farm are part of a heritage plan to rebuild herds of this endangered animal

A dynamic leader, Qatar forges a productive and progressive Islamic society at home and tries to create concrete opportunity among the less affluent abroad.

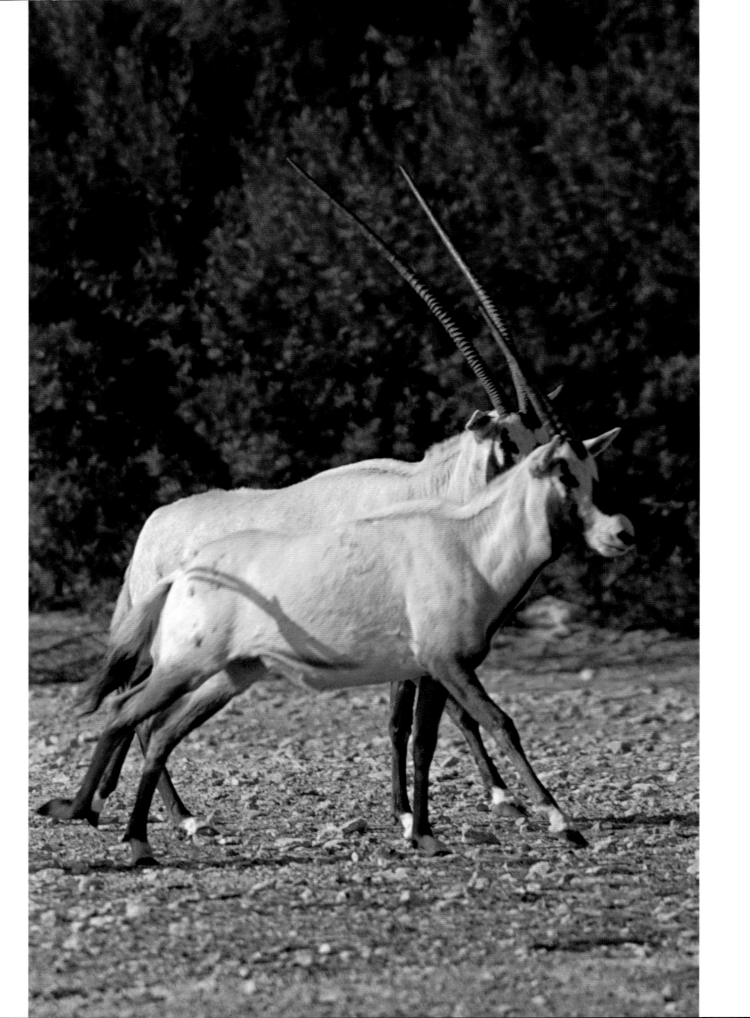

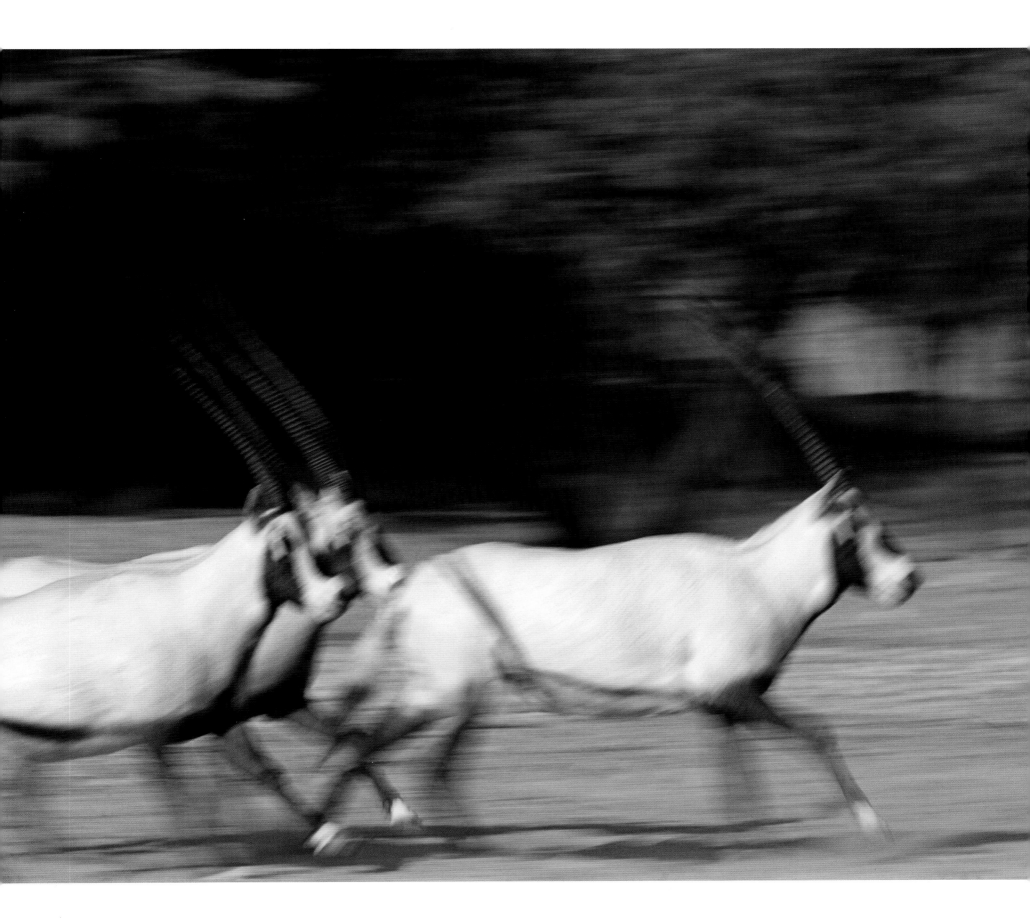

Qatar does not hesitate to import expertise, but when it does, it emphasizes a collaborative approach that broadens the capabilities of its own citizenry.

to Thailand. Qatar sent an unsolicited $100 million dollars to aid Hurricane Katrina victims in America in 2005. Education City provides generous scholarships to needy students from the region, and the Qatar National Research Fund (QNRF) supports collaborative researchers worldwide. Silatech, which means "your connection" in Arabic, is a new non-profit initiative from the Qatar Foundation that addresses the regional crisis of unemployment by giving commercial incentives to global business to create jobs, support entrepreneurship and make capital accessible to young people. In these ways Qatar balances its financial good fortune with magnanimous public responsibility.

How Qatar fuses Islamic tradition and tribal codes with modern systems is the current challenge. Progress is driven by the combined force of private citizens and public policy in delicate balance. Will the balance hold, allowing Qatar to fulfill its goals of modern education, open society and human rights while still remaining grounded in the essentials of family and religion? Will the ethical codes of the desert survive the fast-paced journey of today's children?

Increasingly, there is open debate, which is not only allowed but encouraged. There is more discussion about political and social issues in the press. Northwestern University opened a branch campus in 2008 containing its renown School of Communication and Medill School of Journalism. Al Jazeera indisputably blew open the gates to modern media coverage in the entire region. Qatar TV hosts a show called *Lakom Al Karar* (*The Decision is Yours*), which is similar to a town hall meeting. Prominent figures like the Heir Apparent and cabinet ministers answer questions from a live audience. There are similar opportunities for public venting on local radio. This new conversation is like a traditional *majlis* session incorporating contemporary technologies.

The internationally broadcast Doha Debates (a project of the Qatar Foundation) tackle topics such as the separation of mosque and state and whether a Muslim woman should be free to choose her spouse. The excitement spawned by these debates has led many students to create debating societies at school. The national high school debate team inspired a documentary that was the crowd favorite at the first Doha-Tribeca Film Festival in the fall of 2009. Nurturing not only freedom of speech but also encouraging respectful dialogue in young people should in time counter a common malady, that of media self-censorship. Because Qatar is such a small environment, it is easier to publish the positive than the negative. There has been extensive discussion in the press and over the air that the lack of probing journalism about Qatar comes more from the media's desire to avoid controversy or possible political reaction than from any overt censorship. Outspoken youth at the Doha Debates and other forums give the impression that more scrutiny is coming. As nationals graduate from Northwestern University's Medill School of Journalism in Qatar, they may have more latitude to ask the hard questions from which expatriate reporters shy away.

Teaching its citizens to question the status quo seems the surest sign that Qatar is serious about developing a vocal, active populace. Although Qatar's foray into democracy is still limited, the Emir has stated that participatory government with a basis in Islamic teaching will come. Building a strong civil society is a necessary underpinning, since even the most eloquent advocates for democracy express concern that hasty elections might provide an opportunity for a fundamentalist backlash to roll back progress, particularly the advancement of women.

Qatar's clear, forward-thinking national agenda fosters organic growth. Consideration of need is a bigger motivator than breaking records or building the flashiest projects. Ample oil and gas revenues allow Qataris to be selective about how they expand their economic base, and projects are planned with a purpose, namely the long-term benefit of the people. There will be hurdles to clear along the way, but Qatar's progress makes it a notable part of a renaissance in the Arab world.

As capital of Arab culture in 2010 (a UNESCO initiative), Doha celebrated the occasion with a production of *The House of Wisdom*, a drama about the center of scientific and artistic learning established in Baghdad in the court of the Abbasid caliphs Harun and Abdulla ibn Harun Al Rashid in the late eighth century. While the cultural celebration rotates annually among Arab capitals, Doha strives to be a permanent hub of knowledge and culture. Qatar does not hesitate to import expertise, but when it does, it emphasizes a collaborative approach that broadens the capabilities of its own citizenry. And if the ambitious roster of future museums, libraries, conservatories, theaters and concert halls even approaches the acclaim accorded the I.M. Pei-designed Museum of Islamic Art (which opened in 2008), Doha will become a cultural capital rivaling any international city.

Sand, Sea and Sky | All cultures are shaped by their environment, and this is apparent as Qataris flock to the rustic fish markets in the early morning or wrap their faces with *ghutras* against the wind and sand as they have in centuries past. Even though affluence ensures that Qataris do not have to face the privations of the desert or the hardship of long months at sea, theirs is a proud heritage. Not only do they remember their history but they keep tradition alive in social interactions, recreation and daily prayers. The perseverance proven in past times is needed now to build a stable and successful future. While no one desires a return to a time of almost constant deprivation, neither does anyone want future generations to forget the sheer fortitude it took their ancestors to build lives in this land of sweeping sand, sea and sky. Every day offers the chance to be intrigued by some ancient custom or to be astounded by another superlative initiative as you explore the blending of the old and the new, the traditional and the modern, in this vibrant place called Qatar.

Every day offers the chance to be intrigued by some ancient custom or to be astounded by another superlative initiative as you explore the blending of the old and the new, the traditional and the modern, in this vibrant place called Qatar.

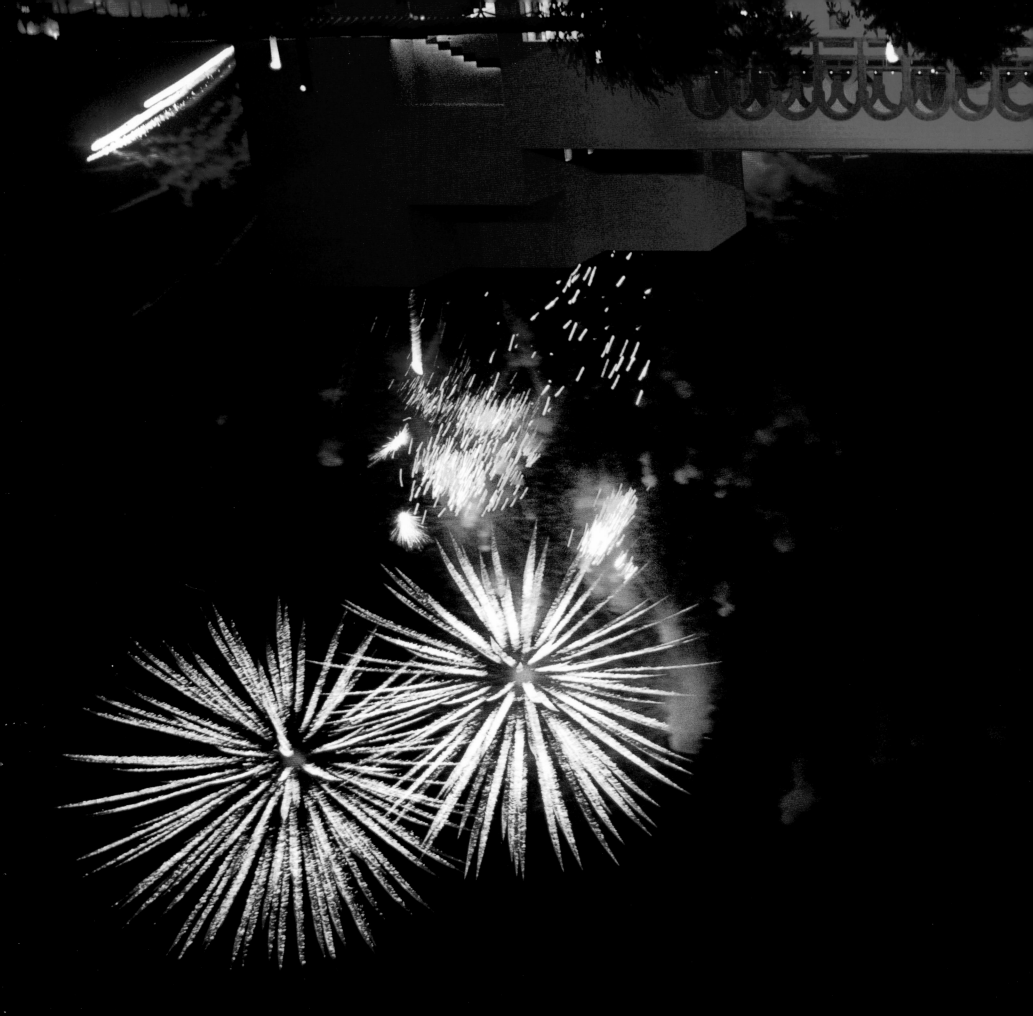

The design of *Qatar: Sand, Sea and Sky* is inspired by Qatar itself. The reds reflect the maroon in the Qatari flag. The motif of seven interlocking circles, a familiar pattern in Islamic art, was drawn from a gypsum window in an old Doha house.

Images throughout the book were captured directly on film; they reflect the true color, hue and magic of each moment just as Henry Dallal experienced it.

Two outstanding Qatari artists grace these pages with their work: Ali Hassan penned the Arabic calligraphy, and Yousef Ahmad provided a reproduction of his painting of Al Zubarah, which is on display at the Weaponry Museum.

The type palette reflects Qatar's melding of tradition and modernity. Garamond, created by Claude Garamond (1490-1561) and considered one of the classic typefaces, conveys both fluidity and consistency. Lucida Sans, designed by Kris Holmes and Charles Bigelow in 1985, has strong shapes and generous proportions based on traditional Roman letterforms and provides power and clarity.

Lebling, Robert W., and Donna Pepperdine. *Natural Remedies of Arabia.* New York: Stacey International, 2006.

Lings, Martin. *Muhammad: His Life Based on the Earliest Sources.* New York: Inner Traditions International, 1983.

Lockerbie, John. "Islamic Design." *Catnaps Design - Islamic Design.* *http://www.catnaps.org/islamic/design.html.*

Lorimer, John Gordon. *Gazetteer of the Persian Gulf, Oman, and Central Arabia.* Calcutta: Superintendent Government Printing, 1915.

Ministry of Foreign Affairs - Qatar. http://english.mofa.gov.qa/main. cfm?id=1.

Muhammad, Al Muffadal Bin, comp. *The Mufaddaliyat: An Anthology of Ancient Arabian Odes.* Trans. Charles J. Lyall. Vol. II. Oxford: Clarendon, 1918. *http://www.archive.org/stream/mufaddaliyatan-th00mufauoft/mufaddaliyatanth00mufauoft_djvu.txt.*

"National Committee for Coordinating Conferences and Events." *National Committee for Coordinating Conferences and Events. http://www.n3ce.org/home.php.*

Nippa, Annegret, Peter Herbstreuth, and Hermann Burchardt. *Unterwegs Am Golf Von Basra Nach Maskat = Along the Gulf.* Berlin: Schiler, 2006.

Parry, James V. "Mapping Arabia." *Saudi Aramco World.* Jan.-Feb. 2004. *http://www.saudiaramcoworld.com/issue/200401/mapping.arabia.htm.*

Qatar Foundation: Home. http://www.qf.org.qa.

Qatar General Secretariat for Development Planning. http://www.gsdp. gov.qa/portal/page/portal/GSDP_Vision_Root/GSDP_EN

Qatar Happening Online, Events Listing. http://www.qatarhappening.com/.

"Qatar Museums Authority: Home." *http://www.qma.com.qa/eng/.*

Qatar Natural History Group. http://www.qnhg.org/.

"Qatar News Agency, News, Photo Archives." *Qatar News Agency. http://www.qnaol.net/QNAEn/Pages/default.aspx.*

"Qatar Petroleum." *http://www.qp.com.qa/qp.nsf.*

Qatar Statistics Authority. http://www.qsa.gov.qa/eng/index.htm.

Qatar Tourism Authority. http://www.qatartourism.gov.qa/home.

Qatar Visitor: Doha Qatar Information. http://www.qatarvisitor.com/.

Qatari Diar. http://www.qataridiar.com/.

Rahman, Habibur. *The Emergence of Qatar.* London: Kegan Paul, 2005.

Raswan, Carl R. *Black Tents of Arabia (My Life Among the Bedouins).* Saint Paul, MN: Hungry Mind, 1998.

Reach Out To Asia Foundation. *http://www.reachouttoasia.org/output/ page1.asp.*

Richter, Tobias. "The Pearl Divers of Qatar." *Qatar Natural History Group.* May-June 2010. *http://www.qnhg.org/files/MAY-JUNE-2010Newsletter.pdf.*

"The Saluki: History and Origins." *http://salukiho.tripod.com/.*

Silatech. http://www.silatech.com/en.

Thesiger, Wilfred. *Arabian Sands.* New York: Penguin Classics, 2007.

Van Lent, Rik. *Qatar.* Doha, Qatar: Rik Van Lent, 2006.

Villiers, Alan. *Sons of Sinbad; an Account of Sailing with the Arabs in Their Dhows, in the Red Sea, around the Coasts of Arabia, and to Zanzibar and Tanganyika; Pearling in the Persian Gulf; and the Life of the Shipmasters, the Mariners, and Merchants of Kuwait.* London: Arabian Ltd, 2006.

Vincent-Barwood, Aileen. "Columbus: What If?" *Saudi Aramco World.* Jan.-Feb. 1992. *http://www.saudiaramcoworld.com/issue/199201/ columbus-what.if.htm.*

Vine, Peter. *Pearls in Arabian Waters: the Heritage of Bahrain.* London: Immel Pub., 1994.

Zahlan, Rosemarie Said. *The Creation of Qatar.* London: Routledge, 1990.

Ziolkowski, Michelle. "The Shasha - Traditional Fishing Craft." *http://www.enhg.org/trib/trib04.htm.*

Resources

Al Jazeera English. *http://english.aljazeera.net/.*

Al Khalifa, Raya. "The New Black." *New Statesman - Britain's Current Affairs & Politics Magazine.* 23 Oct. 2006. *http://www.newstatesman.com/200610230017.*

Al Omari, Jehad. *The Arab Way.* Oxford, United Kingdom: How to Books, Ltd, 2003.

Al-Othman, Nasser. *With Their Bare Hands: the Story of the Oil Industry in Qatar.* London: Longman, 1984.

Al-Shamlan, Saif Marzooq. *Pearling in the Arabian Gulf: A Kuwaiti Memoir.* London: LCAS, London Centre of Arab Studies, 2000.

Al-Thani, Khalid Hamad Ahmed. *Here is My Secret.* Steidl Publishing, 2010.

Anscombe, Frederick F. *The Ottoman Gulf: the Creation of Kuwait, Saudi Arabia, and Qatar.* New York: Columbia UP, 1997.

"Arabian Wildlife." *http://www.arabianwildlife.com/main.htm.*

"Arabs and The Sea." *Saudi Aramco World.* June-July 1962. *http://www.saudiaramcoworld.com/issue/196206/arabs.and.the.sea.htm.*

Armstrong, Karen. *Muhammad: A Prophet for Our Time.* New York: HarperOne, 2007.

Armstrong, Karen. *The Battle for God.* New York: Ballantine, 2001.

Bari, Hubert, and David Lam. *Pearls.* Milan, Italy: Skira, 2009.

Burckhardt, John Lewis. *Arabic Proverbs.* Bibliolife, 2009.

Campbell, Kay Hardy. "Recent Recordings of Traditional Music from the Arabian Gulf and Saudi Arabia." *Middle East Studies Association Bulletin.* *http://fp.arizona.edu/mesassoc/bulletin/campbell.htm.* July 1996.

Chaddock, David, ed. *Qatar.* London: Stacey International, 2008.

Coleman, Isobel. *Paradise Beneath Her Feet: How Women Are Transforming the Middle East.* New York: Random House, 2010.

Crystal, Jill. *Oil and Politics in the Gulf Rulers and Merchants in Kuwait and Qatar.* Cambridge [England]: Cambridge UP, 1995.

Davies, Charles. *The Blood-Red Arab Flag: An Investigation into Qasimi Piracy, 1797-1820.* Exeter, [England]: University of Exeter, 1997.

Dickson, H.R.P. *The Arab of the Desert.* London: George Allen & Unwin, 1936.

Dickson, Martin, and Roula Khalaf. "Interview Transcript: Qatar's Sheikh Hamad." *Financial Times* [London] 24 Oct. 2010. *http://www.ft.com/cms/s/0/9163abca-df97-11df-bed9-00144feabdc0.html.*

The Doha Debates | Qatar's Forum for Free Speech in the Arab World. *http://www.thedohadebates.com/index.asp.*

Doughty, Charles M. *Travels in Arabia Deserta: Selected Passages.* Minneapolis: Dover Publications, 2003.

Edens, Christopher. "Khor Ile-Sud, Qatar: The Archaeology of Late Bronze Age Purple-Dye Production in the Arabian Gulf." *Iraq, British Institute for the Study of Iraq* 61 (1999): 71-88.

El-Nawawy, Mohammed, and Adel Iskandar. Farag. *Al-Jazeera: How the Free Arab News Network Scooped the World and Changed the Middle East.* Boulder, Col.: Westview, 2003.

Facey, William. "Sons of the Wind." *Saudi Aramco World;* *http://www.saudiaramcoworld.com.*

"Falconry." *ArabHunter.com.* *http://www.arabhunter.com/hunting/falconry.htm.*

Ferdinand, Klaus. *Bedouins of Qatar.* London: Thames and Hudson, 1993.

Gillespie, Frances. *Discovering Qatar.* Rimons, France: Creative Writing and Photography, 2008.

Gillespie, Frances. "The Archeology of Qatar", "Falconry", "Desert Diet - The Food of the Bedouin." *Qatar Visitor.* *http://www.qatarvisitor.com.*

Gillespie, Frances. "Shedding New Light on Qatar's History." *Gulf Times.* *http://www.gulf-times.com/site/topics/article.asp?cu_no=2&item_no=376275&version=1&template_id=36&parent_id=16.*

Hansen, Eric. "The Hidden History of Scented Wood." *Saudi Aramco World.* Nov.-Dec. 2000. *http://www.saudiaramcoworld.com/issue/200006/the.hidden.history.of.scented.wood.htm.*

Henderson, Carol, and Mohanalakshmi Rajakumar, eds. *Qatar: Then & Now.* Doha, Qatar: Waqif Art Center; Qatar University, 2009.

Her Highness Sheikha Moza Bint Nasser. *http://www.mozabintnasser.qa.*

Hilden, Joy Totah. *Bedouin Weaving of Saudi Arabia and Its Neighbours.* Oakville: David Brown Book, 2010.

Hirst, K. Kris. "H3 - Earliest Known Mesopotamian Boat at H3." *About Archaeology - The Study of Human History.* *http://archaeology.about.com/od/hterms/g/h3sabiyah.htm.*

"Hukoomi - Qatar Government Online." *http://www.gov.qa/wps/portal?New_WCM_Context=/wps/wcm/connect/cnt/en/1_Home/.*

Islamic Art Collection of Sheikh Faisal Bin Qassim Bin Faisal Al Thani. Doha, Qatar. *http://www.fbqmuseum.com/intro.htm.*

Jaidah, Ibrahim Mohamed, and Malika Bourennane. *The History of Qatari Architecture 1850-1950.* Milano, Italy: Skira, 2009.

"Jean Nouvel: New National Museum Qatar." Mar. 2010. *http://www.designboom.com/weblog/cat/9/view/9593/jean-nouvel-new-national-museum-qatar.html.*

Jongbloed, Marijcke. "The Food Culture of the Bedouin before the Oil Era." *Al Shindagah.* *http://www.alshindagah.com/marapr2006/culture.html.*

"Khor Al-Adaid Natural Reserve - UNESCO World Heritage Centre." *UNESCO World Heritage Centre - Official Site.* *http://whc.unesco.org/en/tentativelists/5317/.*

LeBlanc, Jacques. "A Fossil Hunting Guide to the Tertiary Formations of Qatar, Middle East." *http://sites.google.com/site/leblancjacques/fossilsofqatar.*

243

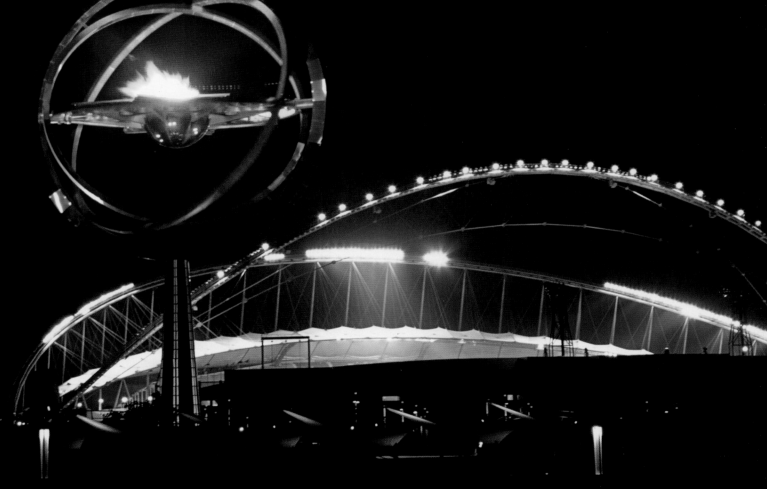

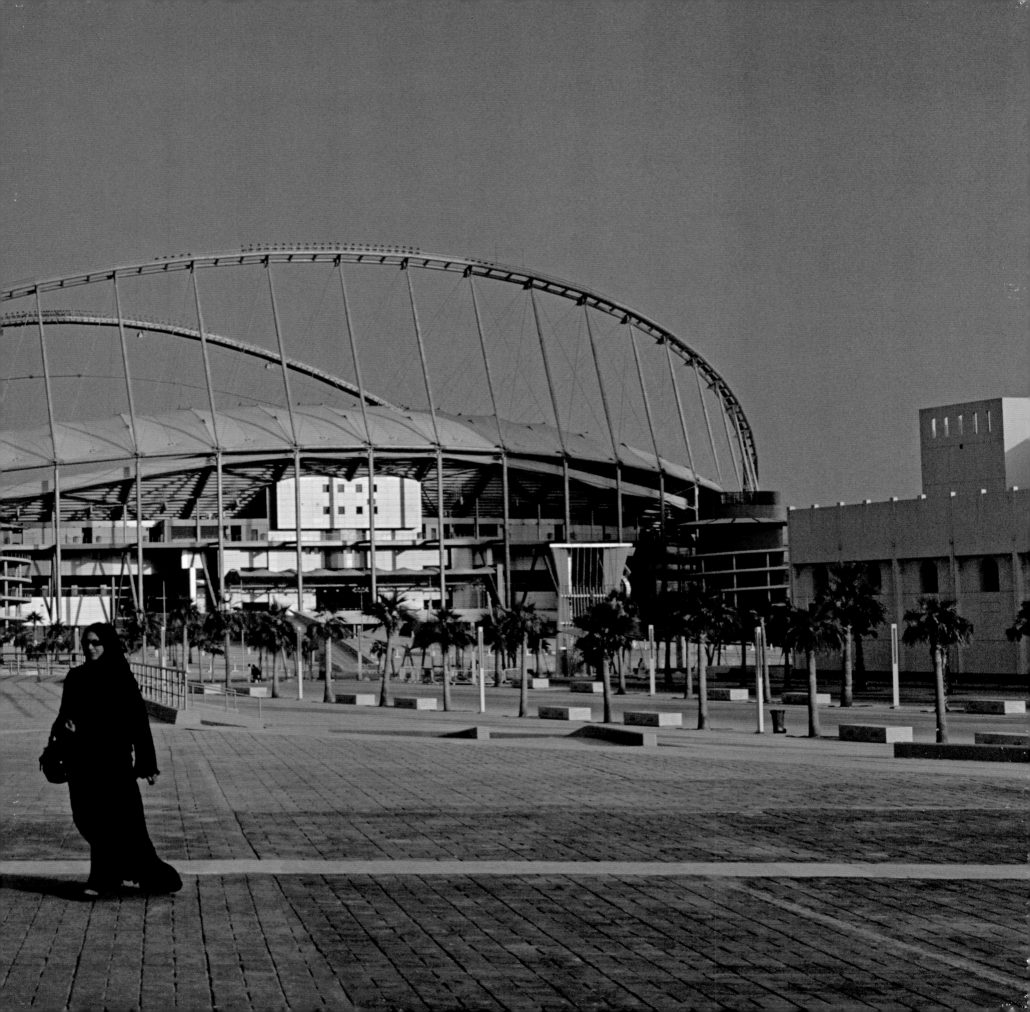

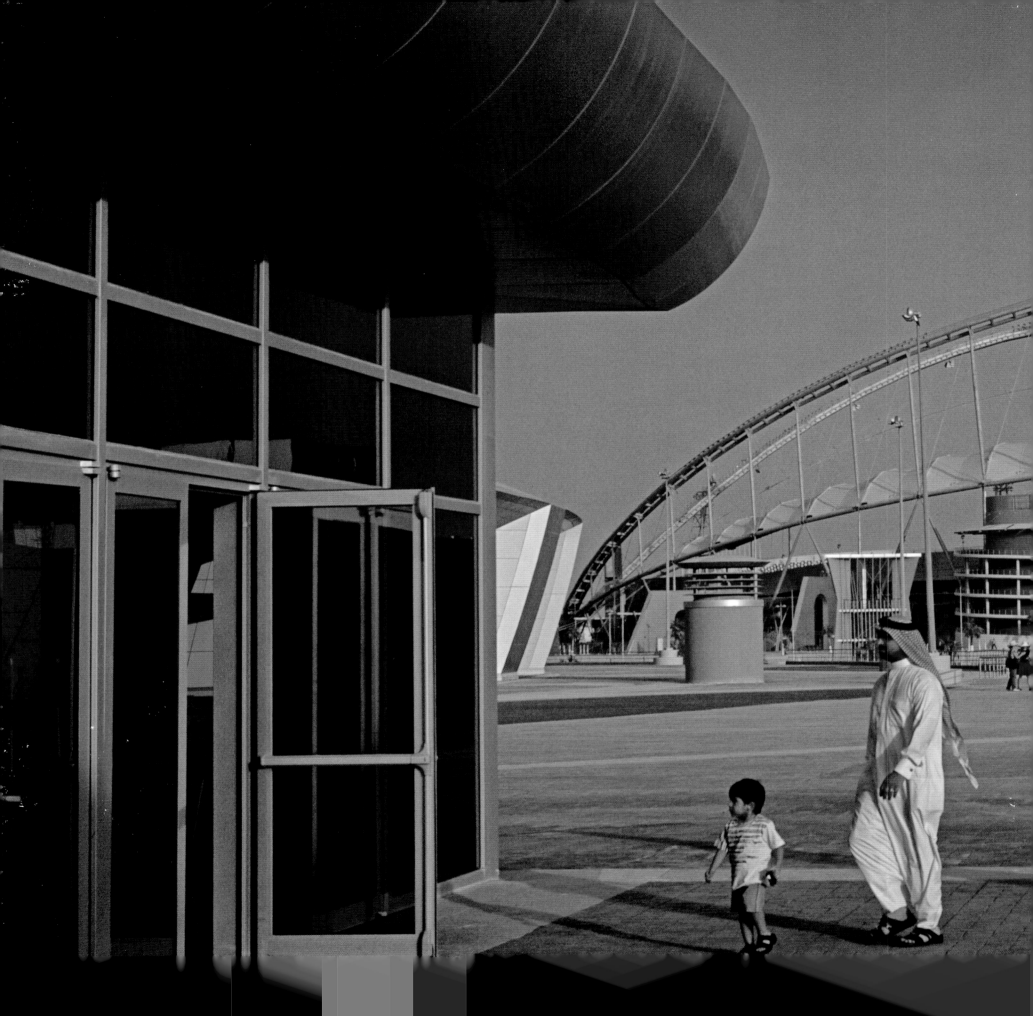

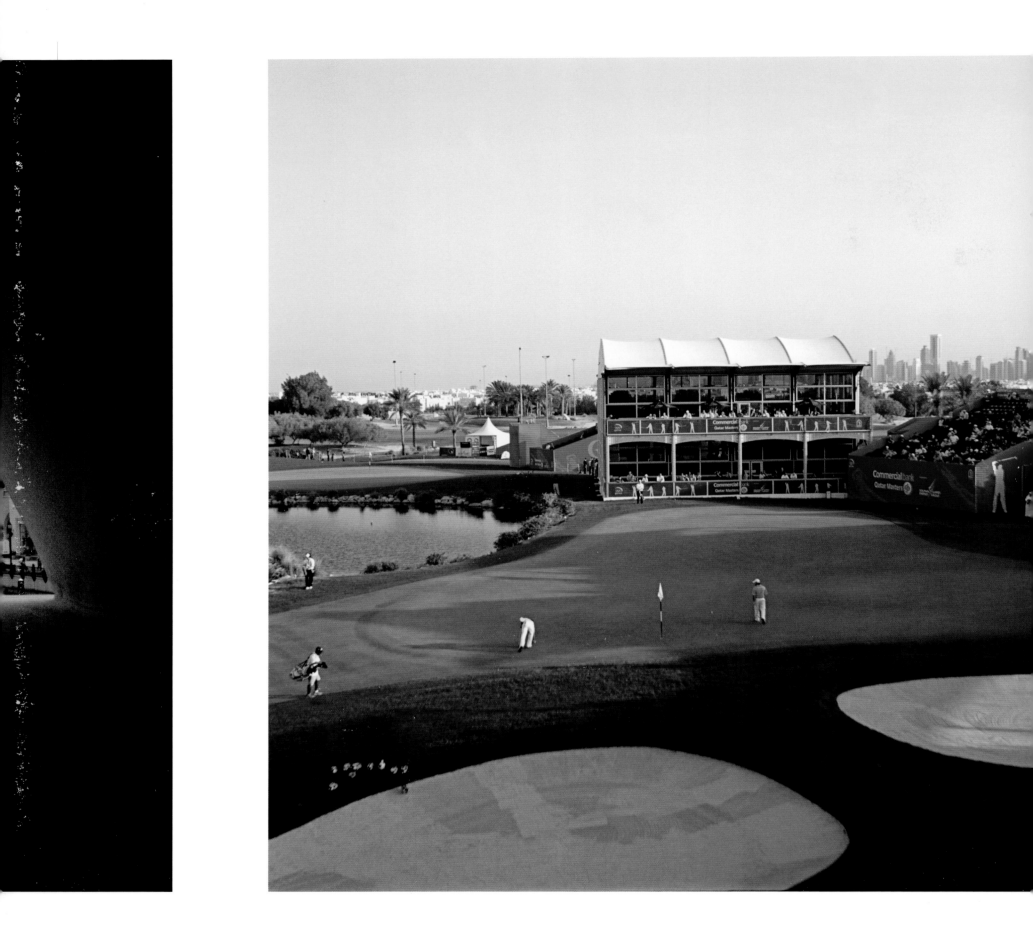

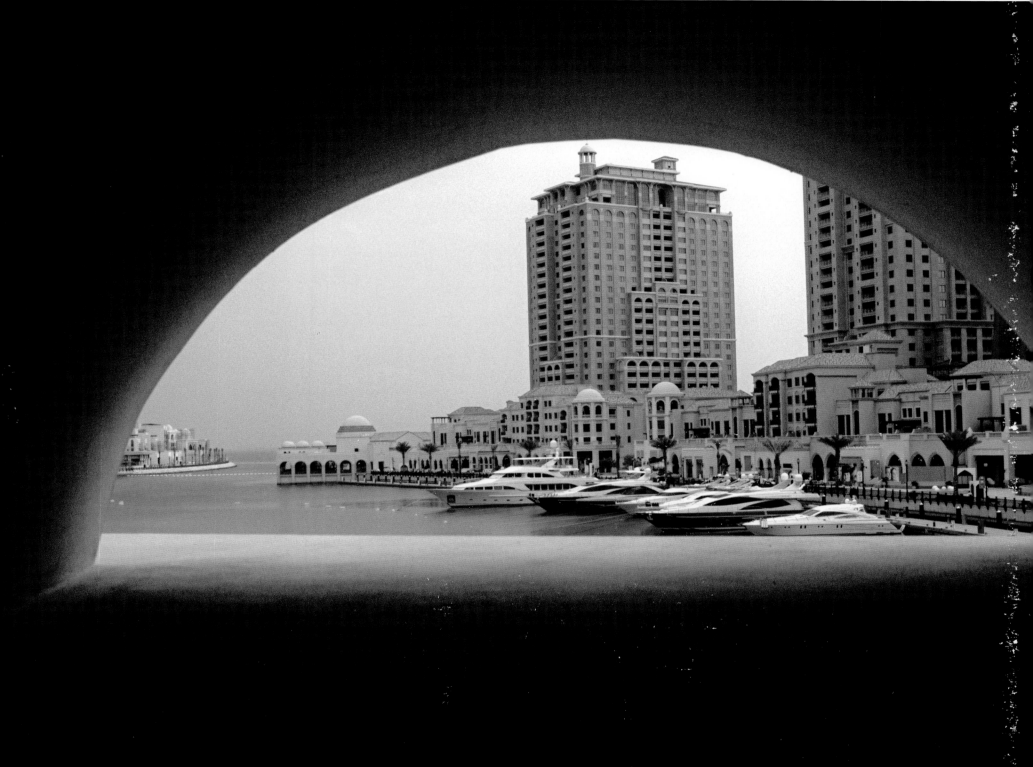

- **2003**: Sheikh Hamad names his son His Highness Sheikh Tamim bin Hamad Al Thani as heir apparent. The U.S.-led invasion of Iraq is run out of the forward headquarters of the U.S. Central Command (CENTCOM), located at Camp As Saliyah outside of Doha. The headquarters eventually moves to Al Udeid Air Base. In the second round of voting for the Municipal Council, a woman is elected for the first time.

- **2006**: Qatar hosts the Asian Games, one of the largest sporting events in the world.

- **2008**: The Museum of Islamic Art, designed by I.M. Pei, is opened.

- **2010**: Qatar celebrates Doha, Capital of Arab Culture with a year of outstanding cultural events. Qatar wins the right to host the FIFA World Cup in 2022, the first time it will be held in the Middle East and hosted by such a small country.

- **2011**: Qatar takes an active role in the Libyan revolt. Qatar announces it will bid for the 2020 Summer Olympics.

This timeline was compiled from numerous sources, including *The Creation of Qatar* by Rosemarie Said Zahlan, *Qatar* by David Chaddock, *Discovering Qatar* by Frances Gillespie and *The Emergence of Qatar* by Habibur Rahman. Online resources are the Qatar Museums Authority (www.qma.com.qa), Qatar Visitor (www.qatarvisitor.com) and the Qatar Natural History Group (www.qnhg.org).

(following)

Yachts at The Pearl; PGA Qatar Masters tournament; Aspire Zone, built for the 2006 Asian Games, now a public sports center; astrolabe-shaped torch and Khalifa stadium lit to celebrate Qatar's winning bid to host World Cup 2022; National Day Parade; secluded western shore

- 1980s: A six-year decline of 46% in oil prices and revenues results from over-production and reduced demand. Qatar and other oil producers suffer financially. Some believe the oil crisis led Sheikh Khalifa to cede more responsibility to his son and heir apparent Sheikh Hamad bin Khalifa.

- 1990-1991: Iraqi troops invade and occupy Kuwait, sparking the first Gulf War. Qatar sends troops as part of an international coalition to liberate Kuwait.

- 1995: Sheikh Hamad assumes power from his father. He establishes the Qatar Foundation, chaired by his consort, Her Highness Sheikha Moza bint Nasser, which creates Education City and sponsors the Doha Debates.

- 1996: The Al Jazeera Network is established by emiri decree. Al Udeid Air Base is established and later becomes a major operating base for the U.S. military during the conflicts in Iraq and Afghanistan.

- 1999: Qatar enfranchises women and holds its first elections for the Central Municipal Council.

- 2000s: A period of unprecedented economic growth in the oil and gas and related sectors; the Qatar Financial Centre and the Qatar Financial Centre Regulatory Authority are established, promoting transparency in commerce; numerous IPOs (initial public offerings) allow for the transfer of public wealth into private hands; massive infrastructure projects, including the Ras Laffan Industrial City, highways, a new international airport, etc.; and Qatar pursues an active and independent foreign policy, serving on the United Nations Security Council in 2006 and 2007.

- 1960: In spite of his agreement to make Sheikh Khalifa bin Hamad his heir, Sheikh Ali abdicates in favor of his son Sheikh Ahmed bin Ali Al Thani.

- 1960-1972: The rule of Sheikh Ahmed bin Ali Al Thani.

- 1968: Britain announces that its historic protection of Gulf States will end in 1971. Qatar considers joining with the seven emirates of the present-day United Arab Emirates and Bahrain, but when no agreement is reached, Qatar appoints its own cabinet.

- 1970: A provisional constitution is promulgated.

Contemporary Qatar

1971 – PRESENT

- September 3, 1971: The independence of Qatar as a sovereign state, terminating the Anglo-Qatari Treaty of 1916, is declared.

- 1971: The biggest unassociated gas field in the world is discovered off the coast of Qatar.

- 1972: Sheikh Khalifa bin Hamad assumes power while his uncle is residing in Europe. This move is largely supported by the people of Qatar and the Al Thani family because Sheikh Ahmed was seen as an absentee leader living an exorbitant lifestyle. Sheikh Ahmed had chiefly left the administration of government to Sheikh Khalifa as heir apparent and deputy ruler.

- 1972-1995: The rule of Sheikh Khalifa bin Hamad. He reorganizes the government, appointing a foreign minister and other ministers. Taking advantage of increased oil income from OPEC-imposed price increases after the 1973 Arab-Israeli war, he accelerates development in Qatar. The number of schools is expanded, the state-of-the art Hamad Hospital is opened, and Qatar University for men and women commences classes in 1977. Reclamation projects and development of the Corniche continue, and the Sheraton Hotel, the first five-star hotel in Doha, opens in 1982 to accommodate a surge in business travelers.

Sheikh Mohammed signs the General Maritime Treaty with Great Britain, a watershed moment in Qatari history because it is the first international recognition of Qatar as an independent political entity and the beginning of the Al Thani family's rise to power.

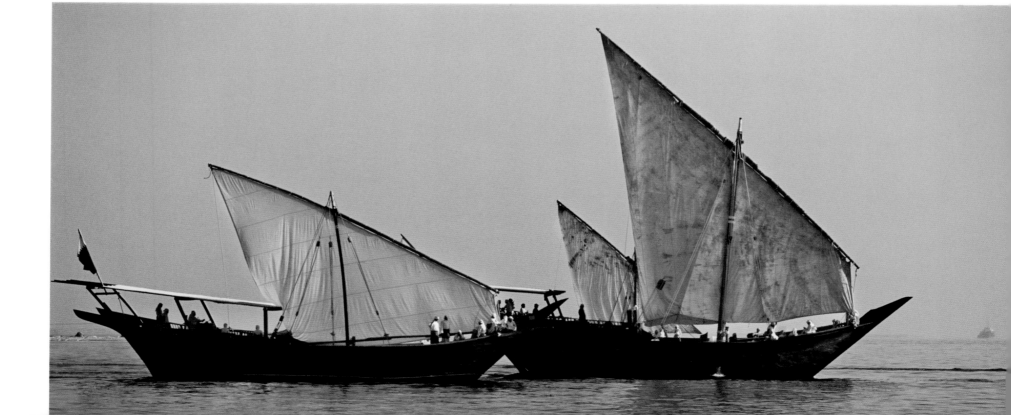

(above and opposite)

Fishing dhow in Al Ruwais;

lateen-rigged dhow sets

sail in Doha harbor as a

cargo ship approaches

A NATION EMERGES

1916 – 1970

- 1916: Sheikh Abdullah signs a treaty of protection with British political resident Percy Cox requiring British consent to cede, sell, lease or mortgage territory. This decision would become especially significant when oil is discovered in the 1930s. With an eye to the rising power of the Al Saud in Arabia, Sheikh Abdullah demands protection from land-based attacks in addition to the sea-based protection that Britain offers to the other trucial sheikhdoms.

- 1920s: The development and manufacture in Japan of cultured pearls begins to flood the world market. Demand for natural pearls is also reduced by the worldwide depression that begins after 1929.

- May 1932: Oil is discovered in Bahrain, and Standard Oil of California (SOCAL) and the Anglo-Persian Oil Company (APOC) begin jockeying for concessions in the Gulf sheikhdoms. SOCAL offers better terms, but APOC relies on the terms of the trucial protection treaties which require British approval of all concessions.

- 1934: The British Foreign office defines the eastern frontier of Saudi Arabia, reaffirming that Qatar is under British protection.

- 1935: Sheikh Abdullah signs a concession agreement with APOC, but exploration proceeds slowly.

- 1939: Oil is discovered near Dukhan on the west coast, but with the start of World War II, further exploration is halted in 1942.

- 1940s: In a country already financially devastated by the crash of the pearl market, the loss of prospective employment and income from petroleum proves disastrous. Hunger becomes widespread. Many men and entire families emigrate to Bahrain, Saudi Arabia and Persia seeking work, to return when the petroleum industry resumes activity in Qatar in 1946.

- 1944: Sheikh Abdullah passes most of the operations of the government to his son Sheikh Hamad, who dies in 1948 before becoming emir. Hamad's son, Khalifa, is too young to be made heir apparent, so Sheikh Abdullah turns to his son Sheikh Ali.

- 1946: Oil exploration and infrastructure development, including roads and pipeline construction, is restarted.

- 1949: In December, the first cargo of oil is exported from the new port at Umm Said on the east coast south of Doha and Al Wakra. Sheikh Abdullah grants offshore concessions to the American company Superior Oil, challenging the British-controlled Qatar Petroleum Company by separating land rights from offshore rights.

- 1949: Sheikh Abdullah abdicates in favor of his son Sheikh Ali, who pledges in writing to make his nephew Sheikh Khalifa bin Hamad his heir.

- 1949-1960: The rule of Sheikh Ali bin Abdullah Al Thani is marked by the development of basic infrastructure, such as electricity and water, schools for boys and girls, a hospital and a plan for a new airport.

- 1952: An independent tribunal rules in Qatar's favor in the dispute with British-controlled Qatar Petroleum Company. Superior Oil transfers its rights in Qatar to Royal Dutch Shell, which obtains the first offshore exploration concession in the Gulf.

- 1960: The Organization of the Petroleum Exporting Countries (OPEC) is established, with Qatar as a founding member.

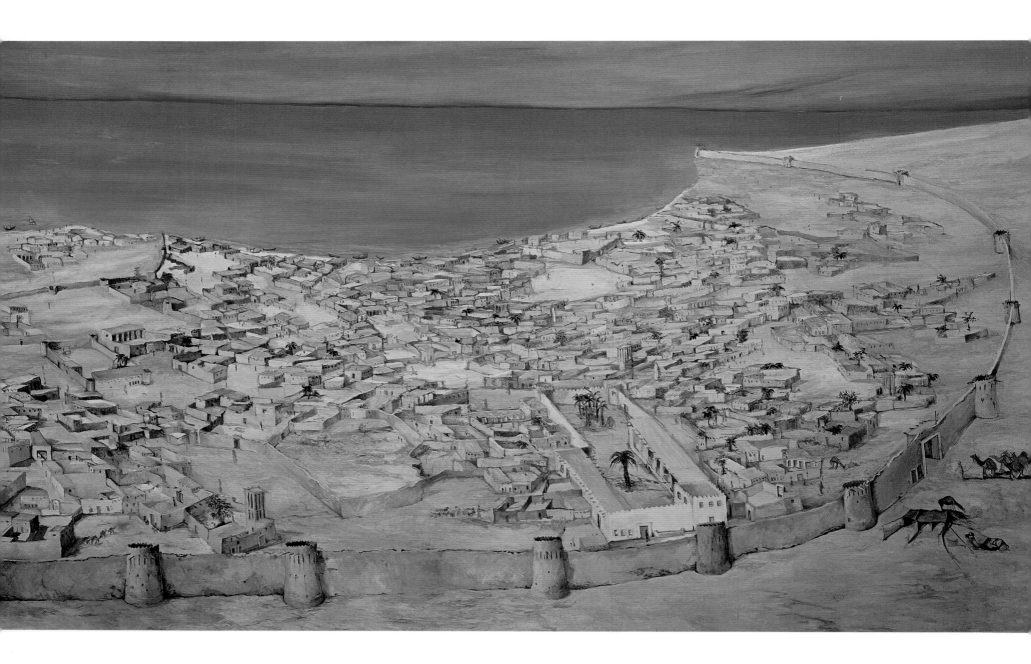

- 1908 & 1915: *Gazetteer of the Persian Gulf, Oman and Central Arabia*, compiled by John G. Lorimer of the Indian Civil Service, is published. It includes comprehensive historical, geographic, and topological information about the Gulf.

- May 1913: Resurgent Wahhabis drive the Ottomans out of eastern Arabia, ending Qatar's nineteenth-century arrangement with Bahrain and the Ottomans and beginning its new relationship with the Wahhabi Al Saud family and the British.

- July 1913: Sheikh Qassim dies and is succeeded by his son Sheikh Abdullah bin Qassim bin Mohammed Al Thani.

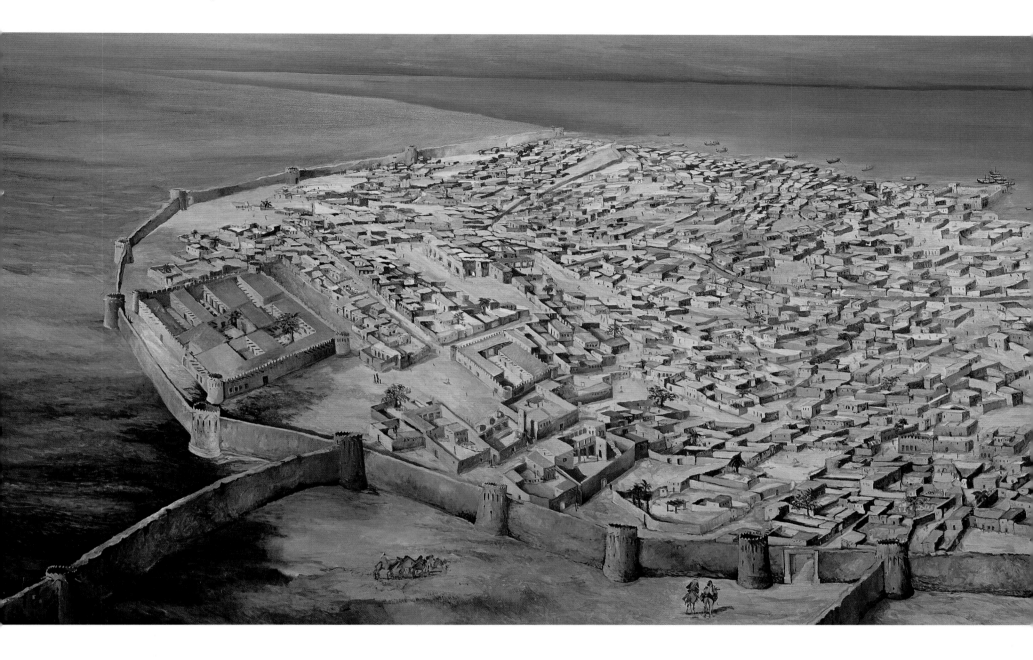

- December 18, 1878: Sheikh Mohamed bin Thani dies and is succeeded by his son Sheikh Qassim, who had already been exercising power in his father's old age. Qatari National Day today commemorates Sheikh Qassim's accession. Sheikh Qassim sacks Al Zubarah, solidifying his control over the entire peninsula.

- 1893: The Ottomans attempt to establish a customs house in Doha and arrest Sheikh Qassim's brother Ahmed. Sheikh Qassim's reputation as a folk hero is established when he defeats the Ottomans in a battle near Wajbah.

- 1895: A crisis in Al Zubarah involving the tribes of Bahrain and Qatar, the British and the Ottomans ends with the implicit recognition of Qatari control of Al Zubarah and thereby the entire peninsula.

- 1638: Al Zubarah, a town on the northwest coast, is described by Hamad bin Nayem bin Sultan Al-Muraikhi Al-Zubari Al-Qatari as a town of 150 houses and 700 inhabitants, with several boats and livestock.

- 1763: The British East India Company establishes a Residency at Bushire on the Persian side of the Gulf.

- 1764: Carsten Niebuhr, part of a Danish mapping expedition, visits Arabia but not Qatar. Using local Arab and English sea captains' reports, Niebuhr places various cities, such as Guttur (al Bidda), Adsjar (probably al Khor), al Huwailah, Yusufiya and Furaiha but neglects to represent Qatar as a peninsula.

- 1766: The Al Khalifa from Kuwait migrate to Al Zubarah on Qatar's northwest coast, which develops into a thriving trading port. Another branch of the same tribe, the Jalahimah, follows.

- 1768: Murair fort is built inland of Al Zubarah, linked to the sea by a technologically impressive two-kilometer canal.

- Qatar, Bahrain, and the east coast of the Arabian Peninsula remain active centers of trade and political rivalry over the subsequent century. Qatari and Bahraini tribes plus Omanis and Wahhabis struggle for power, while the British enforce maritime peace to protect their own trade.

- 1783: The Al Khalifa and the Jalahimah tribe from Al Zubarah and allies from local Qatari tribes capture Bahrain from the Persians. The Al Khalifa claim power in Bahrain. Rahman bin Jabir of the Jalahimah seeks to share power with the Al Khalifa since he had helped in the conquest of Bahrain, but when rebuffed he becomes their sworn enemy and moves north from Al Zubarah to Khor Hassan. Rahman bin Jabir makes alliances with the Wahhabis of the Arabian peninsula and the Qawasim of the north Omani coast and attacked both Persian and Bahraini ships.

- 1809: Captain John Wainwright leads a joint expedition of the Royal Navy and the East India Company to map the Gulf and to suppress piracy in the Gulf and the Indian Ocean.

- 1820: The General Treaty of Peace is signed between Great Britain and numerous tribal sheikhs from Bahrain to the north coast of Oman (present-day UAE), mandating an end to hostilities at or by sea and abolishing the slave trade. What the British had called the Pirate Coast becomes the Trucial Coast. No representative from Qatar signed this treaty.

- 1850s: This decade marks the beginning of the golden age of pearling in the Gulf, with demand stoked by new wealth in Europe, the United States and India.

- 1868: Sheikh Mohammed bin Thani Al Thani represents the people of Qatar in negotiations with Col. Lewis Pelly, the British political resident in the Gulf, after Doha and Al Wakra are destroyed and looted.

- 1868: Sheikh Mohammed signs the General Maritime Treaty with Great Britain, a watershed moment in Qatari history because it was the first international recognition of Qatar as an independent political entity and the beginning of the Al Thani family's rise to power.

- 1869: The Suez Canal is opened, linking the Red Sea and the Mediterranean.

- 1871: Sheikh Qassim (also transliterated as Jassim) bin Mohammed Al Thani, then Heir Apparent, allows the Ottomans to station troops on the peninsula, in part due to an attack from Bahrain in 1867 that highlighted Qatar's need for protection. With astute political acumen, Sheikh Mohammed and Sheikh Qassim balance the Ottomans against the British for the next forty years.

(opposite and above)
Late 19th century fort built by
Sheikh Mohammed bin Jassim
Al Thani, a son of the founder
of Qatar; decoration from
a Gulf door

1850s: This decade marks the beginning of the golden age of pearling in the Gulf, with demand stoked by new wealth in Europe, the United States and India.

Al Zubarah, a town on the northwest coast, is described by Hamad bin Nayem bin Sultan Al-Muraikhi Al-Zubari Al-Qatari as a town of 150 houses and 700 inhabitants, with several boats and livestock.

- Murwab in the eighth and ninth centuries is the first sizeable settlement in Qatar. Located inland from the north coast, it has over 250 houses, two mosques, and two forts built in the Umayyid and Abbasid styles. Pearl diving tools, the shells of pearl-bearing oysters, and an Abbasid coin have been excavated on the site.

- Yaqut Al Hamawi, a Syrian geographer (1179-1229), writes that rough, red wool cloaks were exported from Qatar and that there are camel and horse markets.

European Influence
1498 – 1916

- 1498: The Portuguese explorer Vasco da Gama rounds the Cape of Good Hope, demonstrating the feasibility of an all-ocean route to India. Thus begins the European challenge to Arab domination of the ancient land and sea routes from Arabia to the eastern Mediterranean.

- 1521: Portuguese commander Antonio Correia invades Bahrain to control trade wealth from the Gulf. Undoubtedly, pearls from Qatari waters nearby were included in the resulting expanded trade with the West.

- 1534: Baghdad is captured by the Ottoman Sultan Suleiman the Magnificent, who then seeks to gain control of Gulf trade routes.

- 1602: Shah Abbas of the Safavid Persian Empire defeats the Portuguese in Bahrain.

- 1622: The British fleet helps Shah Abbas expel the Portuguese from strategic Hormuz Island, which dominates the narrows where the Gulf meets the Arabian Sea, the northern part of the Indian Ocean, thereby opening the way to Britain's commercial hegemony in the Gulf.

- "Catara" is mentioned by Ptolemy in Geographia, written around 150 BCE.
- In Naturalis Historia, published around 77 CE, the Roman Pliny the Elder identifies the Gulf as an abundant source of pearls and refers to "Catharrei" nomads.

PRE-ISLAMIC ERA

300 – 600 CE

- The Sassanid Empire, the last pre-Islamic Persian Empire (224 – 651), has strong interactions with the Roman Empire, and its culture influenced early Islamic arts.
- Some scholars believe the stories about Sinbad the Sailor, later popularized in English compilations of *A Thousand and One Nights*, may have originated as the Book of Sinbad during the Sassanid period. Sinbad sailed from the Gulf through the Indian Ocean to India and Ceylon and southward to the east coast of Africa in much the same way that Arab and Persian traders travelled until the second half of the twentieth century.
- Northwest burial sites containing Sassanid glass demonstrate commerce with Sassanids in Persia and an above-subsistence-level economy. Pearls and purple dye were likely exports from the Qatari coast.

EARLY ISLAMIC PERIOD

600 – 1497 CE

- 628: The Prophet Mohammed's emissary Ala Al Hadrami persuades Al Mundhir bin Sawa Al Tamimi to embrace Islam. At the time, Al Tamimi was the leading sheikh of Bahrain, ruling the area from coastal Kuwait to Qatar.
- 750 – 1258: After defeating the Umayyad caliphate based in Damascus, the Abbasid caliphate moves the Muslim capital to Baghdad, bringing the Gulf communities closer to the political center of Islam.
- The fifth Abbasid caliph, Harun Al Rashid, and his son Mamun rule from 786 – 833 CE and create the legendary Bait al Hikma or House of Wisdom, where science, arts, and scholarship flourish, including the development of algebra. The fictional *A Thousand and One Nights* is a product of Harun Al Rashid's court.
- From the eighth to the thirteenth centuries, the Bait al Hikma collects scholarly works, such as those by Socrates, Plato and Euclid, and translates them into Arabic. Otherwise, these classics would likely have been lost to humanity.
- The captains of Arab dhow (a general name for wooden boats and ships used in the Gulf and Indian Ocean) master complex navigation methods using the compass (likely adapted from China) to steer a course and the astrolabe (introduced from Greece) to calculate latitude. These vessels sail as far as China, Malaysia, India and Africa, establishing Arab outposts along the way.
- Cargoes of the luxury goods desired in Harun al Rashid's Baghdad come through the Gulf and up the Tigris. These include silks and porcelain from China, spices from India, ivory and slaves from Africa, and pearls from the Gulf itself.

Cargoes of the luxury goods desired in Harun al Rashid's Baghdad come through the Gulf and up the Tigris. These include silks and porcelain from China, spices from India, ivory and slaves from Africa, and pearls from the Gulf itself.

(below and opposite)
Ancient petroglyph
of unknown provenance
depicting a dhow with
oars and shallow cups that
may have been a type of
game board; ladder in
Al Zubarah fort tower

- Kassite pottery links Al Khor Island to Mesopotamia. A massive shell midden of the sea snail (*thais savignyi*) as well as remains of huge Kassite vats for dye products make this tiny island the first purple dye site discovered outside the Mediterranean. Kassite documents recount that their kings wore red-purple garments.

1300 – 500 BCE

- The Epic of Gilgamesh, a legendary Mesopotamian king, recorded on clay tablets in the seventh century BCE, describes the search for the "flower of immortality" by attaching stones to his feet and diving into the sea. This is the same technique traditionally used by Gulf pearl divers into the twentieth century.

400 BCE – 300 CE

- 326 BCE: Alexander the Great conquers Persia and northern India. In 324 BCE his admiral, Androsthenes, explores the Indian Ocean coast and the Gulf and commented on the prized pearls. Alexander's plan to conquer the Gulf dies with him.

- The eastern remnant of Alexander the Great's Macedonian empire was known as the Seleucid Empire, centered on the Tigris River, dating from 312 BCE-63 CE. Gerrha on the east coast of Arabia near Bahrain was known as a significant trading center at this time, linking Indian goods with the Gulf and sending camel caravans to the Mediterranean. A site at Ras Abrouk in Qatar contains Seleucid pottery fragments and some 100 burial mounds, provisionally dated to that period.

Historical Highlights

227

Prehistory and Early Agriculture

8000 – 4000 BCE

- Increased rainfall in Arabia makes pastoral life possible.

- Flint tools, dwellings and stone slabs dating from the 7th century BCE and arranged in circles on the coast north of Doha indicate early habitation. Three phases of habitation occur at the site, with the latest dating to the 1st century BCE.

- Pearls in burial mounds in Bahrain dating to the 6th century BCE present the oldest evidence of pearl fishing.

- Querns (stone hand mills) found on the southwest coast may have been used by pastoral nomads. These early inhabitants learned to harvest wild grains, to domesticate goats and sheep, and to use camels for milk.

Contact with Mesopotamian and Greco-Roman Civilizations

5000 – 3000 BCE

- Numerous Al Ubaid potsherd (earliest urban Mesopotamian era) discoveries confirm that Qatar had sea links with the civilizations in present-day Iraq. Flint artifacts on both coasts suggest there was widespread, although sparse, habitation on the peninsula.

- Small, isolated communities that focused on fishing and bartering may have been seasonal encampments when herds were brought to Qatar to graze.

- Cairn burial sites dating to this period contain flexed skeletons, shells and obsidian beads (not indigenous to Qatar).

3000 – 1200 BCE

- The climate grows more arid.

- An Assyrian inscription from 2000 BCE describes "a parcel of fish-eyes from Dilmun," perhaps the first written record of Gulf pearling.

- Barbar pottery from the Dilmun civilization shows up in a number of Qatari archeological sites. The famed Bronze Age Dilmun traders were likely centered in Bahrain, which had rare, abundant freshwater springs. Dilmun was the entrepôt for the flourishing trade between Mesopotamia and the Indus Valley.

(opposite and above)
Al Zubarah fort; potsherds
showing signs of long years
buried in salty soil

Small, isolated communities that focused on fishing and bartering may have been seasonal encampments when herds were brought to Qatar to graze.

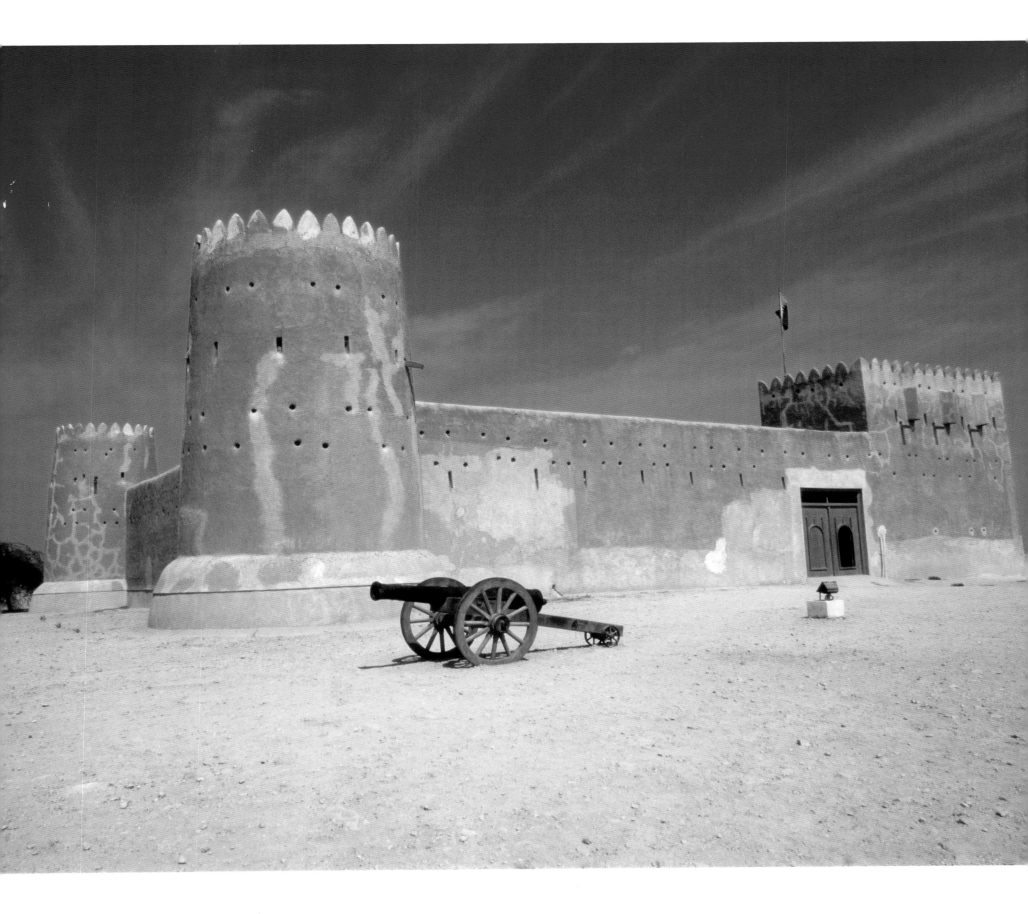

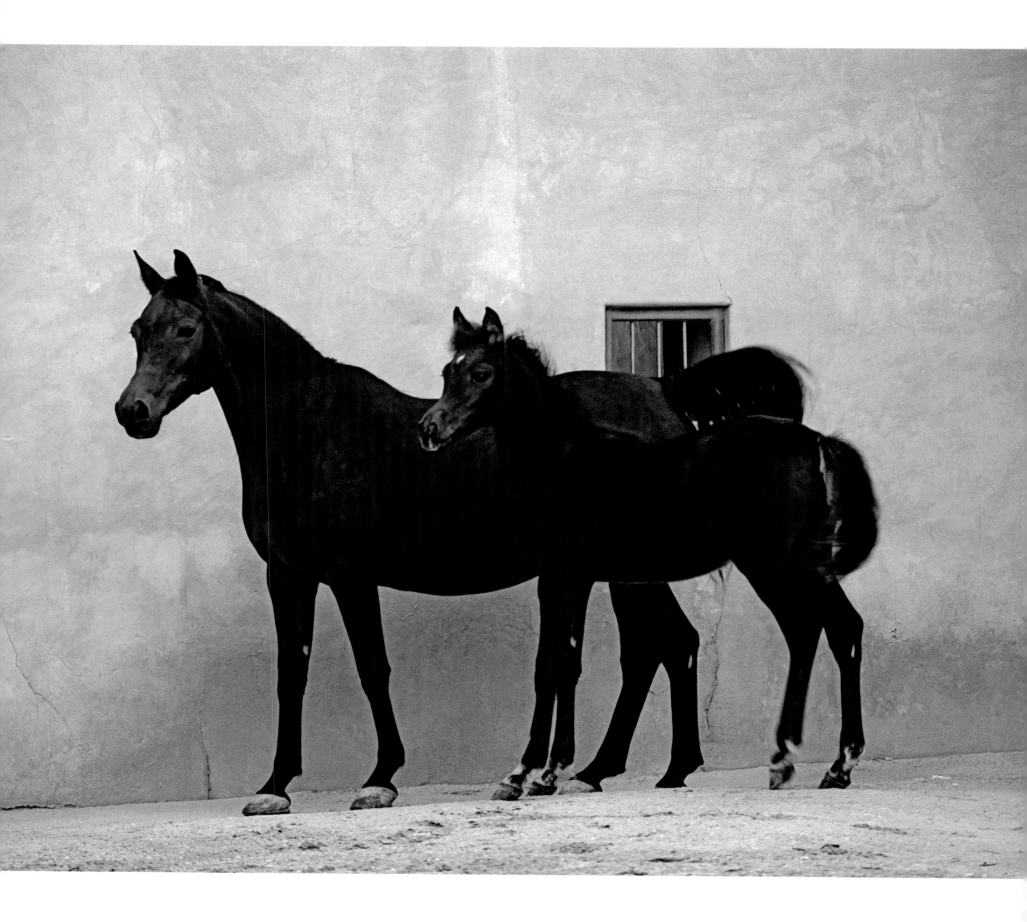

Sheikh Hamad bin Ali Al Thani introduced us to Arabian horses during our first week in Qatar. At the incomparable Al Shahaniya Farm, Deryle Duncan allowed me to ride High Voltage, the black stallion of my dreams, and arranged for Henry Dallal to photograph the farm. It was an honor to crew Sheikh Mohamed bin Nawaf Al Thani at endurance races and to ride his horses. Mohanad Al Yaqout is a steadfast friend. Singh has boosted me into the saddle too many times to count and has spent hours working horses with me. Nasser Al Qaadi and his family always say "yes". Dr. Hossain Abara was never too busy to take care of my horses. All the pages in this book are not enough to express my gratitude to everyone at Al Shaqab Stud, the Qatar Equestrian Federation, the Endurance Committee and the Racing Club.

Our experiences in northern Qatar were enriched by Mohamed bin Yousef Al Obaidli, Heritage Section, Qatar Museums Authority; Juma bin Abdulla Jaham Al Kubaisi, Talal bin Jabr Rashid Al Nuami, and Abdulla bin Saif Al Nuami, who always had a horse, a meal and a boat available.

My admiration and gratitude to Henry Dallal as an artist and a friend are boundless. Lucy Chambers, Ellen Cregan and Kathleen Sullivan at Bright Sky Press, along with designer Wyn Bomar, created a beautiful book. Darrell Hancock motivated me to recheck every word. My brothers and sisters, Harry Webb, Françoise Djerejian, Helen Chambers and Sima Ladjevardian, along with so many other American friends, have been unreservedly enthusiastic. Many thanks to my parents who brought me up with books and horses. Our daughter Elly was always ready with an Arabic translation and kept me company at the kitchen table doing her homework while I typed away at my computer. Most of all, I thank my husband, Chase, whose talents made our family's Qatari adventure possible and who provided invaluable help and insight on the numerous occasions he read through the manuscript.

Houston, Texas, 2011

collectors and a preeminent scholar. We were guests at the Merweb Central Doha for an extended stay courtesy of Sheikha Moneera and Mohamed bin Hamad Al Nasr. Special thanks to Sheikh Sultan bin Suhaim Al Thani and Sheikha Mona Al Dossarey, who are endlessly generous.

Our esteemed friend Sheikh Faisal bin Fahad Al Thani is an invaluable source of information and kindly reviewed the manuscript as did Abdullah bin Faraj Al Abdullah. Sheikha Amna bint Suhaim Al Thani encouraged me to write *Diana in Doha,* which resulted in this book. Sheikha Maha Al Faihani, Sheikha Noor Al Subaie, Sheikh Ali bin Abdullah Al Thani, General Hamad bin Ali Al Attiyah, Jassim Jaidah, Hussein Al Fardan and Abdulbasit Al Shaibei first demonstrated to us the fine art of Arab hospitality. Sheikh Saud bin Abdulaziz and Sheikh Nasser bin Nawaf Al Thani allowed us to photograph their exquisitie salukis. Whenever and wherever I might be lost in Qatar, I know I can call Engineer Dhafi Al Ardi Al Marri to interpret the subtlest clues to guide me onward. Our neighbors, the Jassim Abu Abbas family welcomed us as family. We had a lovely sunset shoot of Doha Bay from Mohamed Abu Abbas' exquisitely restored dhow. Ahmed bin Hussein Abu Abbas shared stories about the early oil days and about a sail-powered trip to India with his father.

Qatari artist Ali Hassan lent his talent to the calligraphy titles. Yusef Ahmed taught us about the subtle palette of Qatari sand and allowed us to reproduce his imaginative painting of old Al Zubarah. Sheikh Faisal bin Qassim allowed us to photograph his spectacular private museum near Al Sheehaniya where Nawale LaCroix assisted us. Dr. Abdulla bin Ali Al Thani, president, Hamad bin Khalifa University, is a constant source of encouragement. His Al Markhiya Gallery is managed by Heather Alnuweiri, who is always ready to help. Photographer Sheikh Khalid Hamad Al Thani, author of *Here is My Secret,* shared some of his favorite desert locations with Henry Dallal. Fahad bin Mohamed Al Attiyah and Raya Al Khalifa are great friends and invited Henry to some wonderful photo sites. Ambassador Badr Omar Al Dafa shared his artistic insight, as did artist and director, Visual Arts Center, Amal bint Abdulla Al Aathem.

and Salah Maktari; at ExxonMobil, Alex Dodds, Saleh Al Mana, Abeer Zaiter and Shirine Sohl; at the Qatar Planning Authority, to Sheikh Hamad bin Jabor Al Thani, Mansoor Al Malki and Dr. Ramesh Taragi; at the Qatar News Agency, to Sheikh Jabor bin Yousef Al Thani, Engineer Khalid Al-Motawa and Ejaz Inayat; at the Private Engineering Office, to Hamad bin Khalifa Al Attiyah, Abdulaziz Al Rumaihi, Abdulla Al Meshadi, Mahmoud Omar and Ziyad Shawkat; at the Ministry of Foreign Affairs, to Ambassador Hamad Ali Al Hinzab, Ambassador Mohamed Al Rumaihi, Ambassador Ali Al Hajiri, Ambassador Rashid Al Khater; Ambassador Yousef bin Ali Al Khater and Amina Al Ameer; at the Qatar Museums Authority, to Abdullah Al Najjar, Aisha bint Khalid Al Khater, Hamad Al Marri, and Rashid Al Hajiri; at the Qatar Foundation, to Dr. Saif Al Hajiri, Saleh Hadi and Norma Haddad; at the National Day Organizing Committee, to Salah Al Maadadi and Moez Al Agha; at Al Shaqab Stud, to Fahad Al Qahtani and Abdullah bin Ali Al Misnad; at Katara, to Malika Al Shraim and Saif Shandhour; at the Oryx Reserve, to Adel Al Yahri; at Qatar Paragliding, to Ovi Staicu; and to Scot Alessi, who spent countless hours organizing transparencies and photographs.

I want to give special thanks to Emad Joudeh, Boccardo (Jun) Lajora, Jr., and Mary Quime at the U.S. ambassador's residence and to the entire U.S. Embassy staff in Qatar 2004-2007.

Qatar Airways' five-star service allowed us to arrive rested and ready to work. Particular thanks to "the Chief," Akbar Al Baker, Colin Neubronner, Updesh Kapur and Sigrid Rath in Doha and to Bob Peek, Kristian Anderson, Kirsten Wilburn and Diana Zemplinski and her team in Houston for all you do for us.

Sheikha Aisha bint Faleh Al Thani is one of my sponsors and a constant source of support and inspiration, as are her sisters who have made my family part of theirs. Sheikha Moneera bint Faleh Al Thani graciously allowed us to photograph part of her natural pearl collection given to her by her father Sheikh Faleh bin Nasser Al Thani, one of Qatar's premier pearl

Acknowledgments | *Qatar: Sand, Sea and Sky* is dedicated to the people of Qatar. While the spirit

of a country can never be captured fully on paper, *inshallah*, you will be gratified by this endeavor. It is a gift of love to all those in Qatar—far too many to list by name—who blessed our family with friendship.

My highest regard and heartfelt thanks belong to His Highness Sheikh Hamad bin Khalifa Al Thani whose wise leadership and dedication to building a modern nation on the foundation of traditional Qatari culture inspired me to create this book. Her Highness Sheikha Moza bint Nasser is a role model for all who seek excellence. Her gracious comments about one of my early speeches gave me the courage to pursue this project.

Sheikha Al Mayassa bint Hamad Al Thani, founder and chairperson, Reach Out to Asia, and chairperson, Qatar Museums Authority, and Sheikha Hind bint Hamad bin Khalifa Al Thani, director of the Emir's office, have been unflaggingly supportive. So have been Sheikh Hamad bin Jassim bin Jabor Al Thani, prime minister and foreign minister of Qatar; Sheikh Hassan bin Mohammed Al Thani, vice chairman, Qatar Museums Authority and cultural advisor, Qatar Foundation; and Sheikh Abdulrahman bin Saud Al Thani, former chief of the Emiri Diwan.

The minister of culture, our dear friend Dr. Hamad bin Abdulaziz Al Kawari, gave the Ministry's imprimatur to the book without which it would have been impossible to fundraise and gain necessary access. Dr. Marzook Bashir Binmarzook has been my point person at the Ministry and a great help, as has been Nabila Zouaoui, Ph.D. Congratulations to the entire Ministry for fine work on Doha 2010 Capital of Arab Culture, of which this book is one result.

At RasGas, my sincere thanks go to Hamad Rashid Al Mohannadi, Abdulla Hashim and his entire family, Carol Pascoe, Christine Detera, Steve Jones and the entire RasGas Communications team; at Qatari Diar, to Ghanim bin Saad Al

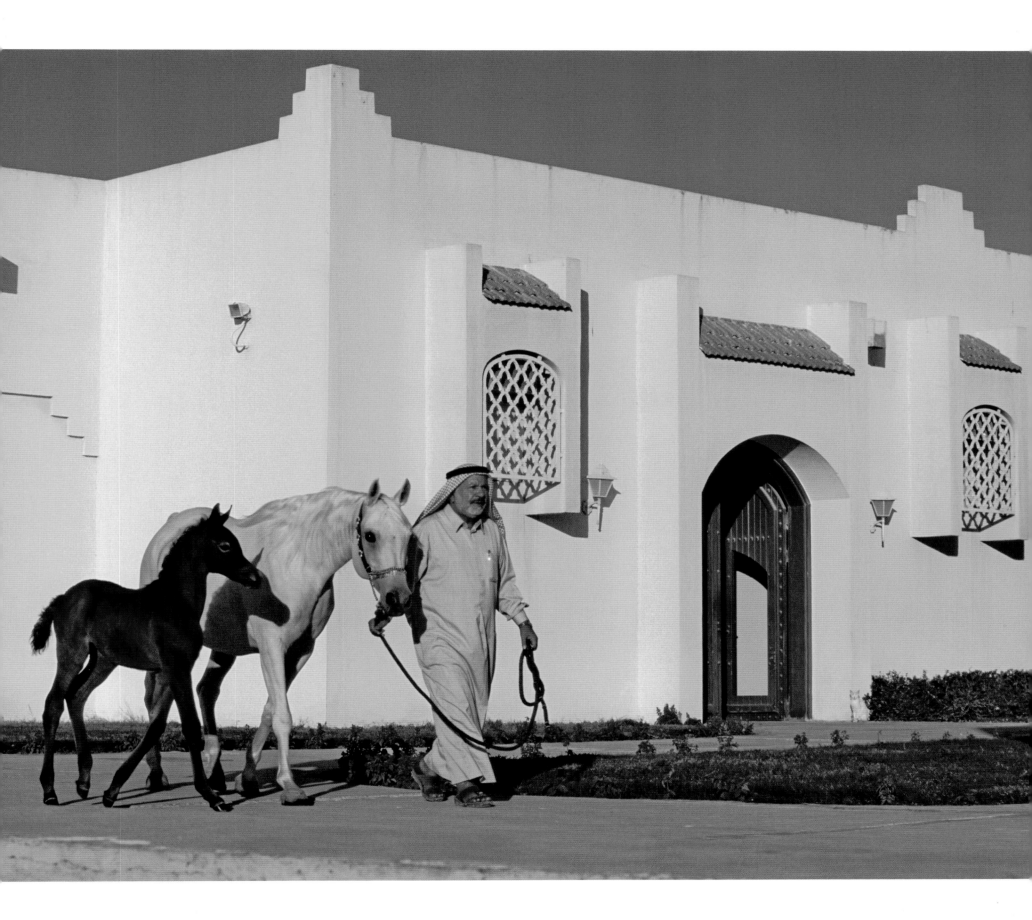

Henry Dallal | My work in photography provides me with the enormous privilege of travelling in a country that is new to me and intimately experiencing its culture, nature, people and traditions. Capturing the spirit of a place or person on film at a particular moment in order to share it with others is my inspiration. Diana Untermeyer's contagious enthusiasm for Qatar and the warm welcome I received from her many friends there allowed me to get to know the country, its people and traditions more deeply and rapidly than I could have imagined.

My heart still pounds fast when I recall one dark night spent hanging out from the edge of a construction site fifty-five floors above the Corniche to capture a shot. The unlit, debris strewn floor offered only tenuous comfort as the wind blew through and no barriers stood between me and the abyss.

Clinging to the side of a helicopter flying over Ras Laffan industrial city trying to create photographic art from the myriad pipes and tubes of the refinery; skirting around the underbellies of the giant jets in the growing Qatar Airways fleet in between landings and take-offs; watching a herd of horses next to the busy runway; revelling in the solitude of the sand dunes by the sea near the Saudi Arabian border—these memories and more make this project unique in ways that have widened the creativity of my lens.

I will not tire of photographing the iconic Museum of Islamic Art. It inspires me to marvel at its changing shades and hues from sunrise to moonrise and dusk. With ancient dhow in the foreground, it is particularly striking. The desert provided another visual delight. Sometimes subtle, sometimes lush and verdant, the desert had carpets of greenery even in May after unusual spring rains.

Idling away afternoons in Souq Waqif with my camera, I absorbed the sights, sounds and smells of its magic atmosphere. I am still challenged to take the ultimate photograph of this very enchanting market at the magic hour of dusk.

From meeting old established families to newly landed expats, Qatar is clearly a country that is being reborn. I saw what a motivated population can achieve, from Education City to Al Jazeera to the efforts to establish a region in the Gulf that preaches tolerance.

In early December 2010, I witnessed Qatar erupting into a rapturous celebration of its victorious bid to host the 2022 FIFA World Cup. Mixing with the jubilant crowds on the Corniche, I felt the country had united as one big family, and the themes "imagine" and "amazing" resonated. As Qatar prepares for the largest global sports event, this ever-changing country will be propelled in yet new directions.

This project differs from my other books—five of which celebrate the horse. Whether I was capturing the desert, sea, towns, souqs, parades, buildings, museums, people or pipelines, my lenses were stretched to celebrate an entire country in many moods. If a country can be counted as a friend, I leave Qatar with the sense that I have added to my circle. The friendships created during this project will stay with me long beyond the click of my camera's shutter.

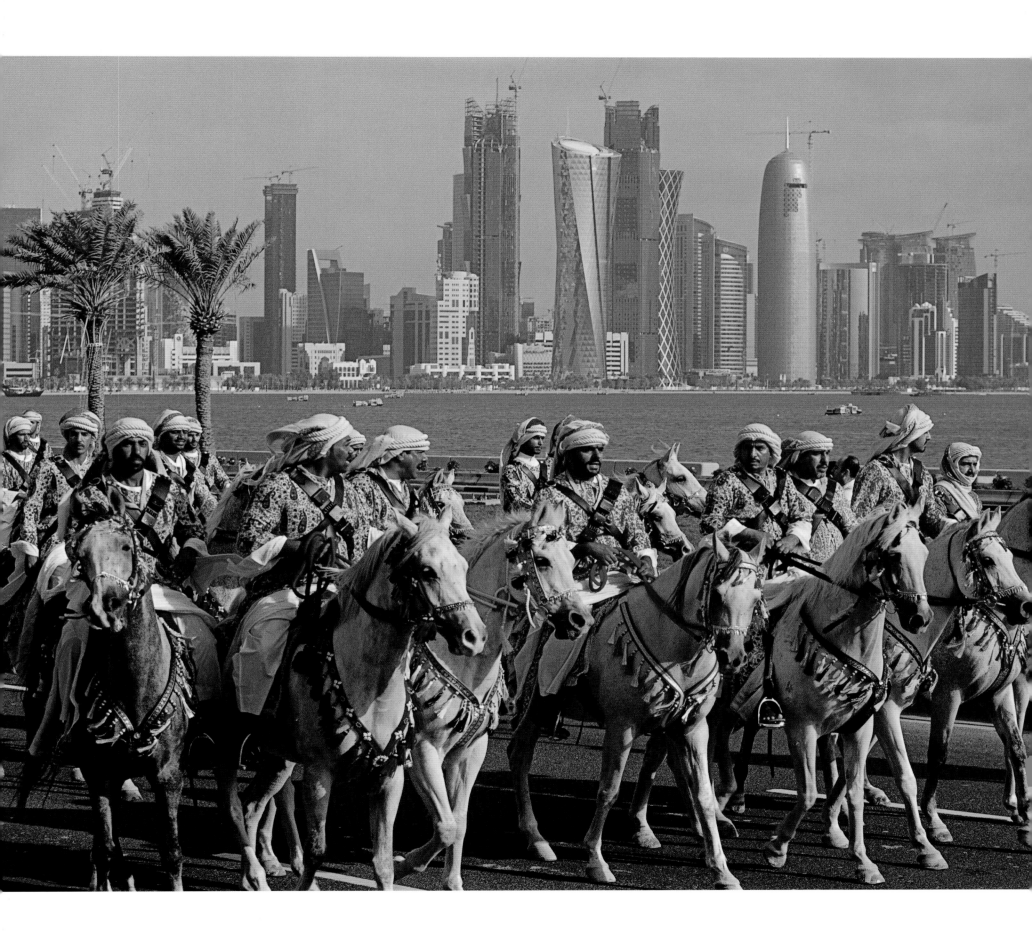

mark; or that my own spirituality would deepen by living closely with people who stopped to pray at the prescribed times, whether at the mosque, the race track or the side of the road. I was delighted to discover that I could drive to even the remotest corners of the country, my biggest concern getting stuck in the sand or in tidal salt flats. Elly said she felt safer than at home in Texas, which was an astute assessment since there is little theft and virtually no violence in Qatar.

Working on a book designed to share the essence of Qatar, the traditional and the modern, occurred to me early in our time there, so it was providential—or, as is said in Arabic, *maktub* ("it is written", destiny)—when I encountered the artistic photography of Henry Dallal, who works solely in film with no digital enhancement. Henry's scrupulous attention to detail and deep connection to his subjects bring a mystical quality to his photography. The process of introducing him to Qatar's subtle beauty, its leisurely social life and the overwhelming pace in the public sphere helped me tell this story.

This book is not meant to be history or a catalogue of flora and fauna, or even an account of the mind-boggling projects and initiatives on which Qatar has embarked. Rather, I have attempted to capture some of the heart and soul of the place that captured me. *Inshallah*, God willing, it will encourage others to explore the country. To that end, the resource section includes many online sources for easy reference.

The country is in constant motion, which is of course what makes it so enthralling. But this quality also encouraged me to write broadly and to avoid pronouncements that things are this way or that, since by tomorrow such statements are likely to be outdated. My sincere desire is that the broad brushstrokes I have used here adequately portray the spirit of Qatar—the warmth of its people and the daring of their dream.

Diana C. K. Untermeyer | Qatar is our family's second home, and even before we "left post" we were thinking of ways to remain involved there. The strength of this emotional bond took me by surprise, in part because we arrived in Qatar with such a clean slate. State Department briefings focused primarily on internal administrative matters, security concerns and a smattering of political briefings, rather than on cultural insights or local customs.

I received a number of copies of the book *Arabian Horses of Qatar* and tracked down a rare copy of the *Bedouins of Qatar* by Klaus Ferdinand. I knew more about the horses and the history of the country than about contemporary life. We had so little time between receiving the assignment and arriving in Qatar that I could do little independent research, and Internet searches in 2004 produced scarce information, and much of it outdated.

My prior experience in the Muslim world was confined to reading the Qur'an, articles in the newspaper, a few books like *The Arabian Nights, King of the Wind* and *The Black Stallion*; and a few weeks traveling in North Africa. My exposure to Gulf people was further limited to chance encounters at Harrods in London and conversations with a few urbane Saudis. My knowledge of the security situation was colored by recent unrest in neighboring Saudi Arabia, so I was anxious about what that would mean for us, particularly for our pre-teen daughter, Elly.

Becoming an ambassador was Chase's dream; I was happy with our life in Houston and committed to my work at an inner-city church there. My main concern was that I would be stuck hosting dreary receptions. If lucky, I might find a place to rub noses with a few horses.

Little did I know that my passion for horses would open the door into a world of magical experiences and abiding friendships; that the depiction of the oppressed Arab woman and the chauvinistic man would turn out to be far wide of the

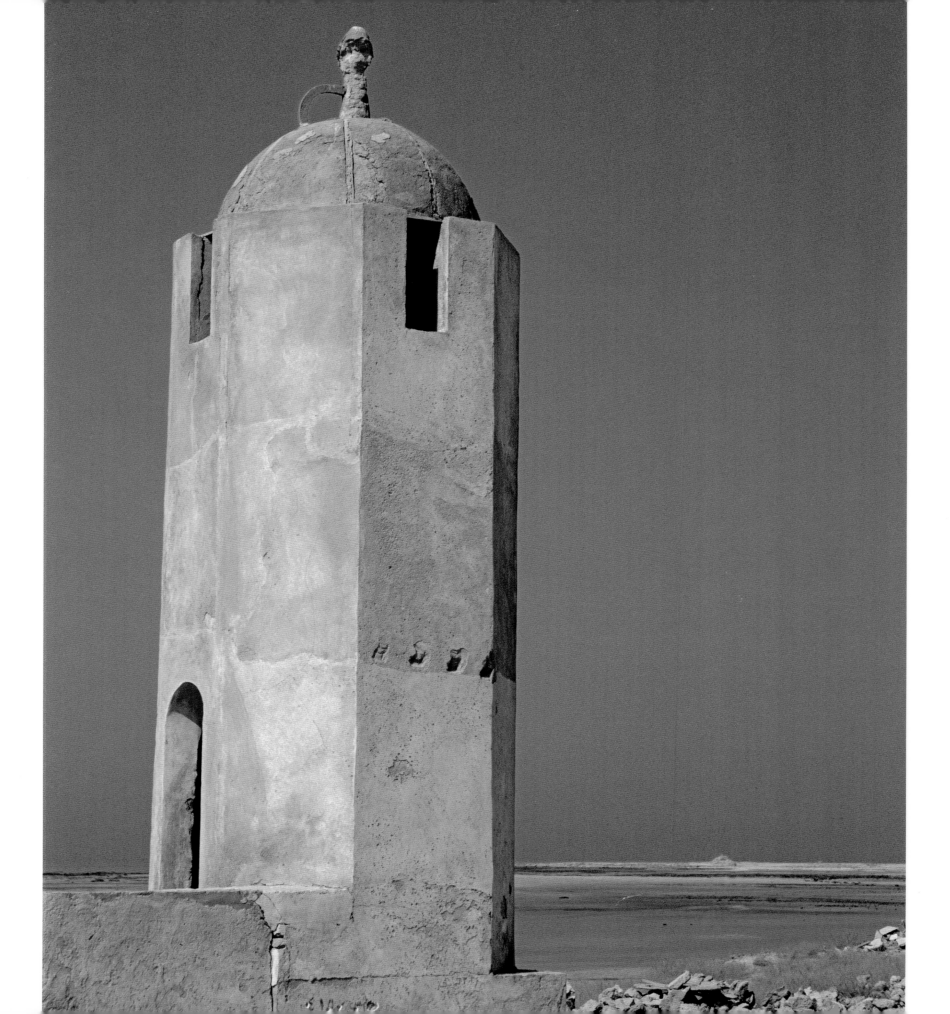

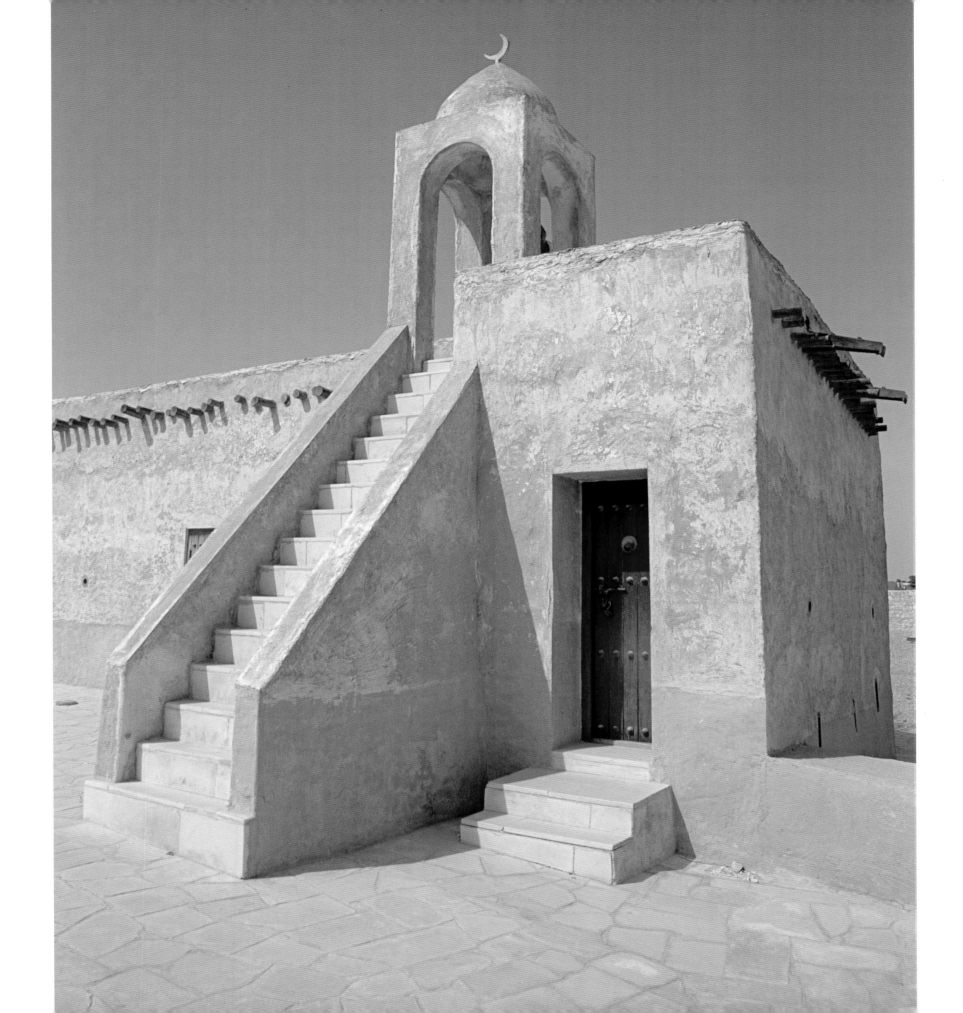

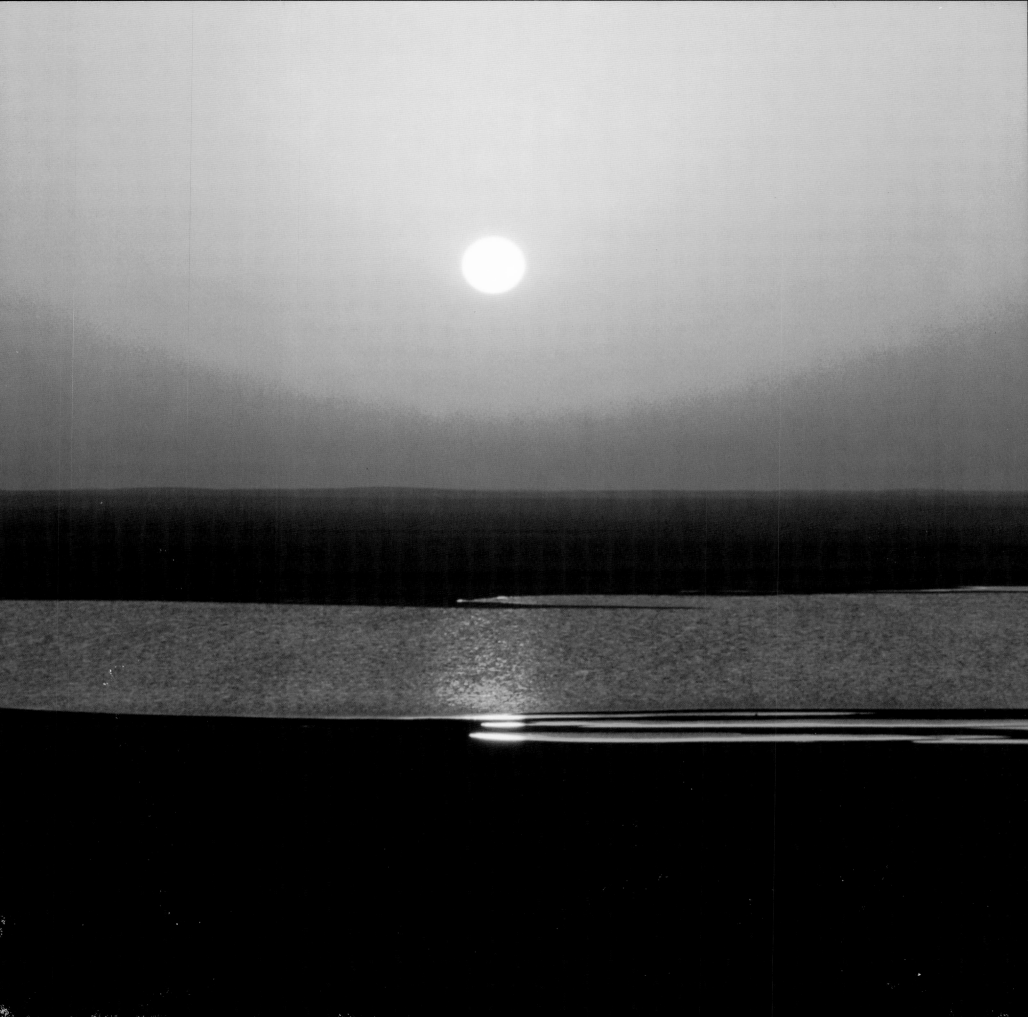

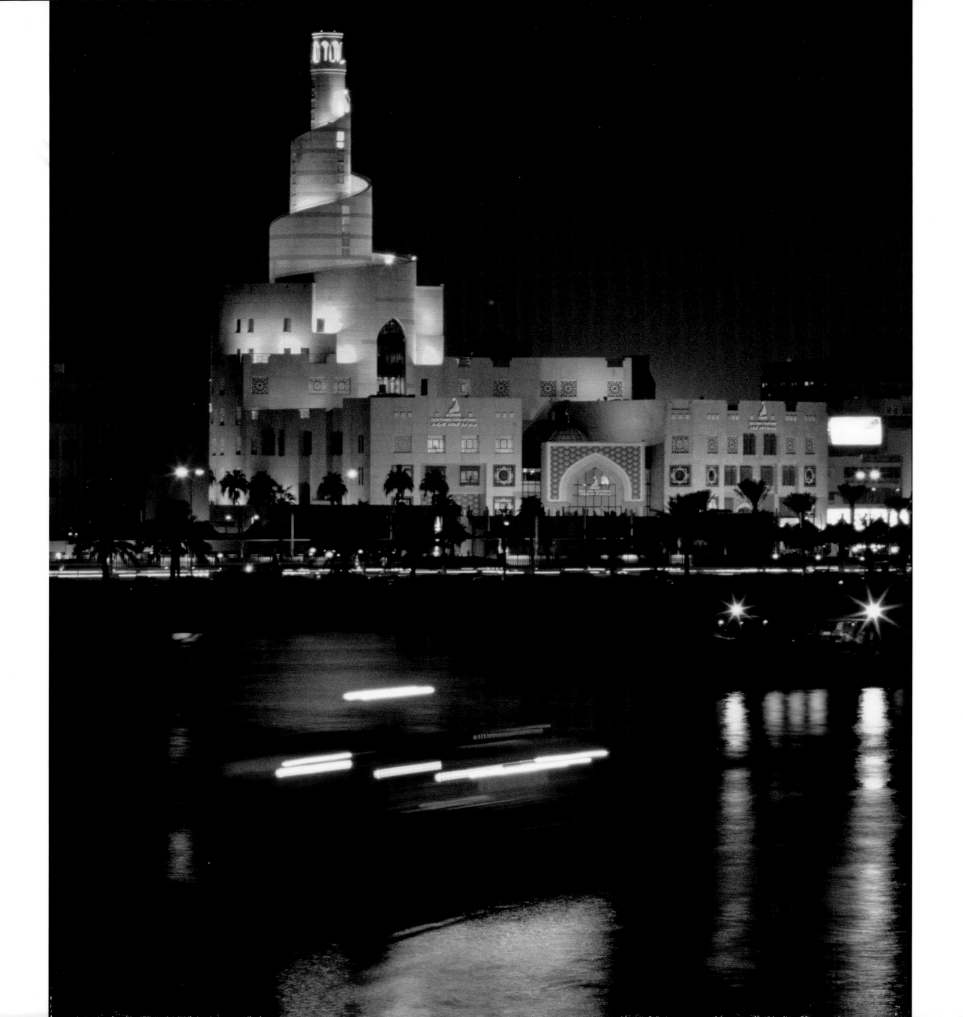

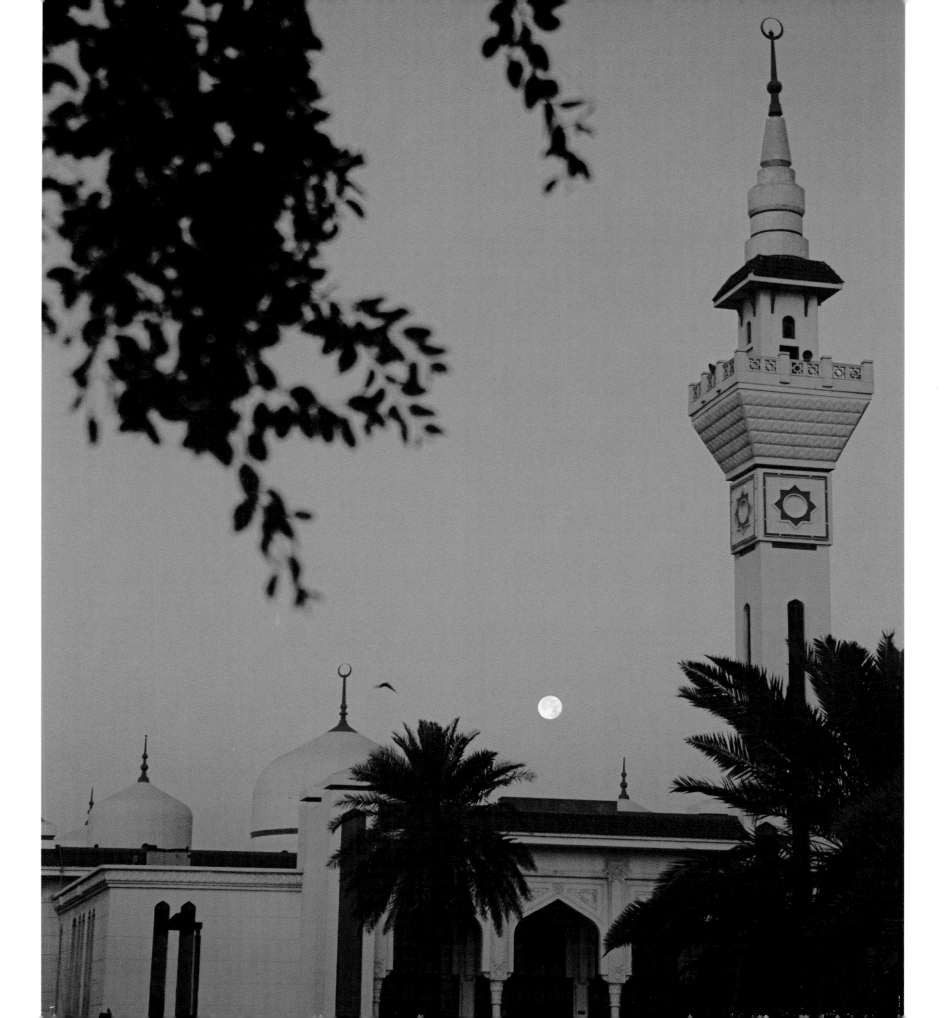

Ramadan, there is both newness and continuity. Qatar slows down to remember those less fortunate and to contemplate God's hand in all things. Women don *galabiya* (embroidered gowns) for evening gatherings that break the fast. School schedules and professional lives may encroach on this sacred month, but families and friends continue to spend considerable time together during the holidays.

While family remains the primary social unit, there has been a profound shift from the close-knit extended family living in proximity, often in the same house or compound, to nuclear families living in single-family dwellings. Affluence, government-subsidized land, and twenty-five-year interest-free construction loans have contributed to urban sprawl and a loss of the traditional *fereej* or neighborhoods. In response, individual families and tribes try to develop land together. Public projects like Musheireb, formerly known as the Heart of Doha, are building mixed-use developments meant to recreate the cohesive village feel in the midst of one of Doha's busiest commercial areas.

As Qataris balance warp-speed modernization with the preservation of a vibrant national character, "heritage" describes not only the relics of the past but the living promise of the present and future as well. The brick and mortar of Qatar's plans are its people, so empowering them with education is the top priority. This is not a new concept in the Muslim world. In the *hadith*—the traditions and sayings of the Prophet Mohammed—it is recorded that all Muslims must "Seek knowledge even unto China." As this injunction was given in the seventh century when even the journey across Arabia to make the obligatory *haj* pilgrimage to Mecca was infeasible for most, this *hadith* can be interpreted as a command to seek learning no matter what obstacles stand in the way. The rush of neatly uniformed children to school every morning and the proud lines of university graduates each spring are living proof that Qatar continues this long tradition of Arab scholarship.

Qatar's vast financial resources and collective will to succeed guarantee fascinating decades ahead. To say "the sky is the limit" would be trite if not true. Bidding for the FIFA World Cup 2022 seemed like reaching for the stars, but winning has engaged the country in a stratospheric storm of preparations. Meanwhile, two of Qatar's most recognized international brands literally take to the skies. Al Jazeera Satellite Network, founded in 1996, beams its programs to over forty million viewers across 137 countries, while Qatar Airways flies to every continent except Antarctica with five-star service and the newest fleet in the industry. Qatar Airways is pioneering commercial flights using GTL instead of kerosene on flights originating in Doha, which greatly reduces particulates and greenhouse gases and utilizes an inexpensive domestic fuel source. This innovative thinking is typical Qatari farsightedness.

Qatar plans to maximize its natural resources into long-term prosperity and to take an active role in world affairs. Doha's culture of scintillating arts and stimulating intellectual pursuits may emulate the Abbasid Empire's famed House of Wisdom, *Bait al Hikma*. But this land founded by resilient Bedouin and intrepid mariners will maintain its desert mystery, vibrant energy and strength of character. As Qatar moves rapidly into tomorrow, a chorus of *muezzin* calling the faithful to prayer resounds over the golden sands of sunset and the dark seas of dawn, connecting one day to the next.

Al humdulillah, thanks be to God.

(*opposite, above and following*) Robot jockey; mosques abound from cities to abandoned villages; Khor Al Adaid sunrise; desert sunset with grass after a rainy winter

207

As Qatar moves rapidly into tomorrow, a chorus of *muezzin* calling the faithful to prayer resounds over the golden sands of sunset and the dark seas of dawn, connecting one day to the next.

The revival of these traditional, Qatari-ridden races began as a resolution to a human rights issue. Young boys from Sudan, whose winnings could support an entire village, were brought to Qatar to ride as camel jockeys. When this practice was abolished in 2005, robot jockeys were developed to keep weights low in high-stakes races. The robot, made from a basic car battery, is strapped onto the camel. A transmitter, set to receive voice commands, is also attached to the saddle, so the trainer who follows along the rail of the race track in an SUV can shout encouragement to his camel. The robot has a mechanical whip attached to an arm that spins around rapidly.

It is as exciting to watch the careening cars as the camels, though remarkably, they rarely collide.

As in most cultures, grand wedding celebrations are the exception to everyday low-key socializing. Qataris expect to sit with their friends regularly if not daily. "To sit" encompasses a wide range of social interaction but fundamentally means to take the time to get to know someone and to share in his or her life. Common interests, of course, create communities of like-minded people. Many ancestral life skills like falconry, camel and horse riding, fishing, saluki hunting and boating provide sport and recreation for contemporary Qataris. But these activities are not merely folkloric: Falcons and camels or dhow and fishing line are as common to everyday life as a bicycle or golf clubs are in America. These age-old practices provide continuity and keep "Arabness" alive, giving stability amidst the swirling atmosphere of change, which is equally part of the Qatari experience.

It is common to see contemporary expressions of traditional life. During the fall and winter hunting season, a Land Cruiser might hurtle down the highway with a falcon perched on the console between the front seats. Women's hands are adorned with intricate patterns of henna to celebrate a wedding or just for fun. On pleasant days or cool nights, families seek out a patch of grass along the Corniche or one of the new parks. There they set out a meal complete with thermoses of tea and *qahwa*, or even gas stoves to make it on the spot. A cardiologist might arrive from the hospital and tie up his thobe to mount a camel to race in a two-man heat.

These races bring alive the days when sheikhs and rival tribes used to pit their best riders and camels against each other. Today they are supported by the Emir and the Heir Apparent and other businesses and tribesmen who provide lavish prizes. The winner of the biggest race, a Gulf-wide tournament, receives a solid gold sword and a handsome cash purse. These races encourage Qataris to be participants as well as spectators and offer new generations a pathway to their past.

In mere decades, Qatar has climbed from poverty, widespread illiteracy, and obscurity to become a wealthy nation that commands international attention for its bold diplomatic, industrial, philanthropic, intellectual and cultural initiatives. Yet, like *al hilal*, the barest sliver of crescent moon that announces the beginning of

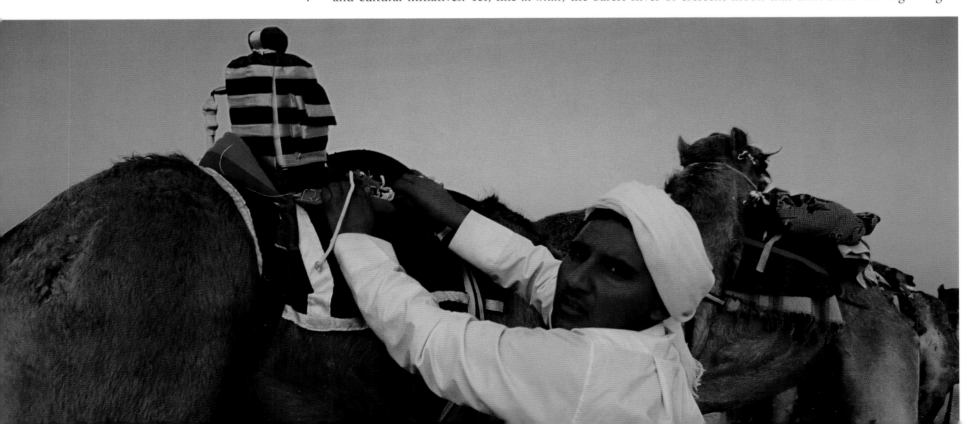

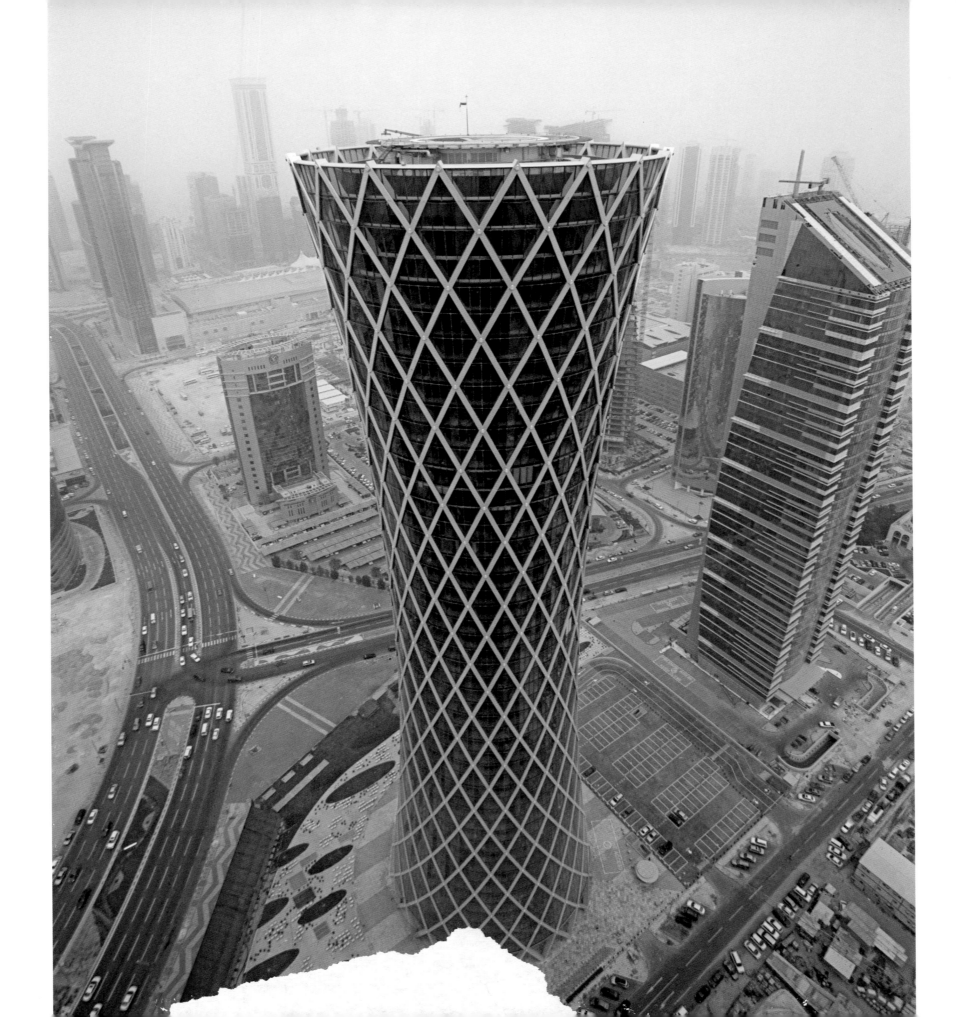

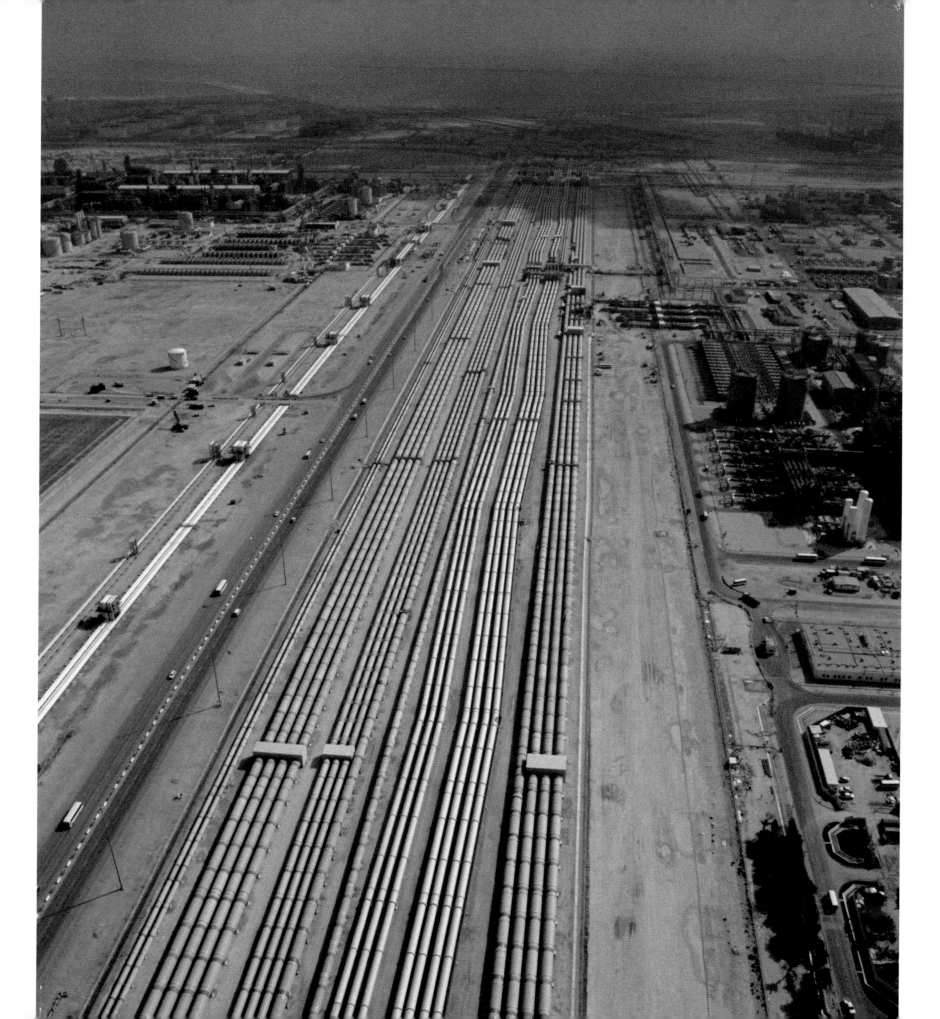

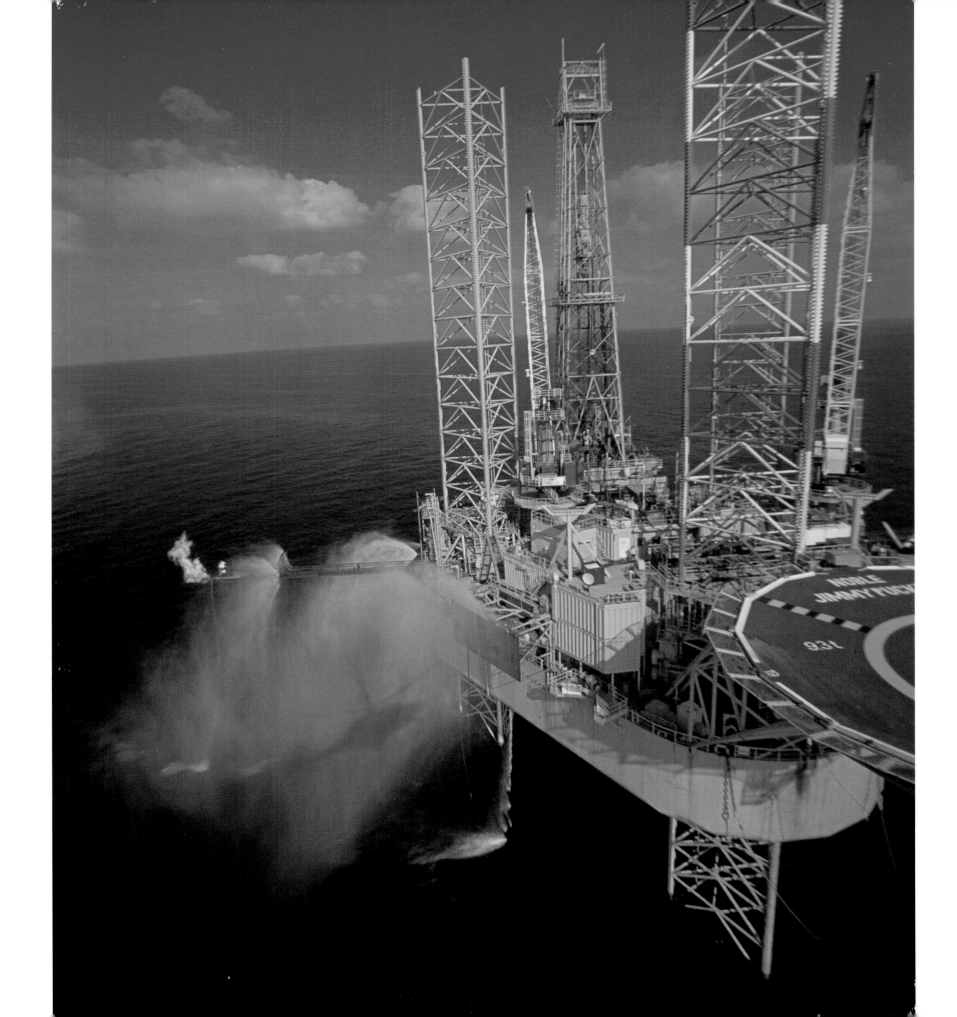

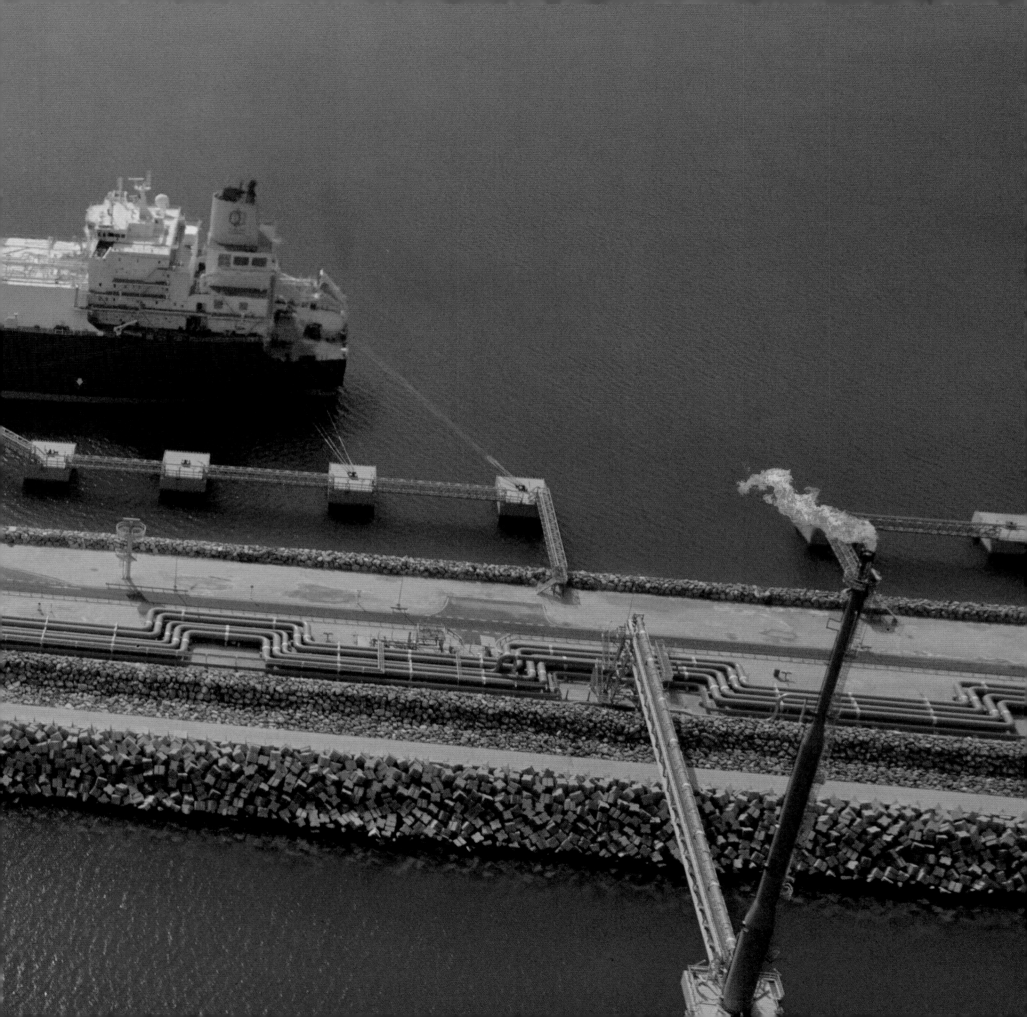

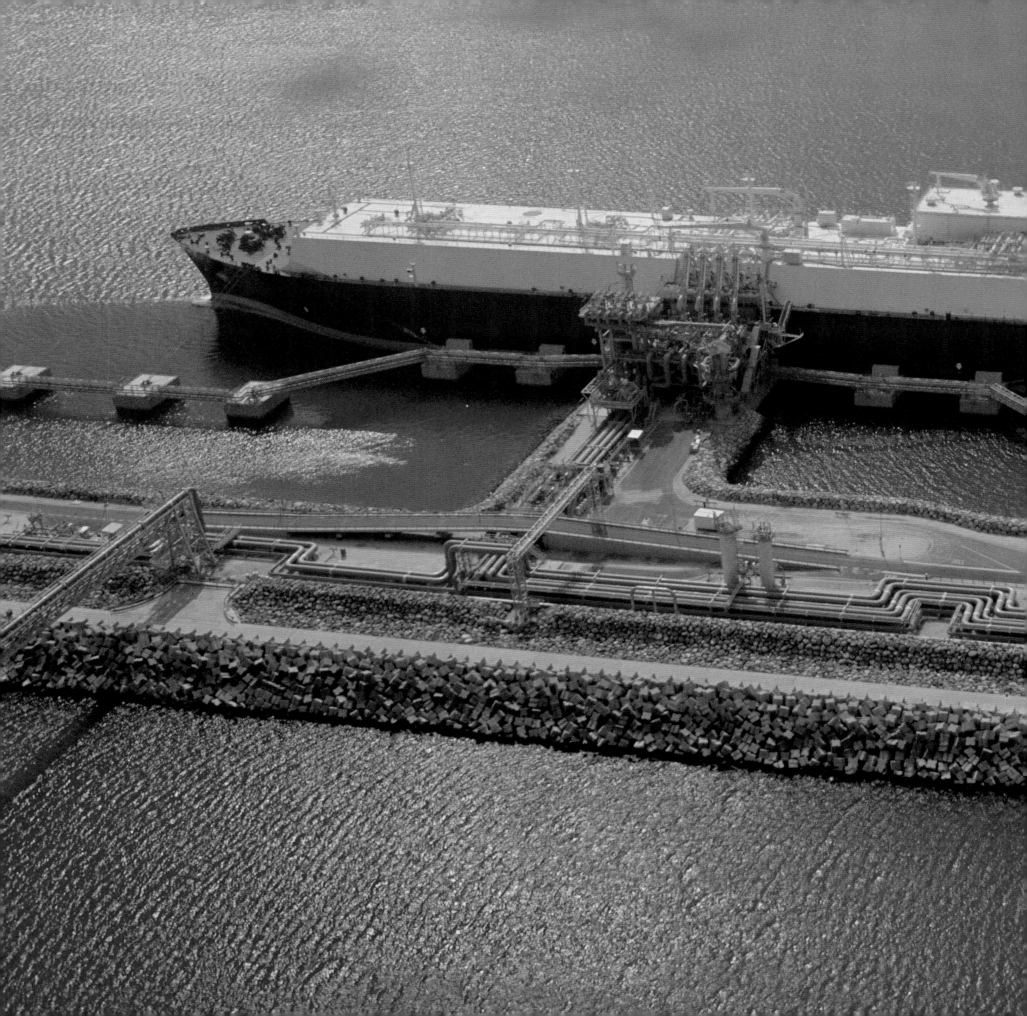

gathered to pay the musicians. At the tables, incense is passed in between rounds of juices, Arabic coffee, tea, chocolates, and hors d'oeuvres served by legions of costumed waitresses. Pre-dinner delicacies quell the appetite, because the four- to five-course dinner is presented in an unhurried way, sometimes after the bride arrives, which can be as late as midnight.

Female film crews are ubiquitous at Qatari weddings. The bride's arrival is signaled by a burst of activity by the camera women and a theme song, ranging from western classical music to traditional Arabic music to an occasional instrumental pop tune like the theme song from "Rocky." The bride enters unescorted or with her sisters as attendants; after the father signs the marriage contract, he has no real role. The bride's beauty is highlighted by black-lined eyes and a stunning dress. Some brides make two entrances, first in a gown of gold-embroidered silk, often green, the traditional wedding color. Sparkling 22-karat gold headdresses, bracelets, rings and collars of gold extending to the waist adorn the bride in the custom of bygone years. In the case of intimate house weddings, brides occasionally wear only this traditional attire. Otherwise, she makes a second appearance in a white western-style gown, detailed with lace and elaborate beading and yards and yards of train. Tiaras and clouds of veiling add to the romance.

Mothers, sisters and cousins serve as the bride's retinue as she processes down the stage to complete the stage-set tableau. Family and friends greet her and sit for photographs until the groom arrives. A shift in the music, often an echoing poetic chant extolling the virtues of the bride and groom, signals his imminent arrival. There is a flurry of activity as women cover themselves before the arrival of the symbolic conqueror. The groom comes with his close male relatives, who often heft swords and perform the sword dance, *ardah*. The groom's white thobe is covered with a black, gold-edged *bisht,* a fine wool ceremonial cloak. He kisses his bride on the forehead—a traditional mark of respect—and sits for photos before he leaves, either alone or escorting his bride.

Weddings are acquiring more variations as families put their own stamp on the party. Some brides and grooms enter together and sit for dinner. A few fathers, including the Emir, make appearances at the parties as well. Another difference is the extent to which female guests and the bride's female kin cover themselves when the groom's entourage arrives. At one recent wedding, the bride's sisters and mother put light shawls around their shoulders but did not cover their hair at all. In so many ways, the homogeneity of Qatar's past is giving way to a more diverse society.

The groom celebrates with his friends, either on the same night or the night before the bride does. The setting can be at home if the family has a big enough *majlis*, in a ballroom, or on an undeveloped lot. If the celebration is outside, oriental carpets swath the desert floor and open-faced tenting contains gilt-edged armchairs or low Bedouin-patterned sofas. *Qahwa*, the aromatic Arabic coffee, is brewed on a low brazier. Drums, perched near the fire to warm the skins for a deeper sound, are picked up to beat the rhythm for *ardah*. Arms stretch skyward with flashing swords, and men's rich voices resound to the beat of the drums. Many weddings employ a professional dance troupe, which family and guests join, wielding a scabbard if no extra swords are available. The men's celebrations end with magnificent feasts; however, the majority of guests come just to congratulate the groom and greet the senior members of his family, staying for only half an hour or so.

In addition to multi-billion-dollar construction and petroleum projects and the activities of the universities and research centers, an average day in Qatar includes an eclectic and exhilarating array of events.

197

(following) Specialized tankers carry LNG extracted from sub-sea reserves using offshore platforms; natural gas is processed at the massive Ras Laffan Industrial City; fifty-seven floors up, workers complete a Doha skyscaper; the Tornado tower in a sandstorm and soaring into the usual clear blue Qatari sky

Safely inside the ladies-only environment—a hotel ballroom, family garden or wedding hall—wraps are shed, revealing gowns that range from European haute couture to fanciful local designs; long, gleaming black hair in soft curls or elaborate coiffures; artistic makeup; décolletage; and noteworthy jewelry. Some of the older women, their faces hidden by gold-colored linen *batoola*, keep their *abaya* on. Women of this generation often reach only to the bride's shoulder, a clear sign that modern nutrition has increased average heights dramatically. A living reminder of the country's transformation, all too soon this generation and the link they provide to the past will be gone.

Weddings range from under 100 guests to well over 1,000. A few families still conduct solemn ceremonies at home with Qur'anic recitation and no music, but most women celebrate elaborately. Decorations can include silk table linens, whimsical flower arrangements and a fashion show-like runway down the center of the room that doubles as a dance floor ending in a tableau set for a princess. The ladies dance to the sounds of famous Arab vocalists, who, if male, perform behind curtains and have their image projected into the ladies area, and of a traditional cadre of women with drums, vocalists and other Middle Eastern instruments.

Women can be shy to dance in public, so it is not unusual for only family and close friends to dance to the beguiling Arabic rhythms. However, the trend seems to be for more and more women and girls to join in. Some mothers use weddings to observe prospective brides for their sons, which is a twist on the matches often made by couples at western weddings. On occasion, dancers are showered with crisp dollar and riyal bills, which are

(below)

The Emir inaugurates RasGas
Train 6 accompanied by RasGas
CEO Hamad Al Mohannadi,
Deputy Prime Minister and
then-Energy Minister
Abdullah Al Attiyah and
Finance Minister Yousef Kamal

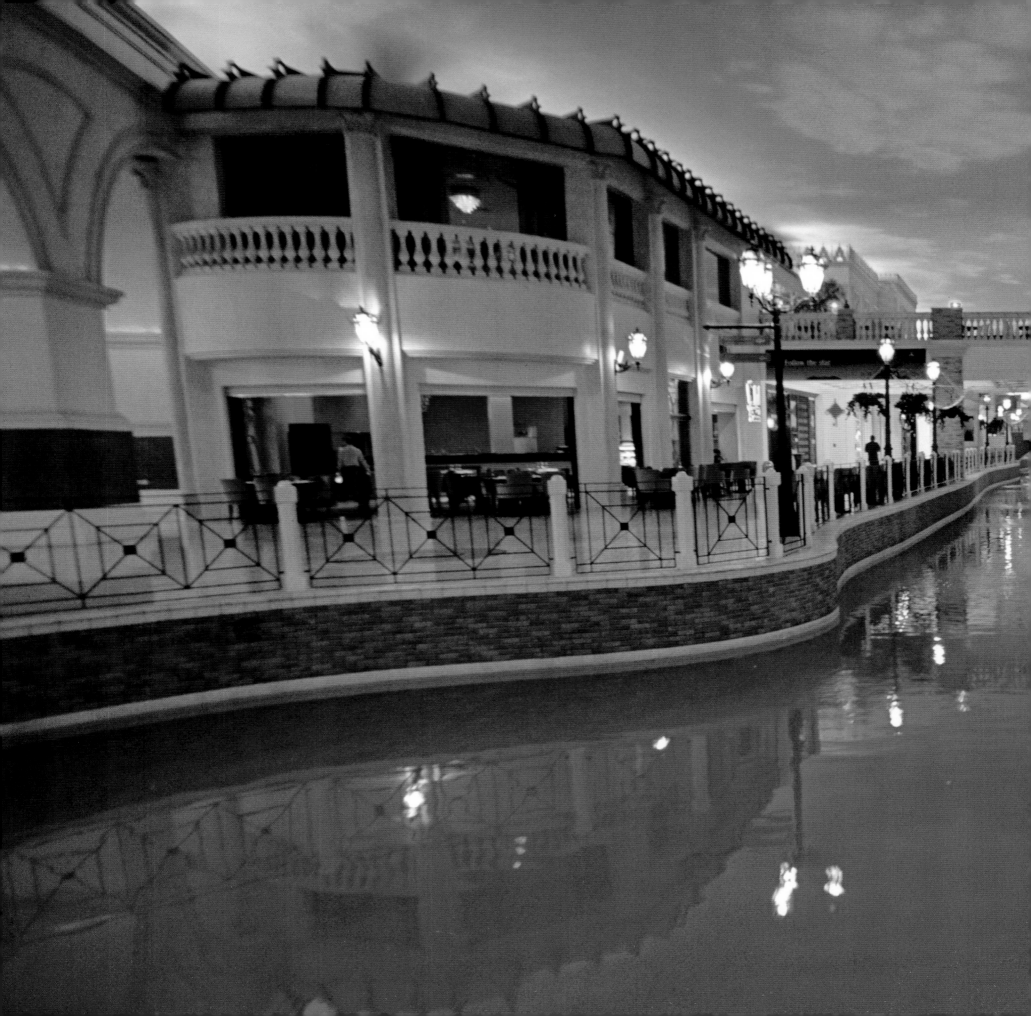

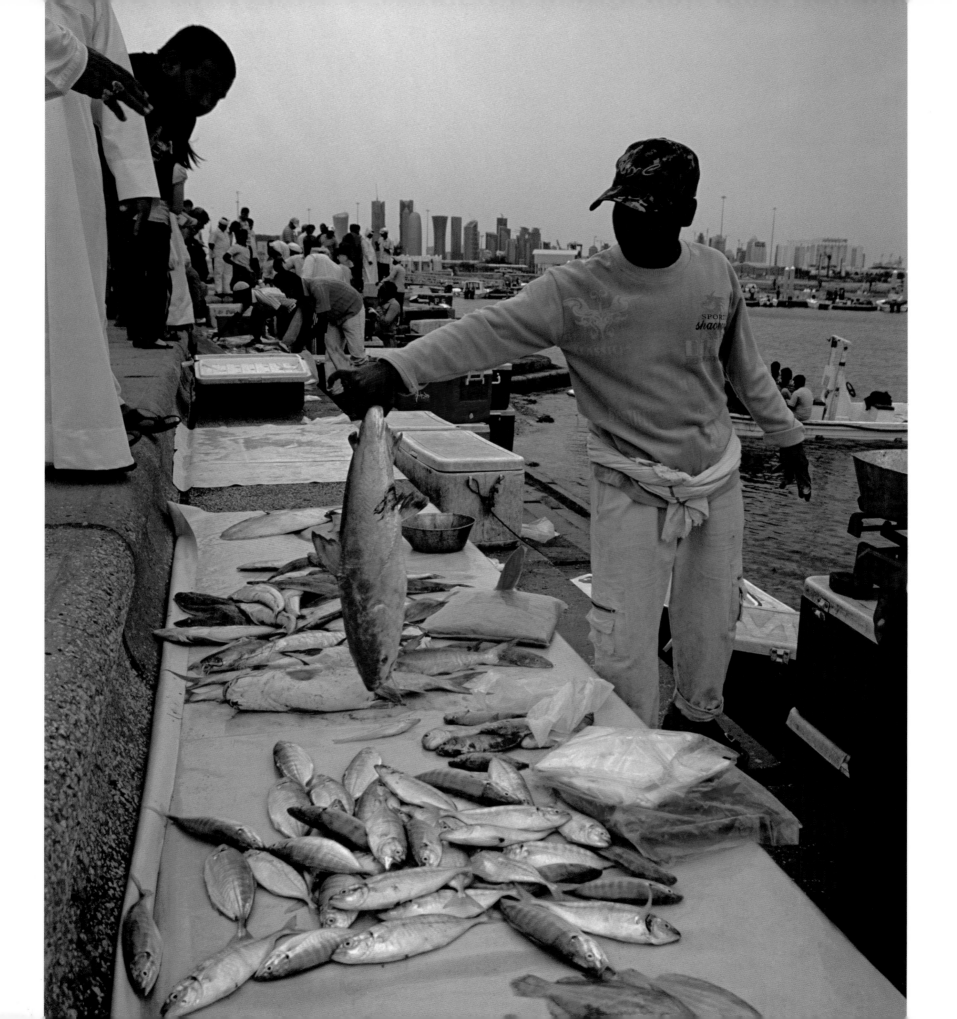

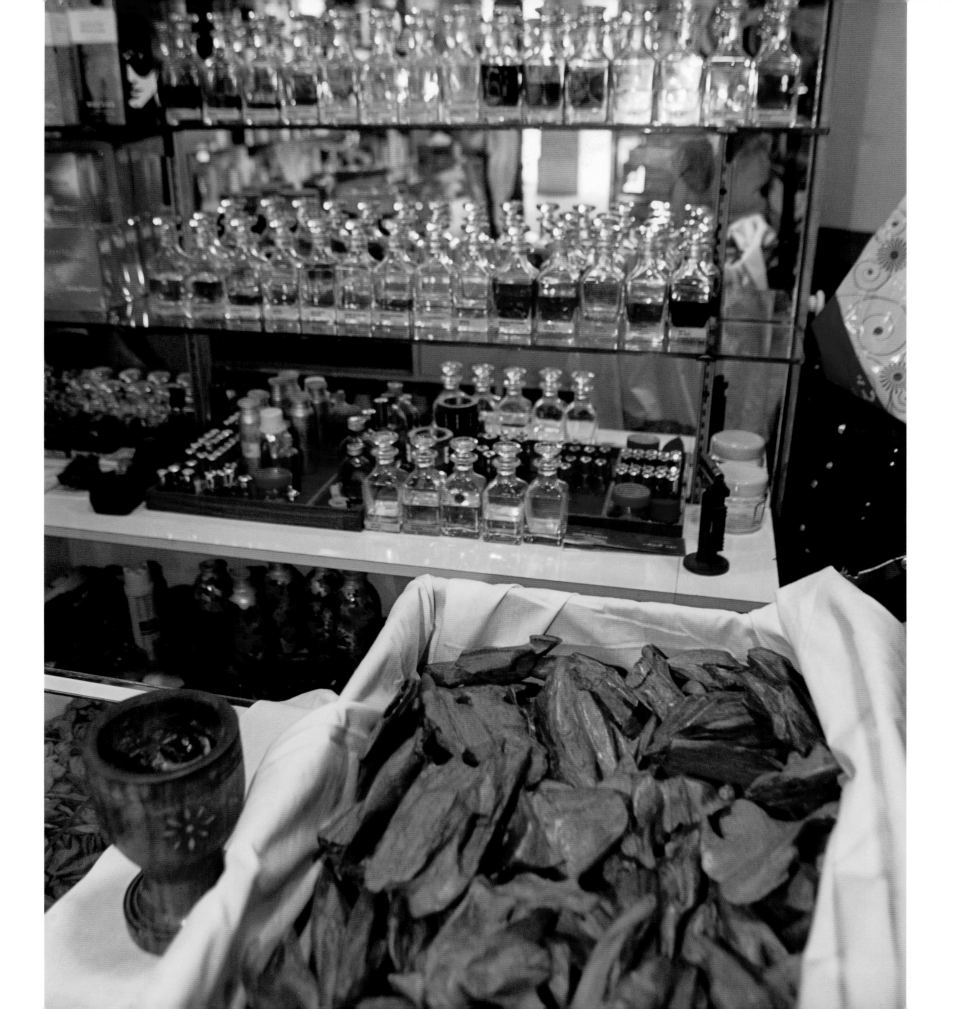

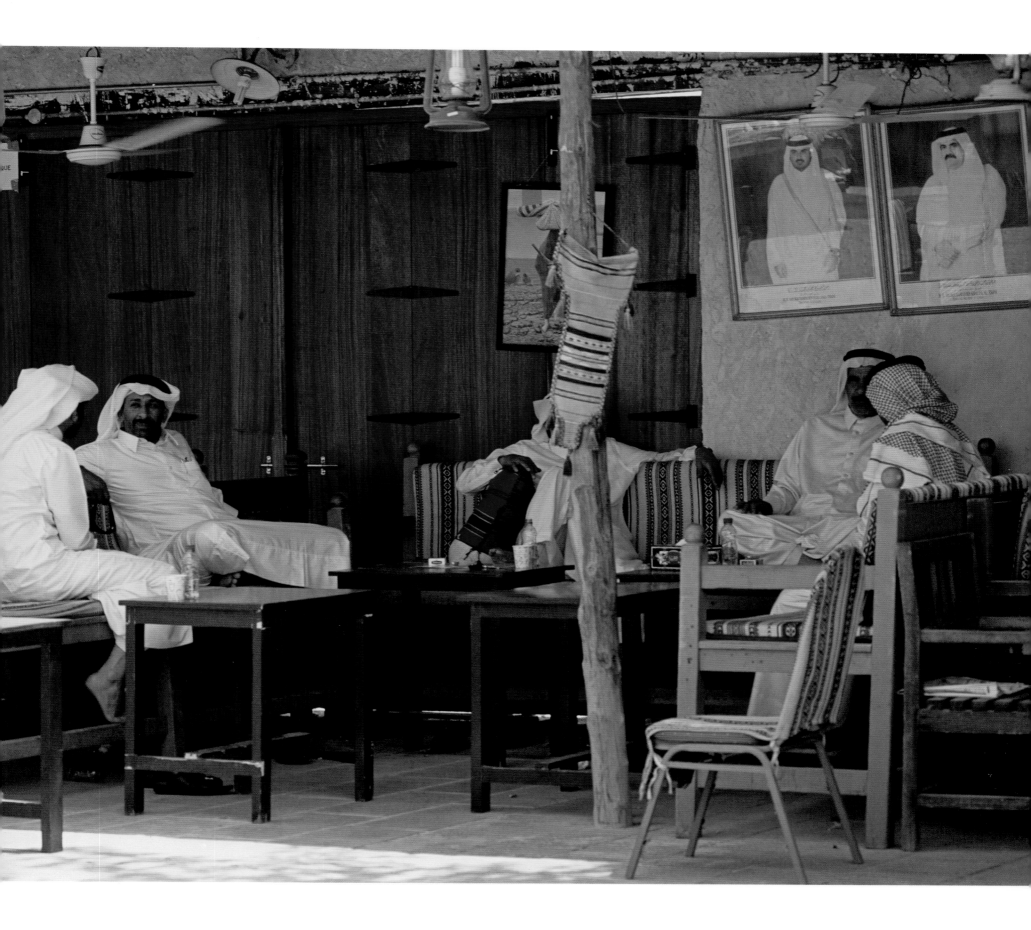

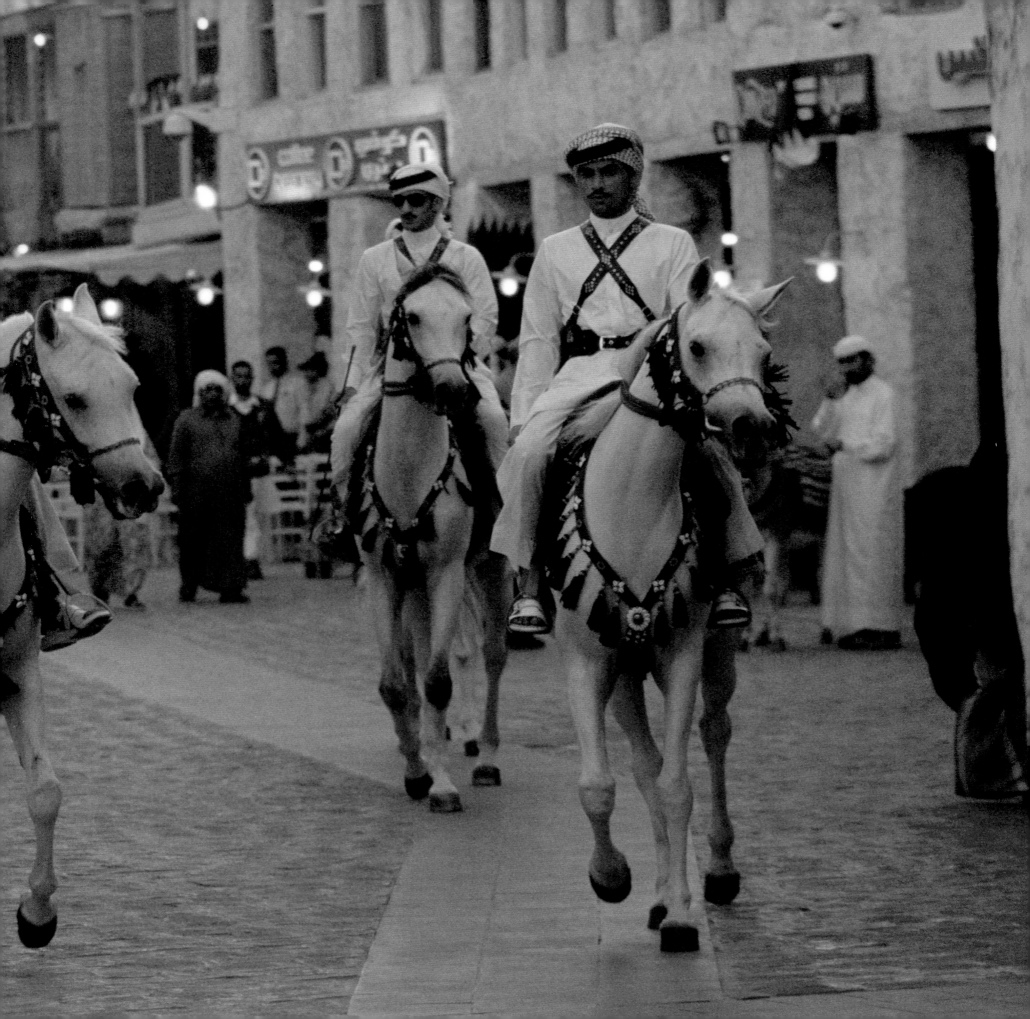

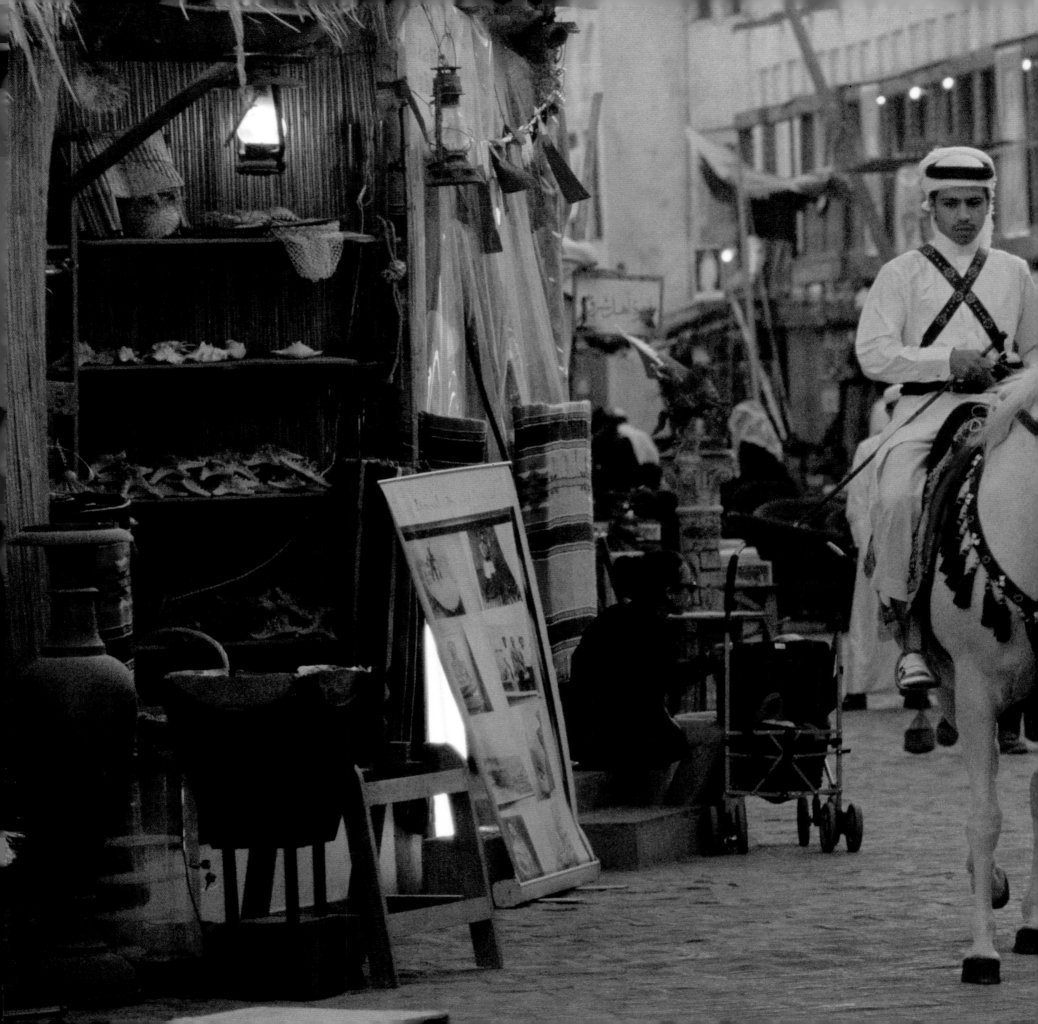

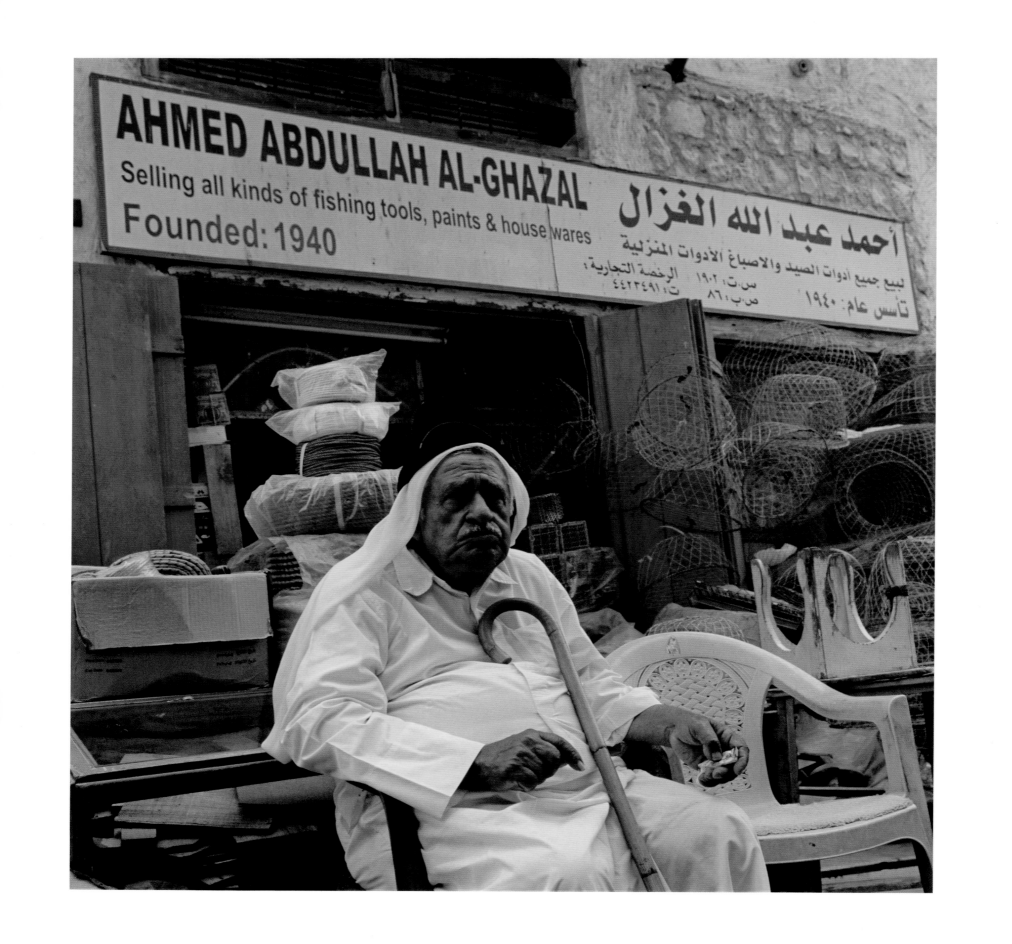

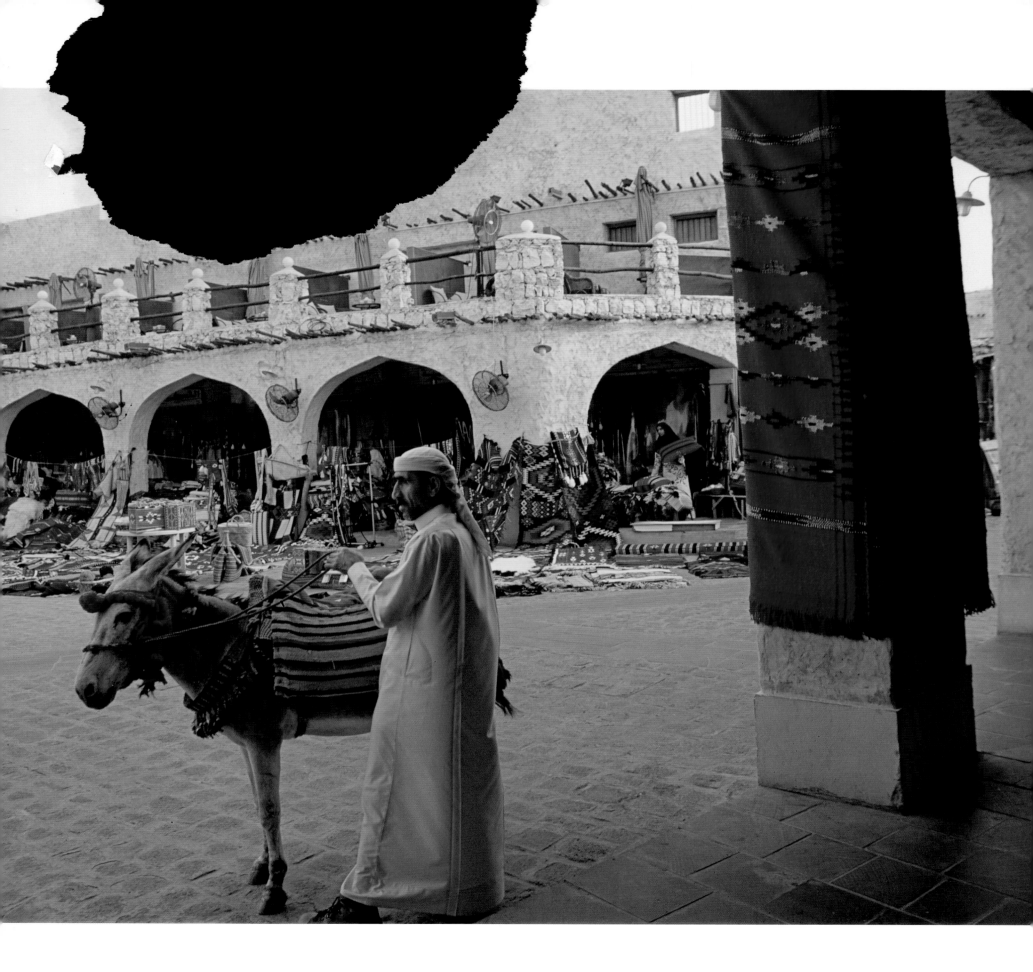

Business of Film Summit, the Doha Debates ("Do you have confidence in the current Palestinian leadership?"), and ongoing festivals for the Capital of Arab Culture celebration. Another few days brings the family-oriented Flower Every Spring environmental initiative, plus horse, camel, falcon and saluki races. Qatar's square mileage is small, but this intense level of high-profile activity is normal.

This fast tempo drives the rhythm of life as Qatar's predominantly young population comes of age. School or work fills daytime hours, while malls and luxurious cinemas are thronged in the evenings. Qatar's climate suits outdoor venues. Six to eight months of the year the weather is predictably rain-free and pleasant. Even during the stifling white-hot days of summer, dusk brings relief. In the evenings, sidewalk cafes in Souq Waqif, Katara (Cultural Village), and The Pearl attract Qataris and expatriates alike. On some nights, the classical notes of the Qatar Philharmonic Orchestra or the rhythms of the traditional sword dance and sea chants float over the Gulf from the stunning amphitheater at Katara. On other evenings, the jewel-like opera house and an up-to-the-minute theater make appealing destinations.

Sitting and sipping coffee in the *souq* is a time-honored tradition in any busy Arab port. What has changed in Doha is that the *souq* and other public places are now family-friendly rather than just the domain of men. In the past, women might shop in the *souq* but never lingered. Now the distinctive stone, mud, and mangrove pole buildings of the market provide a vibrant destination. The area had almost completely given way to cement and glass before the Emir began a comprehensive re-building of heritage sites, beginning with Souq Waqif. Mounted horse and camel patrols in the *souq* are picturesque, but they also allow Qataris to retain their skills with these noble animals.

Souq Waqif is a living museum that makes room for traditional shoemakers, artisans, a falcon market and houseware shops alongside fine art galleries and excellent restaurants, many with rooftop terraces. Venturing into the *souq* on a Friday night, a visitor might get the impression that the entire Qatari population is there, buying colorful parakeets for their children, strolling the stone paths, or puffing on the all-too-common *shisha*—a water pipe filled with sweet tobacco that has become a health scourge.

Although the *souq* is bustling, most Qataris still entertain at home in the age-old, leisurely way. To call it entertaining is almost misleading, because except for special occasions no invitations are issued. Hospitality is a way of life. In countless households across the country, the door to the men's *majlis* is wide open, and visitors can count on being welcomed to a meal if they arrive at dinner time. Women, who are often busy with the children and want to entertain on a more elaborate scale, are more likely to invite guests for a special afternoon coffee or dinner, although casual gatherings of sisters, children and close friends occur frequently.

Weddings are the largest parties most Qataris ever give, and women take the opportunity to create fairytale settings. Generally, invitations arrive in beautifully scripted Arabic, occasionally accompanied by an exquisitely wrapped present, such as perfume, a crystal vase, or chocolates. Ladies come in black evening *abaya*, sparkling with crystals or edged with gold or jewel-toned embroidery. Islam advises conservative dress in front of men and centuries of tradition make women value their privacy, so the risk of unauthorized photographs leaking out is taken seriously. Magnetometers screen for cameras and camera phones.

This fast tempo drives the rhythm of life as Qatar's predominantly young population comes of age.

173

The actual wedding occurs when a contract is signed between the two families, which can take place as much as a year before. So while what is described here is the celebration, it is nonetheless universally called the wedding. The rising cost of these parties is an increasing concern as the celebration, which is usually paid for by the groom's family, can put the couple in debt. In addition to the cost of the wedding, the groom pays a dowry, or al mahar, to his bride, which becomes her sole property. In the past this might have been sheep and camels as well as household items; now it is a large amount of money and sometimes jewelry, cars and other luxury items as well. Some contracts stipulate only a token payment like one coin. In such cases the groom still showers the bride with gifts.

Chapter Four: Sky

Dawn steals slowly over Doha Bay and lingers long before the sun is even a thought on the horizon. The black softens to dusky purples that paint the sea with fading night. Timeless moments exist before morning exercisers start to stride along the Corniche and the traffic builds for another busy day in Qatar.

Actually, "busy" does not begin to capture life in Doha these days. The synergies among the many projects underway at the Qatar Foundation universities, research hospitals, and the Qatar Science and Technology Park promise to bear fruit exponentially. Much of this work crosses over to the industrial sector as Qatar focuses not only on hydrocarbon-based energy but also on projects like solar power, green architecture and environmental conservation.

LNG and GTL are both natural gas products. LNG is gas frozen until it becomes a liquid, making it transportable by specialized tankers. At market entry points it is re-heated into gas. GTL, sometimes called white crude, comprises crude oil products like kerosene and can be transported by pipeline. LNG and GTL allow Qatar to compete in both the gas and the petroleum markets.

Qatar Petroleum's vast ventures like Ras Laffan Industrial City—with both **LNG** and **GTL** (gas to liquids) capacity—and the international partnerships it has created from Asia and Africa to Europe and the Americas make Qatar an active participant in global energy. Qatar utilizes its gas resources to bolster ties abroad and with other Gulf countries, notably the Dolphin Project which supplies natural gas to UAE and Oman by pipeline.

Construction never ceases. Landmark skyscrapers and massive road projects are the most visible manifestations of Qatar's growth, but whole communities like The Pearl—a series of artificial islands that are currently the only place where expatriates can own property outright—and Qatari Diar's Lusail City are springing up as well. Al Wakra, south of Doha; Mesaieed, near the site of the new port and oil refineries; Al Khor, close to Ras Laffan Industrial City; and Dukhan on the west coast near the Qatari oil fields are growing population centers necessitating considerable infrastructure projects as well as upgrading of hospitals, schools and other basic facilities. The New Doha International Airport (NDIA) combines green engineering with luxury and efficiency. Other proposed undertakings include a light rail system and a tunnel under Doha Bay from the airport to West Bay. World Cup 2022 puts a premium on expeditious completion.

In addition to multi-billion-dollar construction and petroleum projects and the activities of the universities and research centers, an average day in Qatar includes an eclectic and exhilarating array of events. The calendar for one ten-day period includes the announcement of the stunning Jean Nouvel design for the National Museum on a 1.5 million-square-foot site, the convening of 1,500 international delegates for CITES (Convention on International Trade in Endangered Species), the World Indoor Championships in Athletics, the World Congress of Muslim Philanthropists, the ongoing Darfur peace negotiations, the *Financial Times*

السَّمَاء

S K Y

IT IS HE WHO CREATED THE NIGHT AND THE DAY, AND
the sun and the moon: All swim along, each in its
rounded course.

— QUR'AN 21:33, SURAH AL ANBIYA

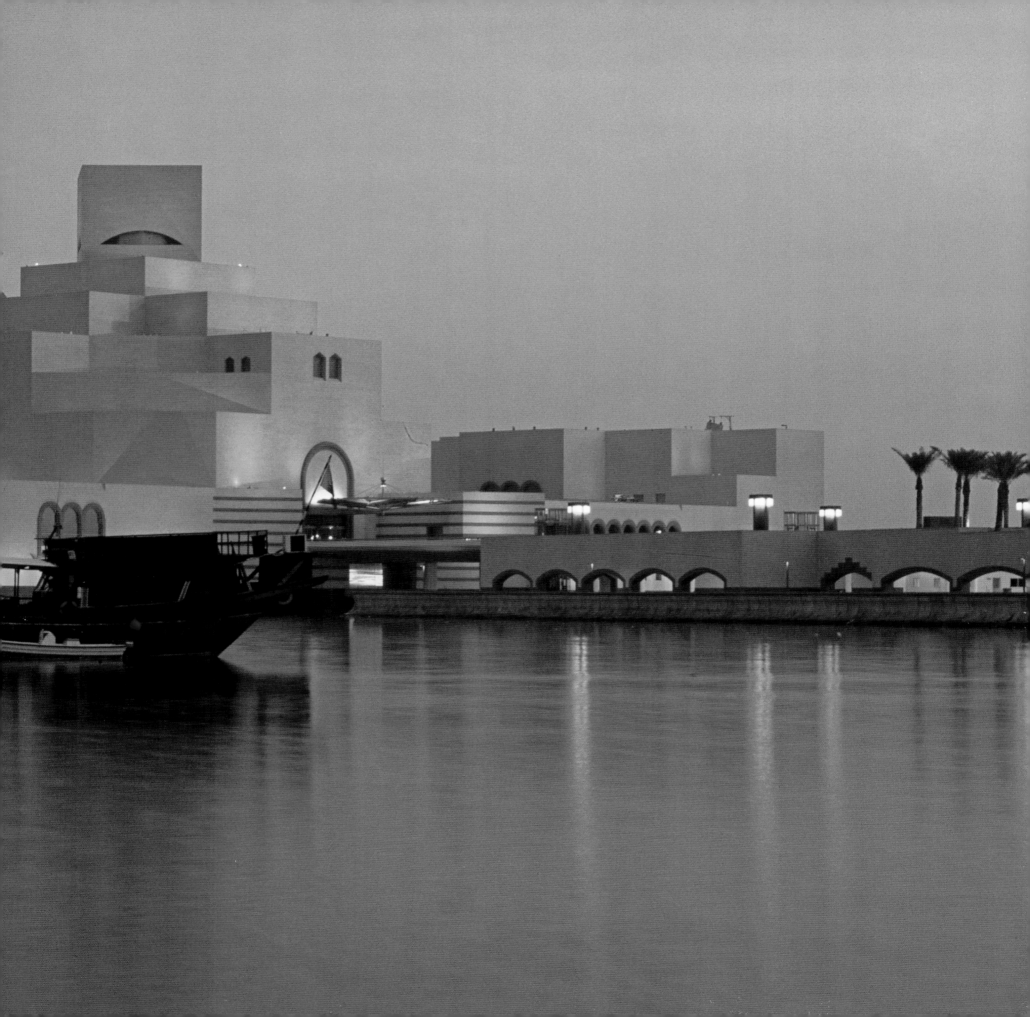

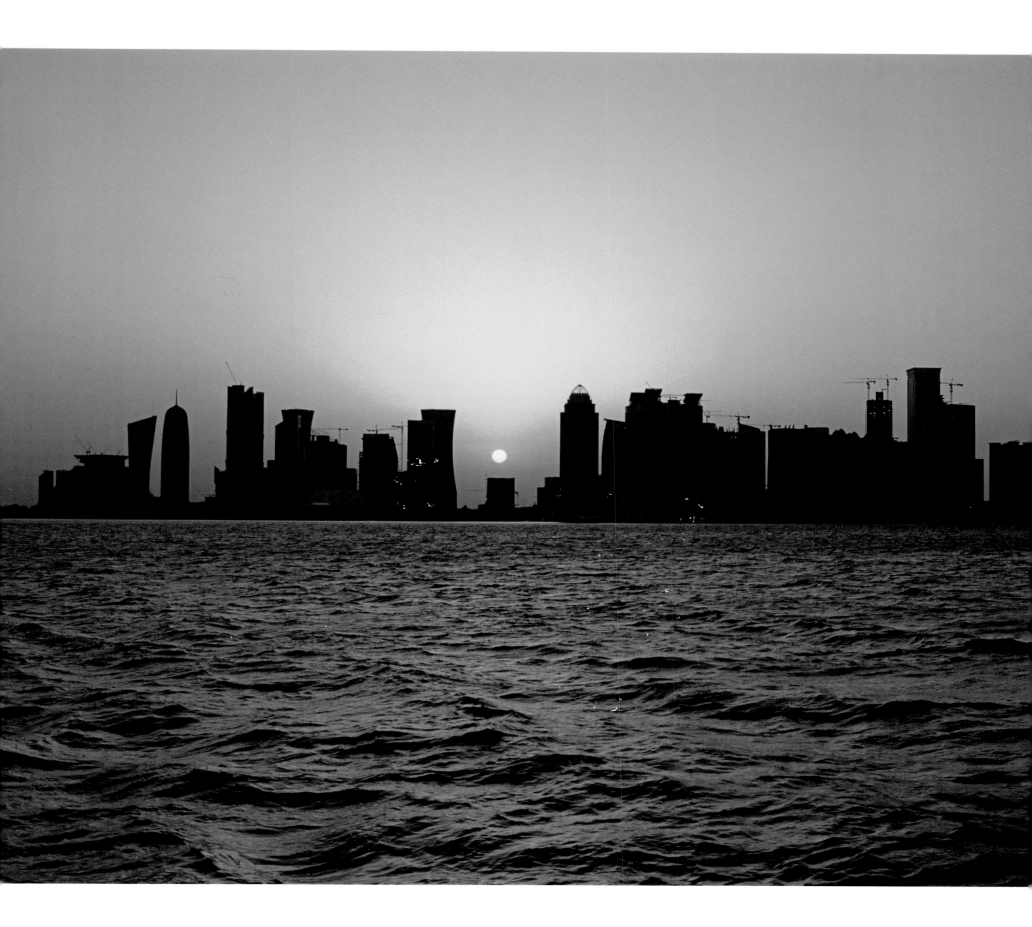

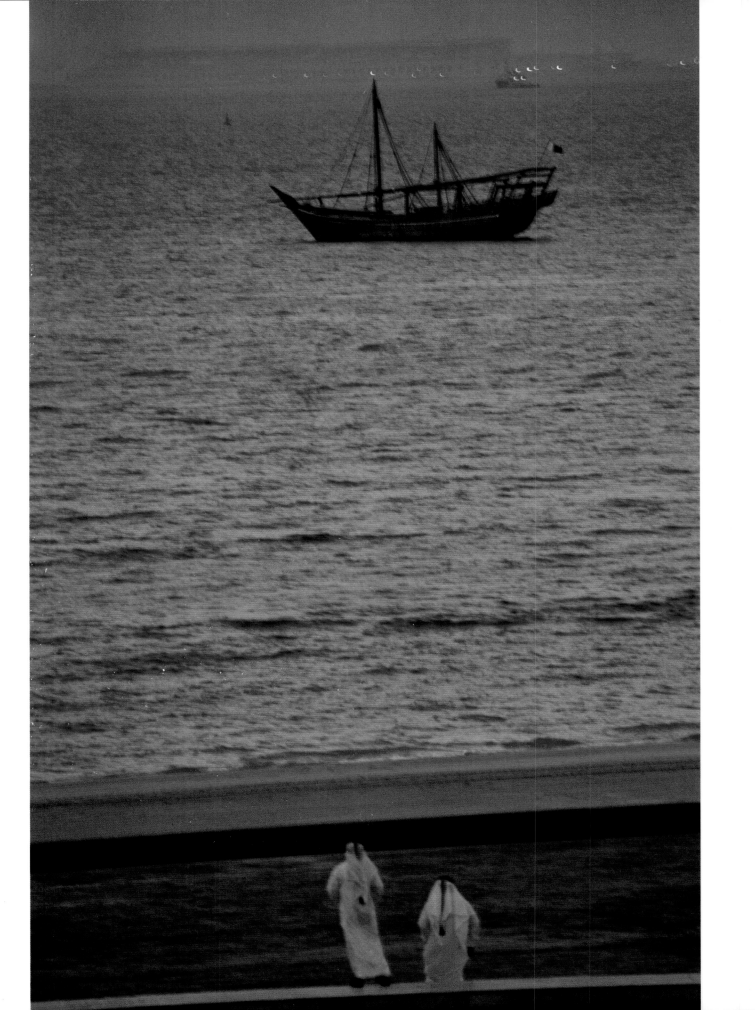

The Bedouin lifestyle fascinated Victorian and Edwardian travelers, who wrote lyrically of it, romanticizing it in much the same way as writers exalted the cowboy lifestyle in America. But the preeminence of the Arab seafarer, so vital to life in this non-agrarian society, is not as well known. Without commerce from across the sea, most notably in food and building materials, only a minuscule proportion of the population could be supported, then or now. The art of shipbuilding and sailing died out quickly in Qatar, first because of competition from European powers, second because of the downturn in the economy, and finally because of the development of oil. Its sudden demise left little record behind. Fortunately, as dhow set their distinctive lateen sails to participate in festivals like national day and the Marine Festival, more of the heritage of the sea emerges. The new National Museum on the Corniche designed by Jean Nouvel also promises to document the remarkable story of Qatar and the sea.

Qatar is a sand-colored country, so the Gulf's vibrant hues, ranging from turquoise to stormy deep greens, provide relief for sun-drenched eyes, one of the many gifts the sea bestows on the nation. But there are others: Rare birds and sea turtles nest on its beaches, and dolphins leap in ships' wakes and play with swimmers in Khor Al Adaid. There are elusive dugongs (sea cows), hidden reefs for divers, and wind for sailors and kiteboarders. Jet skis race across glassy waters that harbor abundant schools of fish. And beneath it all, the sandy floor provides the past of pearls and the future of oil and gas.

(below and following)
Al Wakra office workers' picnic; the northwest coast; the New Doha International Airport across the bay from Katara; the model of Qatari Diar's Lusail City rising on the seashore north of Doha; skyrise sunset from the sea; kiteboard lessons in Al Wakra

Qatar is a sand-colored country, so the Gulf's vibrant hues, ranging from turquoise to stormy deep greens, provide relief for sun-drenched eyes, one of the many gifts the sea bestows on the nation.

A new commercial port to be built to the south of Doha will relieve this backlog and leave Doha harbor to the more picturesque historical craft and sleek yachts. Qatar is also making broad efforts to produce more food through high-tech growing methods.

Desperate villagers sold the wood from half of their houses, leaving a bit of shade but living exposed to heat, humidity and dust storms.

Not until oil exploration resumed in 1946 were Qataris able to return home. Men worked as low-paid laborers or as drivers if they had been lucky enough to pick up that skill in Bahrain or Saudi Arabia. Even though the wages were paltry, they were better than those at sea, because sea wages were based on the price fetched by pearls, which was now below the cost to harvest them. These repatriated workers began to pay off debts to their *nakhoda*, who in turn found it more profitable to stay on shore and collect these payments than to hunt for the natural pearls that were no longer prized.

The first oil tanker left the port of Umm Said in December 1949. That same year Sheikh Abdullah bin Qassim Al Thani granted offshore exploration rights to Superior Oil in a direct challenge to the 1920 treaty with Great Britain. Reports that Standard Oil of California had given Saudi Arabia much better terms than those Qatar received from the Anglo-Persian Oil Company awakened Sheikh Abdullah to the gold mine that the petroleum resources represented. Official independence from the status of British protectorate did not come until 1971, but Sheikh Abdullah's bold act announced that Qatar was going to look after its own interests.

Thus began a half century of unprecedented change. With the discovery of oil, the tattered remnants of the pearling industry died. For the first time, Qatar's *hadher* became truly settled as their graceful wooden boats disintegrated on the beaches under the scorching sun. Schools, a hospital and an airport jostled for attention with projects to bring electricity and water to Qatari households. Doha's ragged coastline—dotted by clumps of mangroves and inlets where boats moored and children played in the wide shallows—was systematically reclaimed, forming the clean lines of the modern Corniche, the waterside road and promenade that arcs around Doha Bay.

Originally, the sea lapped at the doors of old houses and Souq Waqif, which means "standing market," because traders left their small shops to walk out to the boats which moved inland as the tide came in. Small craft were beached in front of the fishermen's neighborhoods. Large dhow used kedge anchors to haul themselves ashore on an incoming tide, where they were propped up for cleaning and repairs and shaded by a simple palm frond shelter. A *nakhoda* might look from his doorway directly to his dhow.

Because of the reclamation of land, what was once seafront is now a few hundred feet inland. Yet no amount of modernization can ever break Qatar's tie to the sea. Every day, scores of wooden dhow fitted with diesel engines set forth from Doha, Al Wakra and Al Ruwais to fish. Every day at dawn, fresh catch is put on sale on the steps of the Corniche in the shadow of the postmodern Museum of Islamic Art designed by I.M. Pei. Private citizens are restoring some of the larger dhow as recreation craft, while the Emiri dhow workshop has brought sail power back to Doha harbor with exquisite restorations and reproductions. Various examples of historic Arabian boats are on display at the Sheikh Faisal bin Qassim Al Thani Museum near Al Sheehaniyah. In contrast to the humble wooden dhow, Qatar's **maritime present** features the largest liquefied natural gas (LNG) tankers in the world. Long lines of container ships often wait to unload their cargoes at the harbor, because just as in the days of the dhow trade, Qatar still imports most of what it consumes.

Pearling boats were so crowded that men slept on coiled ropes, oyster shells, or the hard deck, cushioned, if at all, by a flimsy mat. Fresh water was too precious to use for washing, so men spent months coated in biting salt. Fish, rice, and dates were the mainstay, but divers grew disturbingly thin because they avoided diving on full stomachs, and the energy required to keep their bodies warm even in the intense summer heat consumed massive amounts of calories. Divers spent more than two hours each day under water with no air, and while the surface temperature might be warm, the dark depths were chilling.

Chanting, clapping, and foot-stomping accompanied every task, all driven by the rhythm of a heavy beat. Larger boats competed to have a well-known singer, or *nahham,* onboard to keep morale high and the pace of work steady. The deck was silent only at prayers and at the end of the day when the men gathered over supper, ravenous from a grueling day that often did not include a midday **meal**. Evening prayers followed, and then the men—wrapped in their robes— bedded down, body against body, on the jammed deck.

As challenging as trading voyages could be, they at least offered a chance to rest when the dhow sailed in front of fair winds or layover in port. But pearling was brutal, dangerous work. It turned men gray early. Blindness and deafness were the fate of many divers. Shark and stingray attacks claimed some, and occasionally a stray storm would sink a vessel, causing great loss of life. So the coming of *al quffal,* the official end of the pearling season, was met with rejoicing on land and at sea. *Al quffal* also coincided with the monsoon season, whose winds carried sailors out of the Gulf into the Indian Ocean on the trading trips that some *nakhoda* made in the off-season.

After the pearling season, Bedouin went back to their families in the desert, and sailors signed on for trading voyages, traveling short distances to Basra or Persia or greater lengths to India and East Africa. Ship captains visited merchants and sheikhs to sell those pearls not sold on the banks. Others went back to fishing, ceramic-making, net-mending, trap-making, tailoring, sail-making, carpentry, shop-keeping and metal-working—all the work a busy port needed.

No matter how hard pearling was, with the debts, the hardship and the loss of life, it was better than no work at all. The introduction of cultured pearls followed by global depression dealt a dire blow to Qatar and the other Gulf pearling areas. People struggled for survival during the twenty-plus years between the decline in the pearl market and the first shipment of oil in December 1949. The credit and debt system collapsed because no one had money to lend. Some who fared better maintained the tradition of sharing leftovers from meals with their neighbors. But as one elderly Qatari relates, it was the time of "flat plates," when even sheikhs and merchants had only a sparse serving of rice and perhaps a little meat, in contrast to the heaping dishes of the past.

Single men, entire families and tribes emigrated to find work to feed their families. *Hadher* trekked through the desert like Bedouin to reach Saudi and Bahraini oil fields or loaded their meager goods and livestock onto dhow to travel by sea. The discovery of oil in Bahrain in 1931 and in Saudi Arabia in 1935 meant laborers were needed in droves. Some went across the Gulf to Persia where many had family from their long years of trading in those ports. Hopes soared when the first wells at Dukhan on the west coast spurted oil in 1939, but the optimism was short-lived. The wells were capped and jobs disappeared when the British departed upon the outbreak of World War II. Children went hungry, and dhow were taken apart plank by plank to be used as firewood.

Even today, during traditional meals around a common platter, talking is reserved more for before and after the meal than while eating. Of course this is not the case in restaurants or at a dinner where multiple courses are being served.

157

Only one shell in thousands produced a worthy pearl, so any pearl was a rarity. The Gulf pearl oyster is not an edible variety, and after opening, shells were tossed overboard where they contributed to reef-building.

(opposite and following)

Jewelry belonging to Sheikha Monira bint Faleh Al Thani designed around rare natural pearls collected by her father Sheikh Faleh bin Nasser Al Thani, a prominent businessman and scholar; Sheikh Faleh's scales and sieves used to sort pearls by size and weight

The main pearl season began in early summer after the sun had warmed the Gulf waters and ended at the end of September or early October when the waters cooled. The pearling boats sailed out as a fleet to the sound of chants and drums. Larger boats sailed to deeper seas, while smaller boat boats followed the coast. Sometimes a *nakhoda* would anchor in a secluded spot, but at times, the boats would cluster at the same bank.

Repetitive work filled the days from dawn until dusk. The boat dropped anchor and slowly drifted across the bank as the line was played out. Depending on the size of the dhow, there were up to eight or ten oars on each side. Oars, scored by years of wear from rough coir ropes, were lashed perpendicular to the vessel to keep the divers' lines from fouling each other. Each oar had two sets of divers and one puller.

With fingers and toes protected from sharp shells by small leather caps, the first group of divers jumped into the water. The diver plugged his nose with a clip made from tortoiseshell or wood, slipped a foot into a loop of rope attached to a heavy stone which dragged him down to the sea floor. With his other hand he grasped a second rope, his lifeline, which was tied to a netted basket hung around his neck to keep both hands free. At a signal from the diver, the puller let the weight sink. As soon as the puller felt the weighted rope go slack, he knew his diver was on the bottom and pulled up that line.

One minute, ninety seconds, even two minutes passed as the diver pried oyster shells from the sea bed and tossed them into his basket. Then he gave a small tug, whereupon the puller reeled in the rope hand over hand, hard and fast, to bring the diver up from the depths. This process was repeated ten or more times, depending on the depth of the water. In between each dive the men took a few breaths and then sank once more to scour the bottom as the ship floated down the bank. At the end of their shift, they climbed out to huddle around the cook fire, drying their chafed and ulcerated skin while the other team of divers took their turn. Then back into the water went the first team for another set of dives until the sun was low in the sky. In a typical day, a diver would make between 100-120 dives, more in shallow waters. Divers often suffered burst ear drums and infected eyes, which they dabbed with a bit of fresh water laden with insects and larvae, stored in wooden casks waterproofed with fish oil and in later years kept in rusty metal drums.

Oyster baskets—some full and some with only two or three shells—were dumped in a heap on the deck until the next morning when they were forced open with a knife. The oysters would die overnight, and their shells would loosen. Since profits were divided by shares, this process prevented a particular pearl being claimed by a diver. The pearls belonged to the boat; a rare pearl was a blessing shared by all. Only one shell in thousands produced a worthy pearl, so any pearl was a rarity. The Gulf pearl oyster is not an edible variety, and after opening, shells were tossed overboard where they contributed to reef-building.

The pearl boats were not alone on the banks. Pearl merchants or their agents sailed fine dhow out to join the fleet. A crew from the merchant dhow would row a longboat among the pearling fleet, hoping to buy pearls directly from the source. News of a special find traveled fast as buyers competed to buy the pearl before competition from other buyers drove up the price. The fleet was also visited by other dhow that came to sell dates, fresh water and dried camel-thorn branches for cook fires.

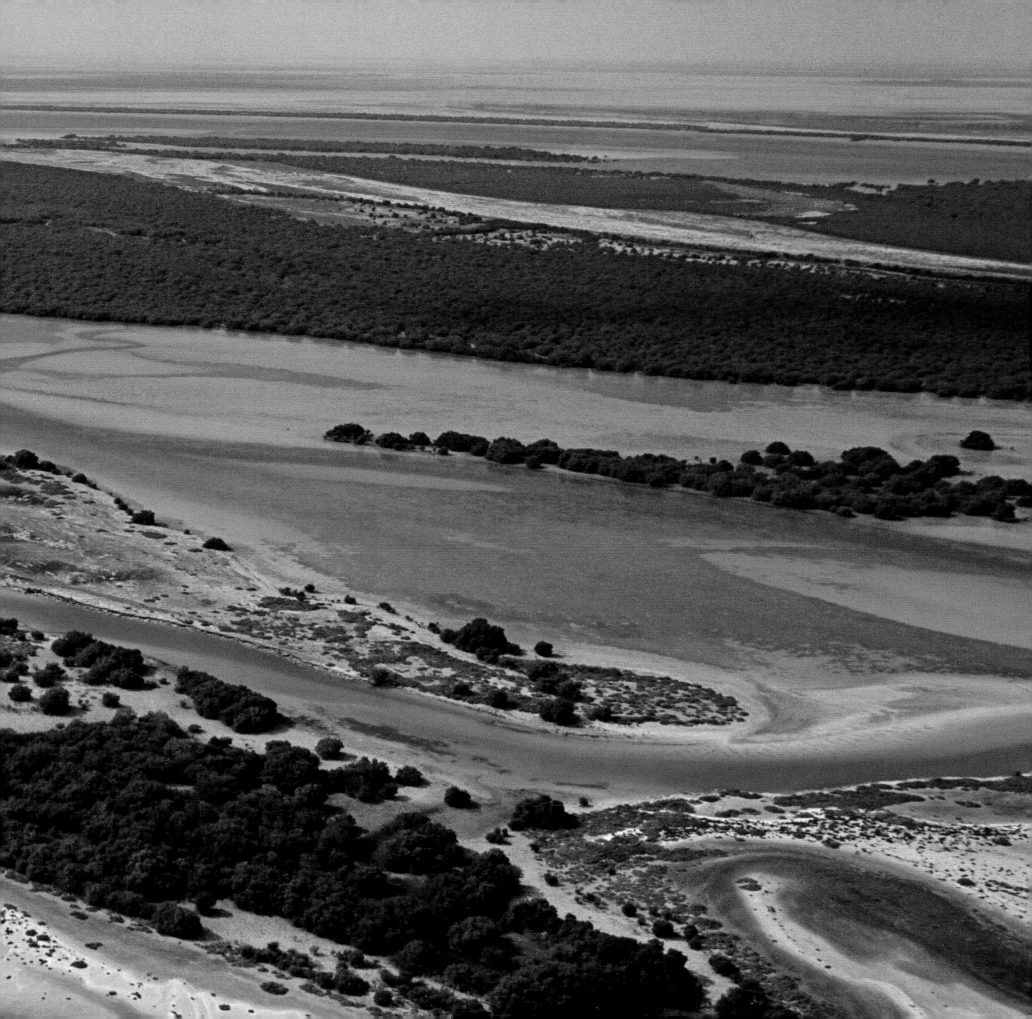

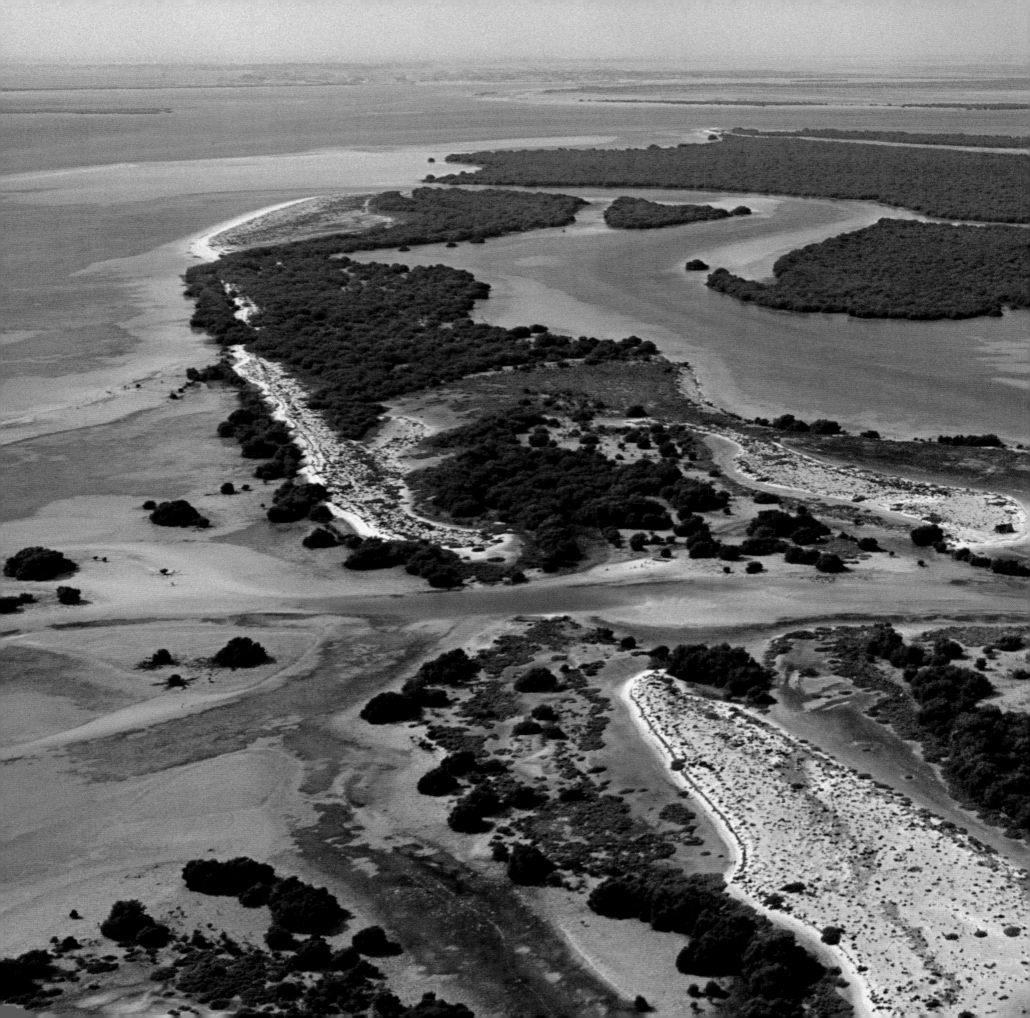

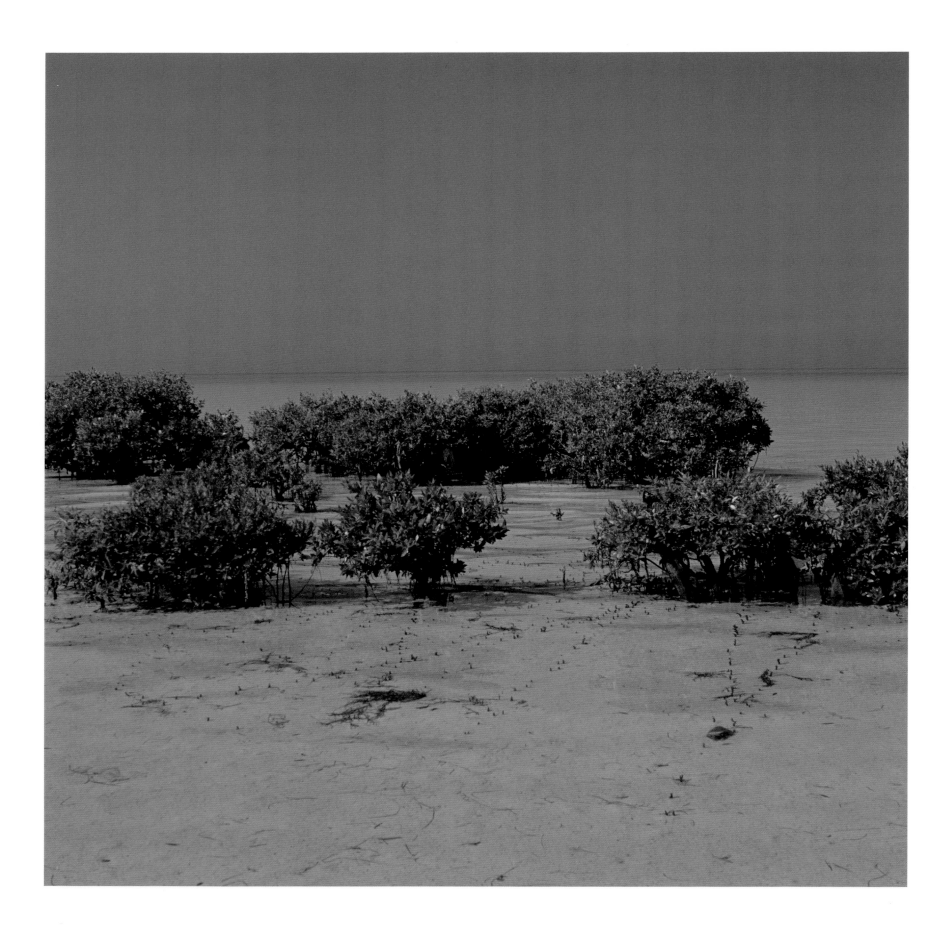

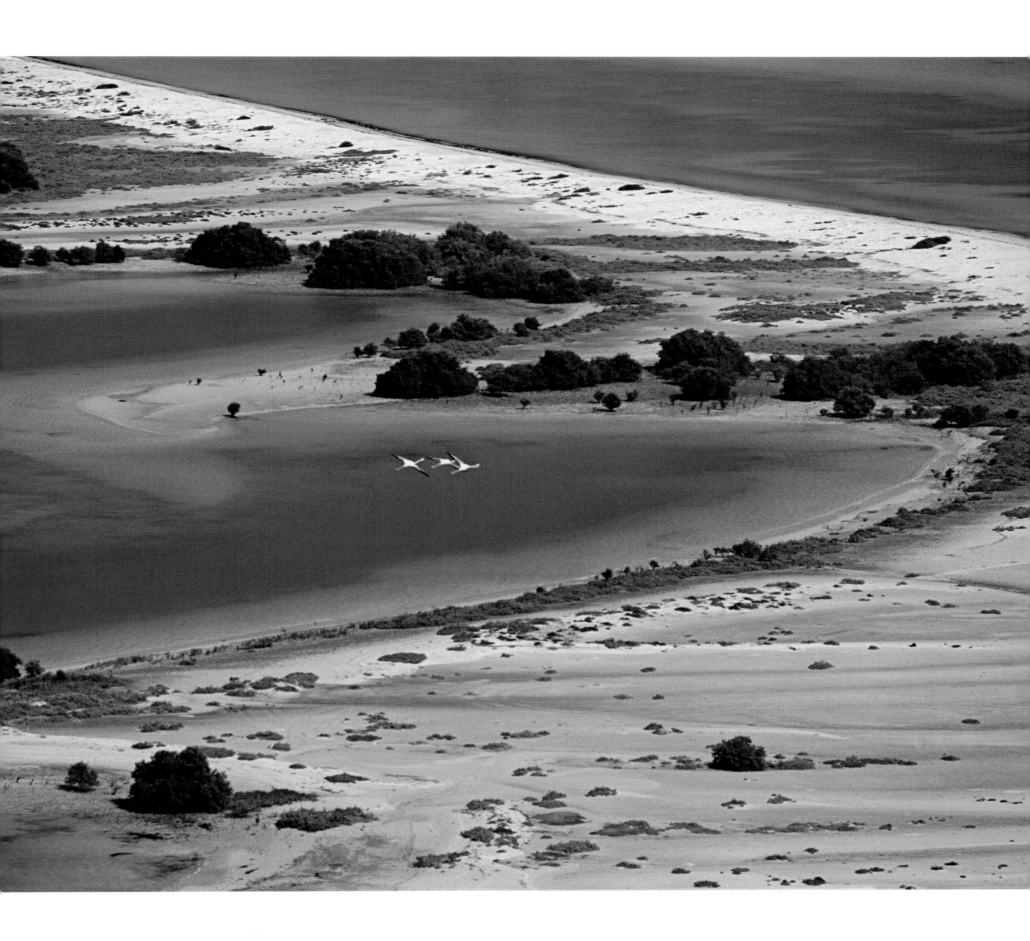

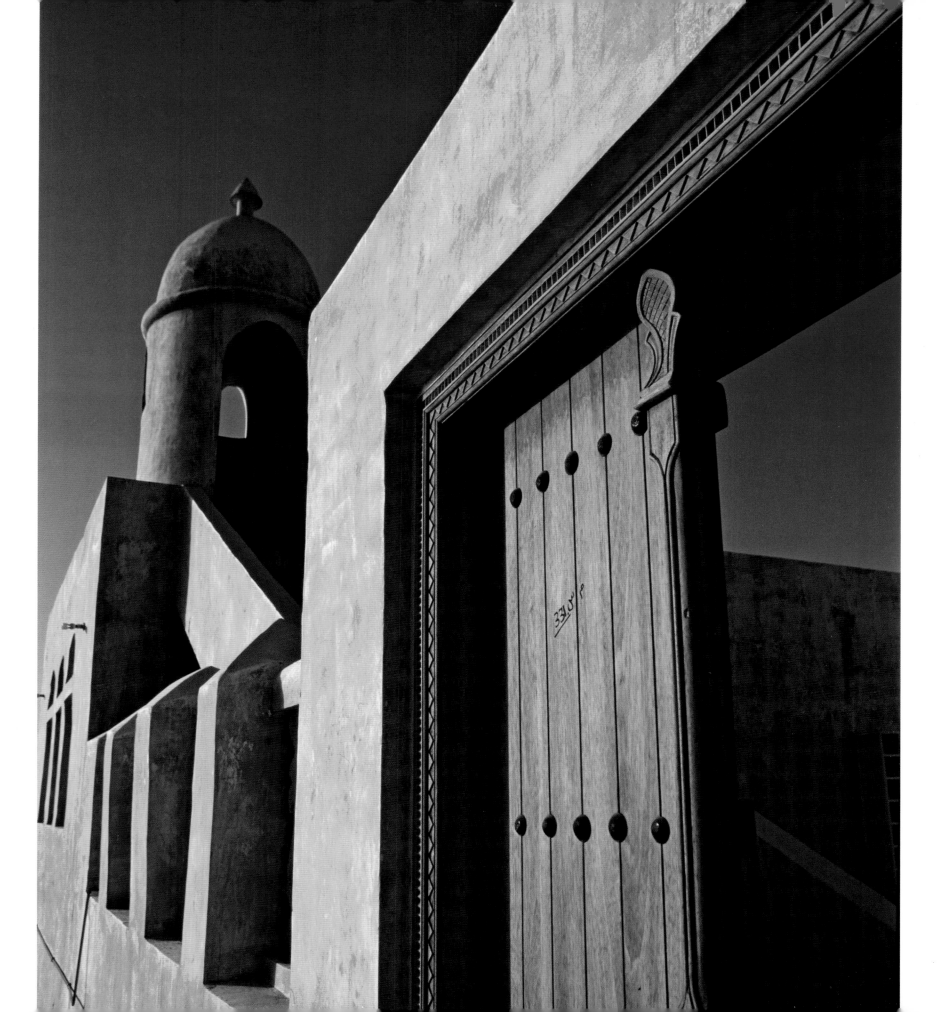

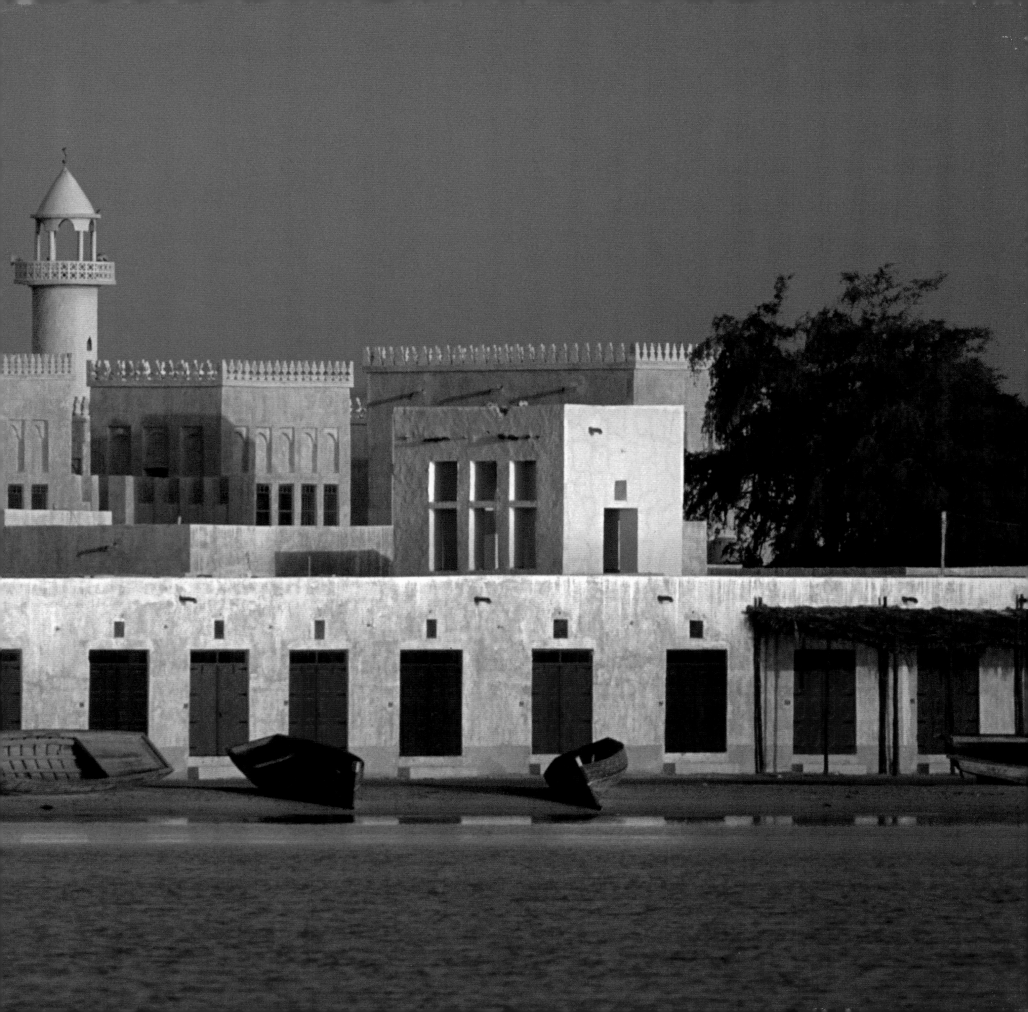

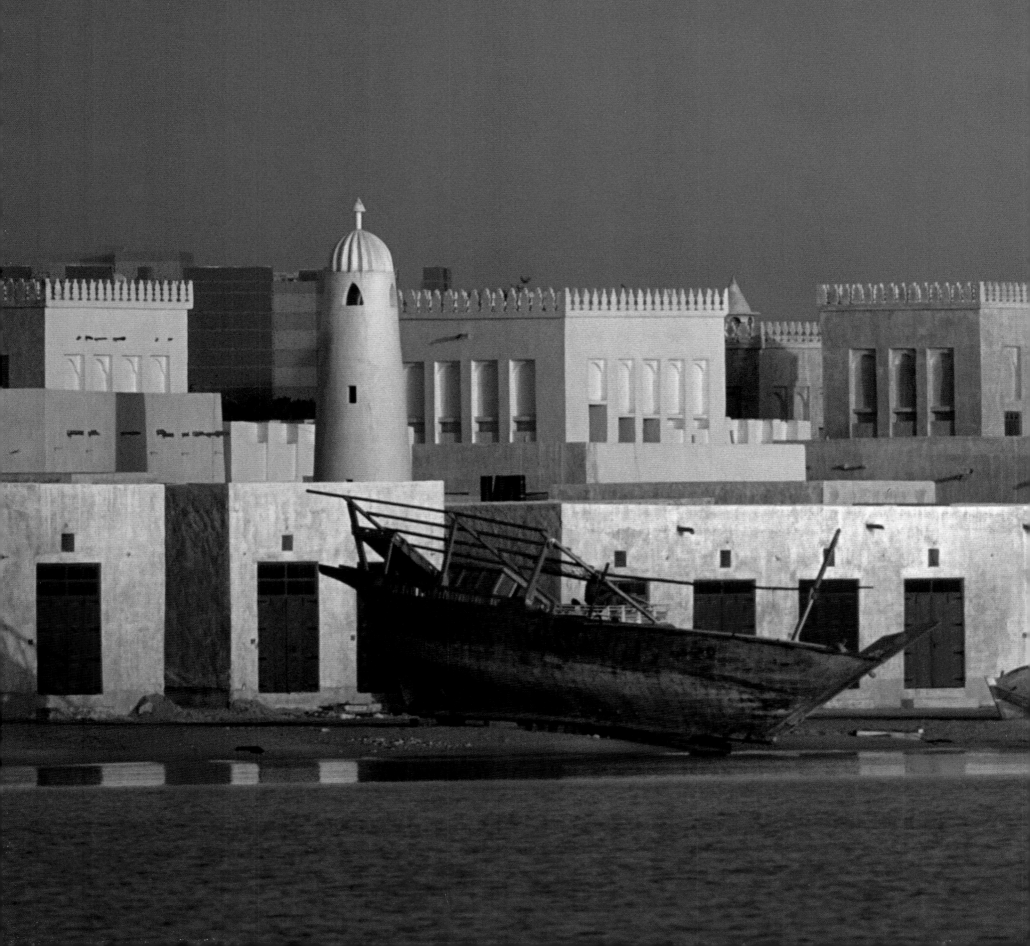

No representative from Qatar signed the General Peace Treaty; however, after a series of attacks on Doha and Al Wakra in 1867, Great Britain signed the General Maritime Treaty with Sheikh Mohamed Al Thani in Doha. While the peninsula remained a tribal society ruled by independent sheikhs, this recognition by the British marked the rise of the Al Thani family and the first acknowledgement by a European country of Qatar as a distinct political entity. The Al Thani leadership was further solidified in 1916 when Sheikh Mohamed's grandson Sheikh Abdullah signed a treaty of protection with Great Britain, which required British consent to cede, sell, lease or mortgage territory, a decision that would become especially significant when oil was discovered in the 1930s.

Around the time of the 1867 treaty, European steamships overtook the wind-powered **dhow** in the Indian Ocean trade. Steamships were faster, more reliable, and unfettered by the seasonal monsoons, which essentially restricted the route and timing of dhow passages to once-a-year long-hauls to India or Africa. Ironically, what was bad for Arabian trade in general was good for the pearl market. The wealth amassed by European colonial expansion, modern industrial development in the United States, and the creation of multiple, wealthy Indian principalities at the end of Mughal control in 1857 created an insatiable market for luxury items. The golden age of pearling lasted from the mid-nineteenth century until the 1920s, when it was halted by a flood of Japanese cultured pearls onto the market, followed by the stock market crash in 1929 and the subsequent worldwide depression.

Even at the zenith of pearling, only a few large-scale merchants prospered. The Gulf functioned as a credit-based economy where lifelong debt wove webs of equally long-term obligations resembling indenture. The onus continued even after death, because sons, widows and brothers inherited debts. Merchants advanced money to a *nakhoda*, or ship captain, who would use it to outfit his ship, buy his cargo, and give advances to his crew. Seamen were paid with a set number of shares from the profit made by the ship from the sale of cargo or the harvest of pearls, but only after all expenses were deducted. Expenses included the cost of their food as well as that of outfitting the ship. A year's work might end with more owed than earned, in which case the man or his family was bound to that *nakhoda*. In turn the *nakhoda* was bound to the lending merchant until the debt was repaid, often a Sisyphean task.

In 1907, the consummate Gulf chronicler John G. Lorimer counted 817 pearling ships and 12,890 sailors out of a population of only 27,000 in Qatar. Since no women participated, that would mean nearly all the men would be gone for the four months of the pearling season. Some question the accuracy of these numbers, but no one doubts that pearling dominated the economy of the day and that a majority of able-bodied men took part.

Even Bedouin joined the fleet to earn money or repay debts. With their long black hair woven into braids, the Bedouin were easily recognizable when they took their place as divers and, less frequently, as crew. Slaves of East African and South Arabian descent were sent off to pearl by their owners, who often skimmed the meager earnings, a practice which continued into the oil days until slavery was abolished in 1952.

Dhow is a general term for the wooden boats and ships that sailed in the Arabian Gulf and Indian Ocean. It is not an Arabic word and the derivation is uncertain.

(following)
Al Wakra village has been restored painstakingly; a nature preserve protects sensitive mangrove swamps adapted to the high-saline Gulf waters which provide habitat for abundant wildlife

147

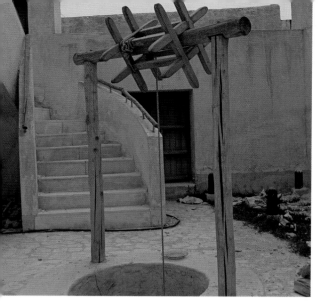

Unlike India, which was colonized, the Gulf States were officially British protectorates. As such they maintained their independence, an important distinction and a major factor in national pride.

The Ottoman Sultan Suleiman the Magnificent also coveted the Gulf as an avenue to trade and captured much of modern Iraq and parts of the Arabian Peninsula in 1534. This Ottoman expansion faltered but retained sporadic influence in the region, including Qatar, until expelled by Ibn Saud, the future king of Saudi Arabia, in 1913. The Ottoman presence remained a factor in Arabia into World War I as the British, in an extension of the European battlefield, supported the Arab revolt against the Ottoman Turks. Many Westerners are familiar with this clash from the romanticized version depicted in "Lawrence of Arabia." But Lawrence operated along the Red Sea coast, Palestine and Syria, nowhere near the Gulf.

In 1776, the Al Khalifa moved from Kuwait to Al Zubarah on the northwest coast of Qatar, described by a Qatari observer in 1638 as a town of 150 houses and 700 inhabitants, with several boats and livestock. At that time, a series of tribal struggles pitted factions in Qatar against those in Bahrain, Saudi Arabia and Oman, which included present-day UAE. In the interest of enforcing safe seas for shipping, and much later of securing oil concessions, the British sought to end these disputes. In the mid-nineteenth century, Qatar's early Al Thani sheikhs gained political standing through their treaty negotiations with the British and the Ottomans, as well as through successful armed exploits against the Ottomans and other aggressors in Al Zubarah. These challenges came from as far away as Oman, often in company with the Al Khalifa, who had migrated to Bahrain from Al Zubarah in 1783 to take advantage of the island's superior harbors and abundant wells. There they expelled the Persians and continue to this day as the hereditary rulers.

Nonetheless, the Al Thani were aware of their vulnerability, not only from their substantially stronger neighbors but also from other Qatari tribes. Consequently, they looked for allies, at times shrewdly courting two sides, such as the Ottomans against the British and later the Wahhabis and the Al Saud against the British. Fortunately for Qatar, its political aspirations to develop an individual identity coincided with British interests, in trade and later in oil.

A series of treaties marked the stages of Qatar's relationship with Great Britain. After the rout of the Portuguese in 1622, the East India Company extended its influence into the Gulf. In 1820, the British negotiated The General Treaty of Peace with numerous tribal sheikhs from Bahrain to the north coast of Oman which mandated the cessation of hostilities at or by sea and the end to the slave trade. From 1763 until 1971, Great Britain maintained a "residency" in the Gulf. Unlike India, which was colonized, the Gulf States were officially British protectorates. As such they maintained their independence, an important distinction and a major factor in national pride.

The trade ships that plied the Gulf waters were rich targets for pirates, causing the British to dub the southern littoral the Pirate Coast due to the prevalence of marauding. After the ratification of the General Treaty of Peace, the British renamed it the "Trucial Coast." Some historians question whether piracy was really as widespread as claimed. No one disputes that there were pirates and privateers who plagued trade ships, whether they flew British, Arab or Persian flags. However, some historians contend that many tribes identified by the British as pirates were actually legitimate merchants trying to protect their historical trade routes against European interlopers.

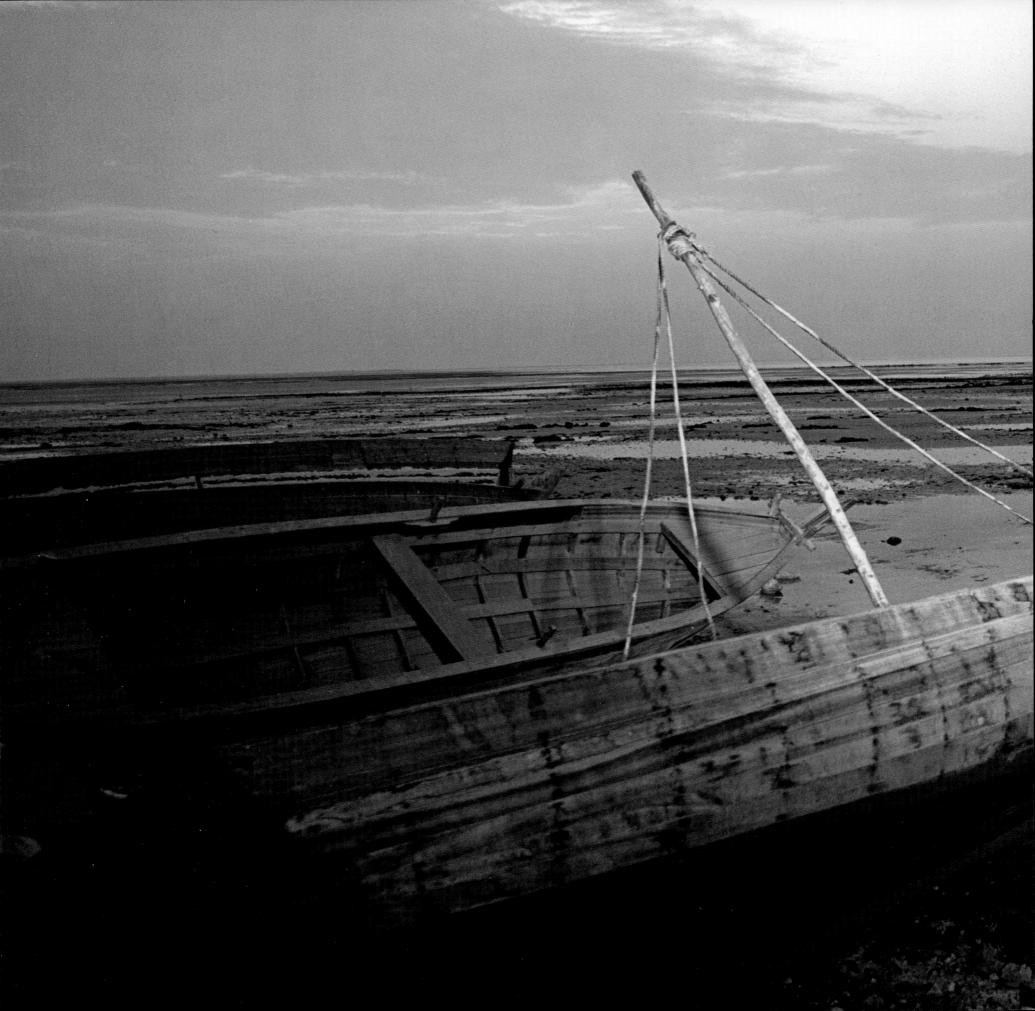

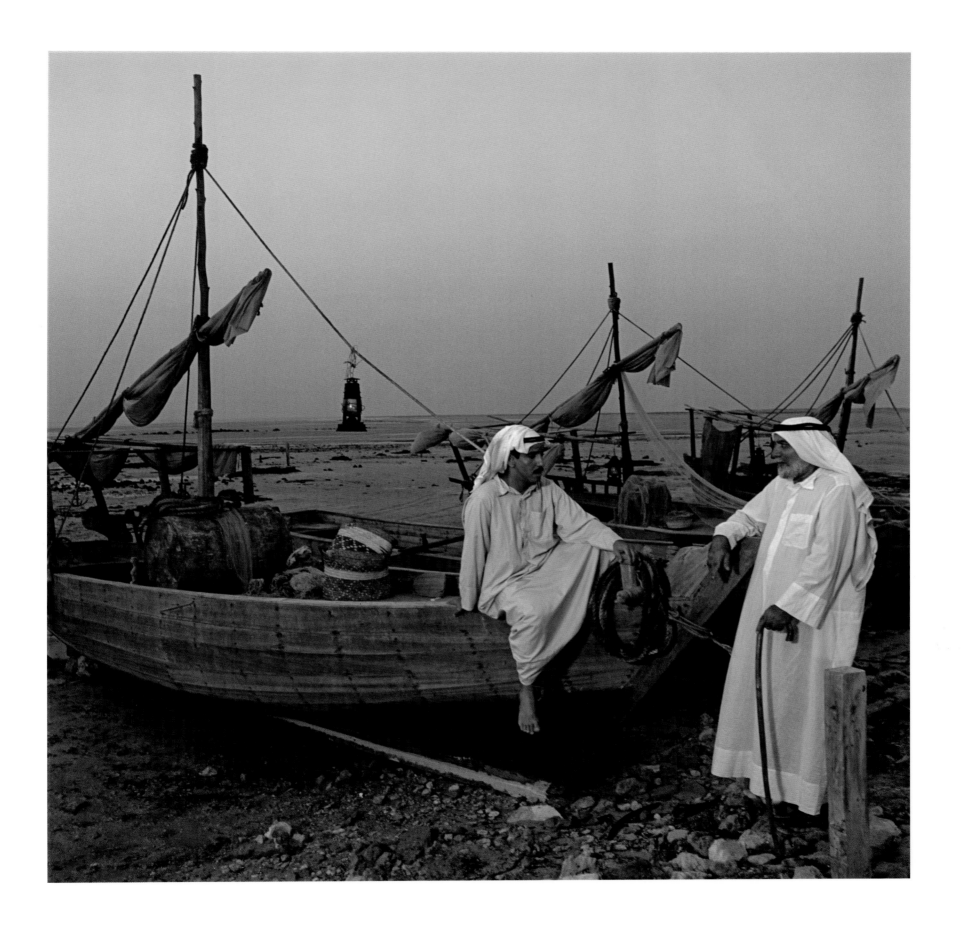

Before Qatar began its meteoric transformation in modern times, there were long years of daring sea ventures, political intrigue, economic riches and ruin. A geopolitical shift began when Vasco da Gama rounded the Cape of Good Hope in 1498. He sailed on to India with an Arab navigator, perhaps the renowned Ahmad ibn Majid, a prolific poet and author of a sophisticated encyclopedia about navigation from Indonesia to East Africa. Born in what is today the UAE, ibn Majid followed the path of his father, also a famous navigator.

The advent of European sea power in the Indian Ocean had far-reaching ramifications for the political and economic future of the Gulf. The winds of change were not new in the Gulf: Power had shifted with the rapid spread of Islam in the seventh century and the conquest in 750 CE of the Mediterranean and Red Sea-centered Umayyad caliphate by the Gulf-centered Abbasid caliphate based in Baghdad. Certainly history would be different had not Alexander the Great's death in 326 CE prevented his intended conquest of the Gulf. Political power thrives on economic might, and the Gulf's priceless trade was an appealing target for expansionist powers.

After 1498, the actors changed. For the first time, Europeans became major figures, and their willingness to use their superior firepower to support their economic trade interests forced the East to look warily to the West. Close behind the Portuguese, the Dutch and the British also sought to command the lucrative Eastern trade routes. The British prevailed in the Gulf when their fleet helped Shah Abbas of the Safavid Persian Empire drive the Portuguese from Bahrain in 1602 and **from** Hormuz Island (which controls the strategic narrows where the Gulf meets the Arabian Sea) in 1622. The British East India Company then quickly asserted **commercial hegemony** in these waters.

Before Qatar began its meteoric transformation in modern times, there were long years of daring sea ventures, political intrigue, economic riches and ruin.

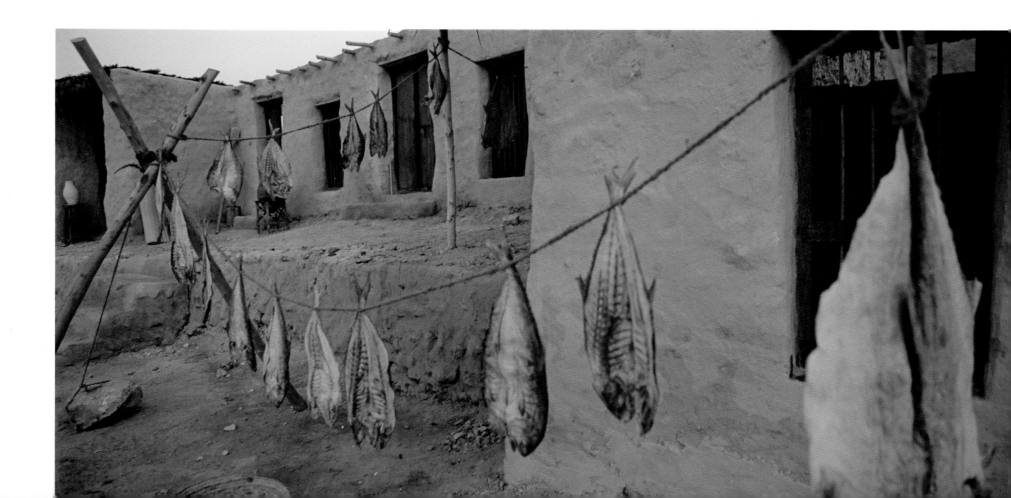

bread. Anything that had to be imported, like rice, flour, sugar, dates, oil or spices, was a luxury; much-loved traditional dishes still abound with these ingredients.

There was little idle time. Boys became men at an early age. Sometimes a *mutawa*—literally, one knowledgeable about Islam—taught basic reading of the Qur'an, writing and simple math at the mosque. But for the most part, boys as young as eight or ten went to work, usually for free at first, with a father, uncle or someone in their village who could teach them a skill like shipbuilding, pot-making, carpentry, fishing, net-making or metal-working.

Women and even small children worked at cleaning, cooking, repairing nets, salting and drying fish, and caring for livestock. They rested from heavy work by gathering with family and friends in the shade cast into the courtyard. There they talked and sewed clothes and embroidered intricate designs. The length of their break was gauged by the shadow cast by the morning and afternoon sun. When the shadow disappeared, they resumed their regular work.

The cycle of the sun measured the day as the community paused for *salat*, the five daily prayers: *fajr* in the pre-dawn, *dhuhr* at noon, *asr* in the late afternoon, *maghrib* at sunset, and *isha* before sleep. No matter what hardships befell them, five times a day the community stopped to focus on submitting to the will of Allah and to thank him for the blessings of life. The moon counted the months until the annual new moon-to-new moon fast of Ramadan, observed by all save the sick and travelers.

138

Villages were often the domain of single tribes. On the north coast, villages were a couple of miles apart, while those around Doha Bay were only a hundred yards apart. Each tribe had a sheikh, who governed his own people and determined intertribal alliances. As other tribes settled nearby, distinct *fereej* (neighborhoods) with narrow winding passages preserved community cohesiveness.

The more powerful tribes built strong, square-walled forts with towers at the four corners. Forts served both as defensive structures and storehouses for trade goods. Merchants also built large walled courtyards at their warehouses to safeguard their goods. The ruins of Al Zubarah on the northwest coast distinctly show three successive walls as the town sprawled across the coastal flats. Almost all early villages in Qatar were either on the coast or in close proximity; the few exceptions were built around wells or near *rawdat*, the rain-dependent seasonal oases, that were productive enough to support limited agriculture like date tree groves and grazing. Al Zubarah's fresh water was transported from an inland well.

Families shared cooking and communal spaces. When a bride married into the family, a room was built onto the house for the couple (a practice still common today). One Qatari grandmother recalls her newlywed life in the early 1960s when she lived with her husband's family. Their neighborhood did not have running water or electricity; she and her husband shared a single room with their three young children, who slept on simple floor mats. Illustrating the extraordinarily rapid development in Qatar, within five years this same family built a modern house with soaring ceilings, air-conditioning and luxurious reception rooms, or *majlis*.

The Gulf follows the path of the drowned Tigris-Euphrates Rivers for 615 miles (989 km) south and east until it winds through the narrow Straits of Hormuz, where only 35 miles (56 km) separate Iran and Arabia. There it joins the Arabian Sea, the northern part of the Indian Ocean. Seafarers have plied these waters for at least seven thousand years in search of fish and trade. The Gulf's protected waters linked the people of the Gulf with the southern edge of the Arabian Peninsula, Africa, India, and East Asia. Sailors learned to use the providential monsoon winds that blew steadily southwest during the summer months and steadily northwest during the winter months to make these voyages.

As a peninsula jutting into the Gulf, Qatar's relationship with the sea was inevitable. Although a small country (4,473 square miles or 11,586 sq km), Qatar has a coastline of some 350 miles (563 km) and a land border of only 37 miles (60 km). The desert will probably never give up the secret of what attracted the first people to Qatar, but most likely an increase in rainfall from 8000-4000 BCE brought nomads on a seasonal basis for grazing. Archaeologists have unearthed sites with probable postholes suggesting palm frond huts of the type still built in the region deep into the twentieth century. Very likely, sailors ventured down the coast in small boats made of bundled reeds waterproofed with bitumen or in *shasha*, palm fronds lashed together with date fiber rope. They traded ceramic pots and dates for meat and fresh water or even pearls, which could have been discovered in oysters exposed at low tide. Qatar's geography literally put it in the way of these boats.

Ancient life on the edge of the desert and the sea continued in a timeless manner until the fifteenth century, when the daily rhythms took on patterns that remained familiar until the coming of oil in the late 1940s. The Bedouin roamed their vast distances, while the *hadher* lived in small villages consisting of palm-frond huts or (for the more fortunate) houses made of thick coral rock. The porous rock was a natural insulator, as were the layered mud ceilings made of woven date palm matting atop a lattice of bamboo, all resting on bitumen-coated mangrove poles. The matting kept the dirt roof from crumbling into the interior. Rooms were narrow, their width determined by the length of mangrove poles, which were mostly imported from India and East Africa because wood was a **scarce commodity** in Qatar. Clusters of woolen Bedouin tents periodically swelled the coastal population as they came to trade, wait out the summer months near sea breezes, or seek work on a pearling boat.

In contrast to Bedouin women who lived in tents and worked in the open weaving or caring for livestock, women in settled communities led a more segregated life. Walls not woolen panels separated them from the outside world. Dwellings were built in close proximity, so privacy for the family, particularly the women, dictated a courtyard design surrounded by small, simple rooms. Many houses had a well of brackish water suitable only for cleaning. Fresh water was delivered by a human water-carrier or donkey about once a week from communal wells or from ships from nearby Bahrain or Basra in Iraq. The carrier poured the precious content of his leather bags into large, cooling ceramic jars.

Even near the sea, food could be scarce, sometimes little more than a few dates for breakfast and a main meal of dried fish and rice. Before widespread electricity in the 1960s allowed refrigeration, leftovers from the evening meal were stored in woven palm-frond baskets hung from the ceiling to discourage cats. Grilled fish was a staple, but on the worst days small dried fish were ground up with tamarind pods as a dip with rounds of unleavened

As a peninsula jutting into the Gulf, Qatar's relationship with the sea was inevitable.

Part of the reason that buildings in abandoned villages decayed rapidly is that wood was so scarce that it was scavenged from the old houses for new purposes. Without their roofs, the simple mortared structures disintegrated rapidly in the few, yet heavy, winter rains.

135

(above and following)
A *maskar*, man-made coral wall formerly used to trap fish as the tide receded; shells left by an ebbing tide; Khor Al Adaid islet

Arab sailors mastered
deep sea routes
and sophisticated
navigation long before
the fifteenth-century
European Age
of Exploration.

Chapter Three: Sea

Arab sailors mastered deep sea routes and sophisticated navigation long before the fifteenth-century European Age of Exploration. For thousands of years before Europeans ventured on long ocean passages, Arab ships transported rich cargoes from the East—incense, pearls, silks, peppercorns, cinnamon and other spices —from India to Arabian Gulf and Red Sea ports and then by camel caravan to the Mediterranean. It was the lure of this bounty that enticed Western explorers to seek sea routes to India.

The Gulf starts at the mouth of the Tigris and Euphrates Rivers in modern-day Iraq, an area often called the cradle of civilization because of the succession of ancient Mesopotamian civilizations that blossomed there. The oldest known urban settlements date to the Ubaid period beginning in 5300 BCE, while Sumerian written tablets, made by pushing reeds into wet clay, appeared around 3200 BCE.

Part of a seagoing reed boat coated in tar-like bitumen dating to 5300-4900 BCE was found in Kuwait along with clay models of reed boats. Pottery shards, also from the Ubaid period, were unearthed in coastal Saudi Arabia, Qatar, and even in inland sites in the United Arab Emirates (UAE). Pearls have been discovered in burial mounds in nearby Bahrain dating to the fifth century BCE, leaving no doubt that these gifts from the sea already had value.

Pottery shards from the famed Dilmun civilization centered in Bahrain around 2000 BCE and the Babylonian Kassite civilization of about 1500 BCE have been excavated in Qatar, demonstrating that the peninsula was a link in the growing chain of seaborne travel. On tiny *Jazirat bin Ghomen* (Al Khor Island) on the east coast, a massive midden of crushed sea snail shells as well as the remains of large Kassite ceramic vats reveal that this site was used to produce the purple dye associated with the robes of royalty. Significantly, this dye site is the first to be found outside the Mediterranean. Kassite documents recount that their kings wore red-purple garments, lending credence to Qatar's participation in an important aspect of ancient Gulf trade.

(previous and above)
Net fishing near Al Shamal
on the wide tidal flats
of the northern coast;
dhow at the Emiri shipyard

Probably due to the scarcity of sweet water, Qatar did not develop large urban centers as did Bahrain, Mesopotamia and various ports on the Persian coast. However, its long-term engagement with the Gulf's bustling commerce is indicated by artifacts like ceramics and glass from Murwab (eighth to ninth centuries) with its 250 dwellings, and from the Indian and African coins, Chinese porcelain, and clay crucibles for metal smelting found at Al Zubarah, which in the eighteenth and nineteenth centuries had 300 houses and a probable population of more than 1,000 people.

السَّا

SEA

It is He Who has made the sea subject that you may eat thereof flesh that is fresh and tender, and that ye may extract therefrom ornaments to wear, and thou seest the ships therein that plough the waves, that ye may seek of the bounty of Allah and that ye may be grateful.

– Qur'an 16:14, Surah Al Nahl

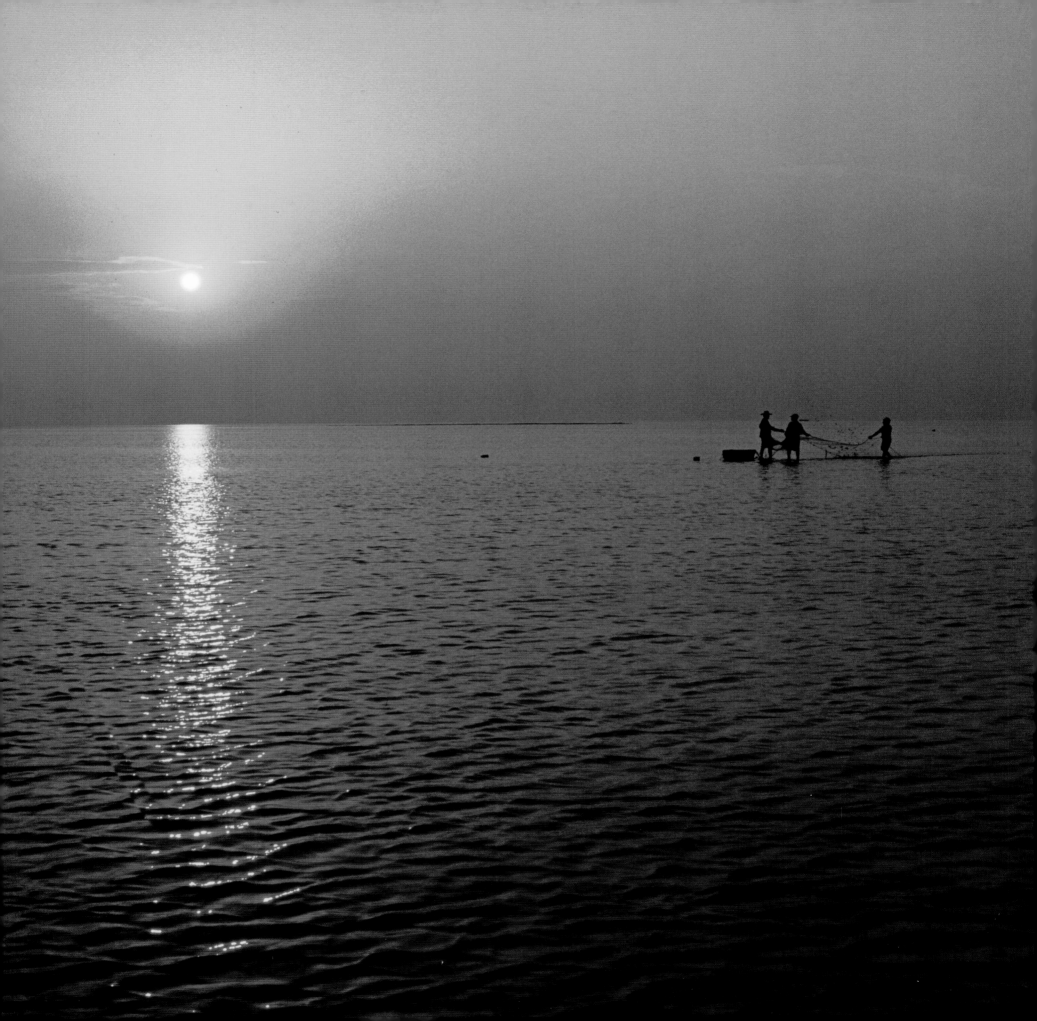

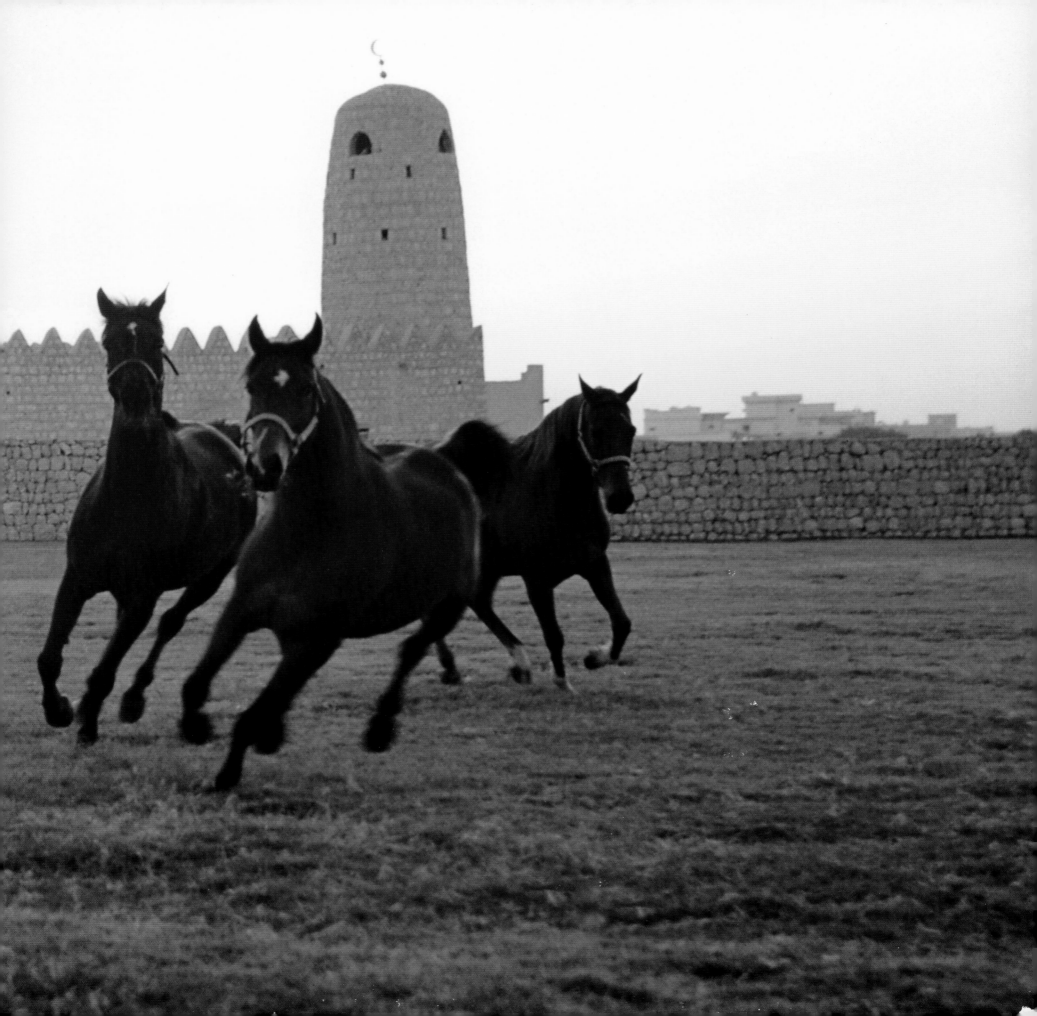

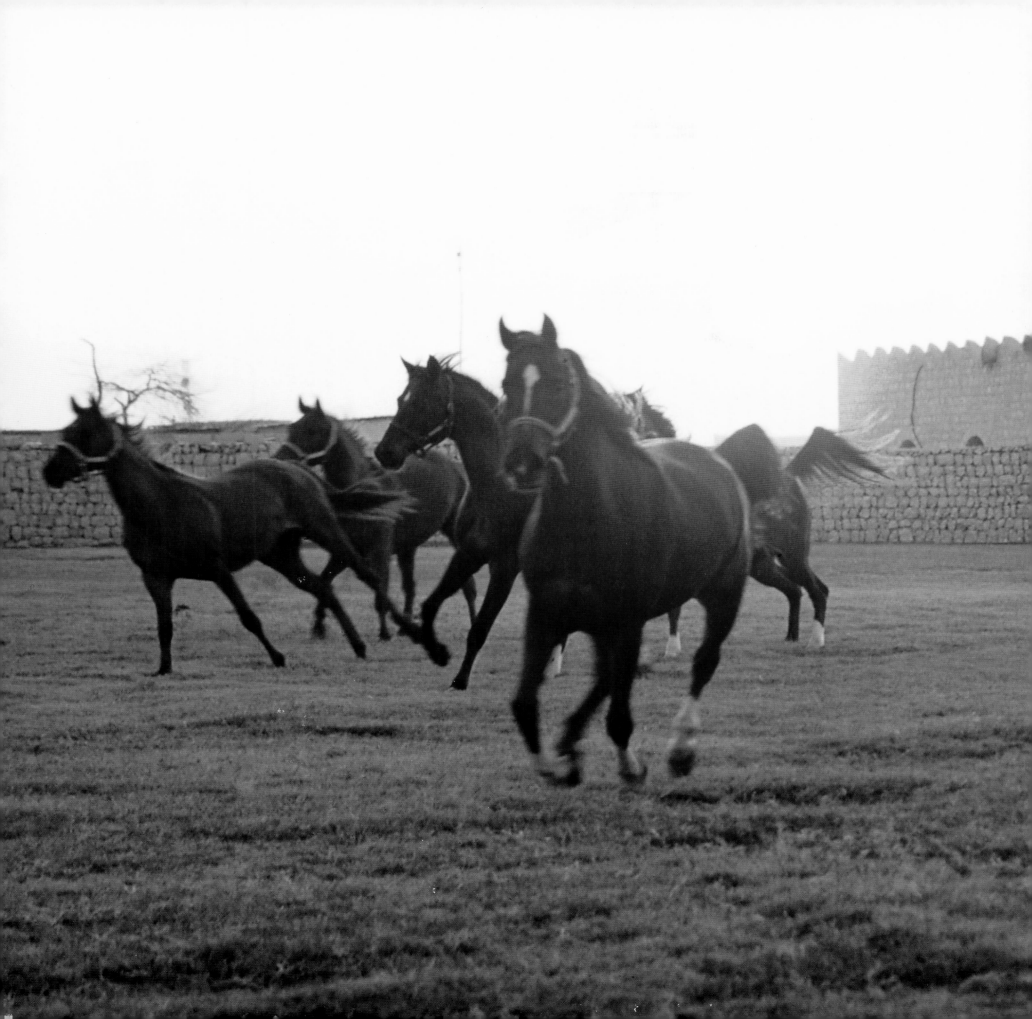

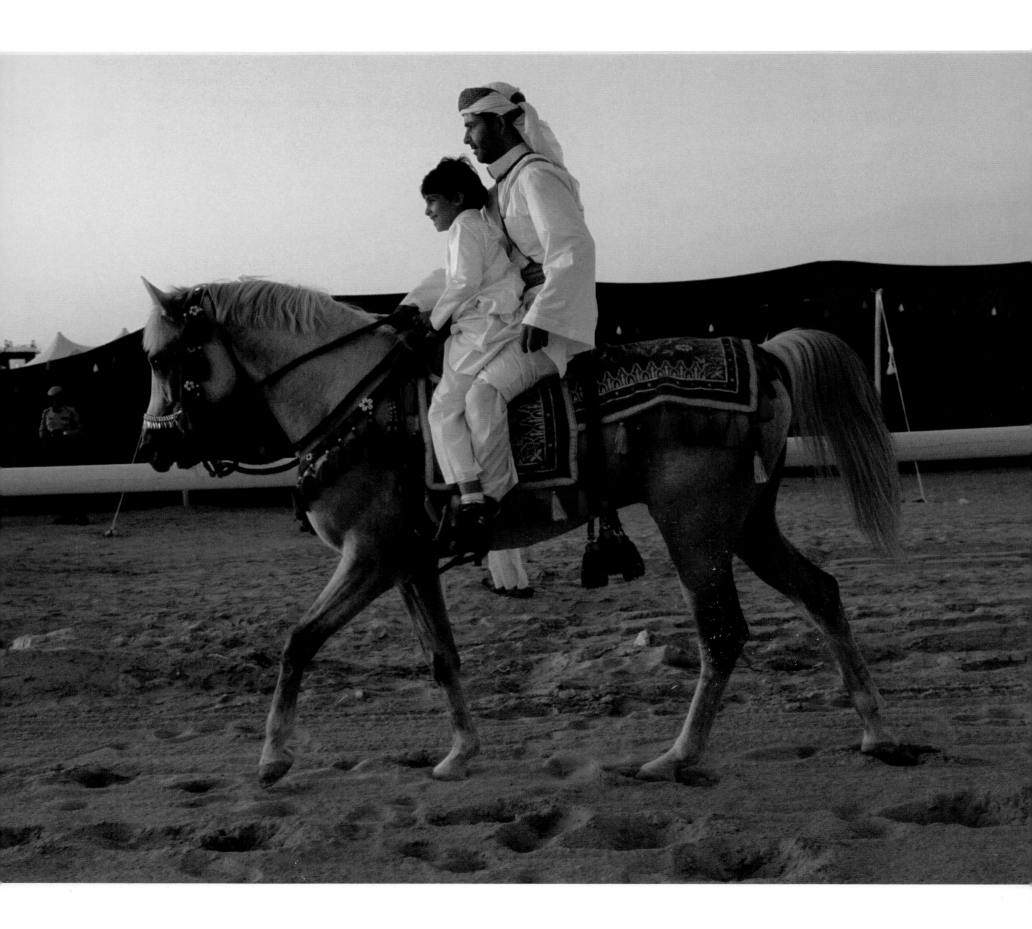

Fortunately, the desert remains strong in the Qatari heart, and its strength and fortitude will carry the country forward.

Now, people have awakened to the damage, and side by side with high-tech desalination and hydrocarbon processes, school children conduct desert clean-ups and replant indigenous flowers and mangroves. Laws and regulations mandate clean camping and newly-designated nature preserves provide habitat for stressed flora and fauna. Public competitions for falcons, horses, camels and salukis give opportunities for everyone to take part—as a participant or spectator—in traditional activities that nurture a connection to the land. In addition, an emphasis on sports and fitness is getting Qataris back to the fighting trim of their leaner days, which will serve them well as they face the pressure, diabetes, cancer, and heart disease that plague the industrialized lifestyle. In a cycle similar to that of most modernizing nations, Qatar first focused on the economics of development and only later on the problems that flow from it.

In an ode to the honor, dignity and self-reliance of the desert dweller, Bedouin chronicler and photographer Wilfred Thesiger wrote, "All that is best in the Arabs has come to them from the desert, and there the harder the life the finer the type it has produced." He feared that the values of the Bedouin life would be lost as the nomadic life gave way to modernity. Fortunately, the desert remains strong in the Qatari heart, and its strength and fortitude will carry the country forward.

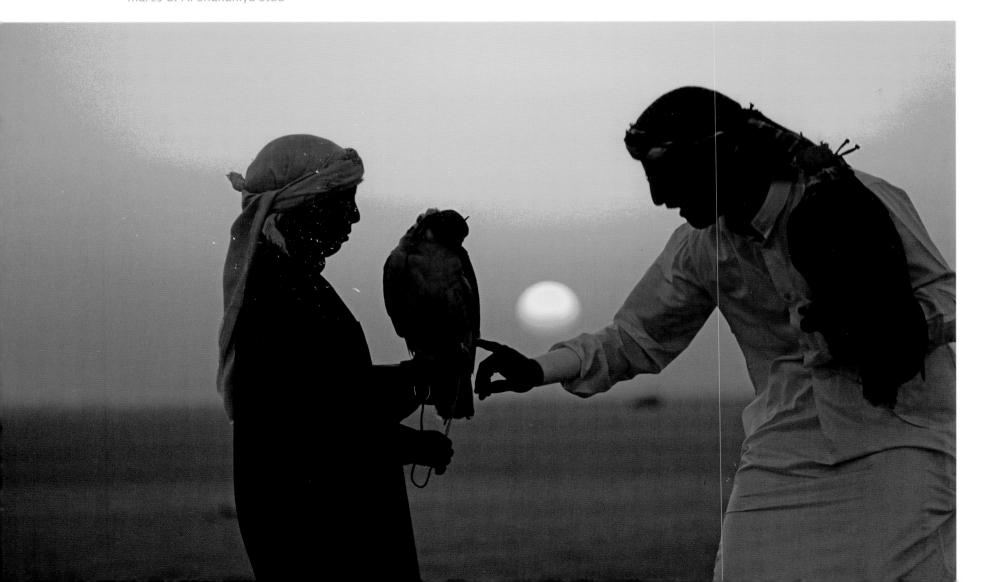

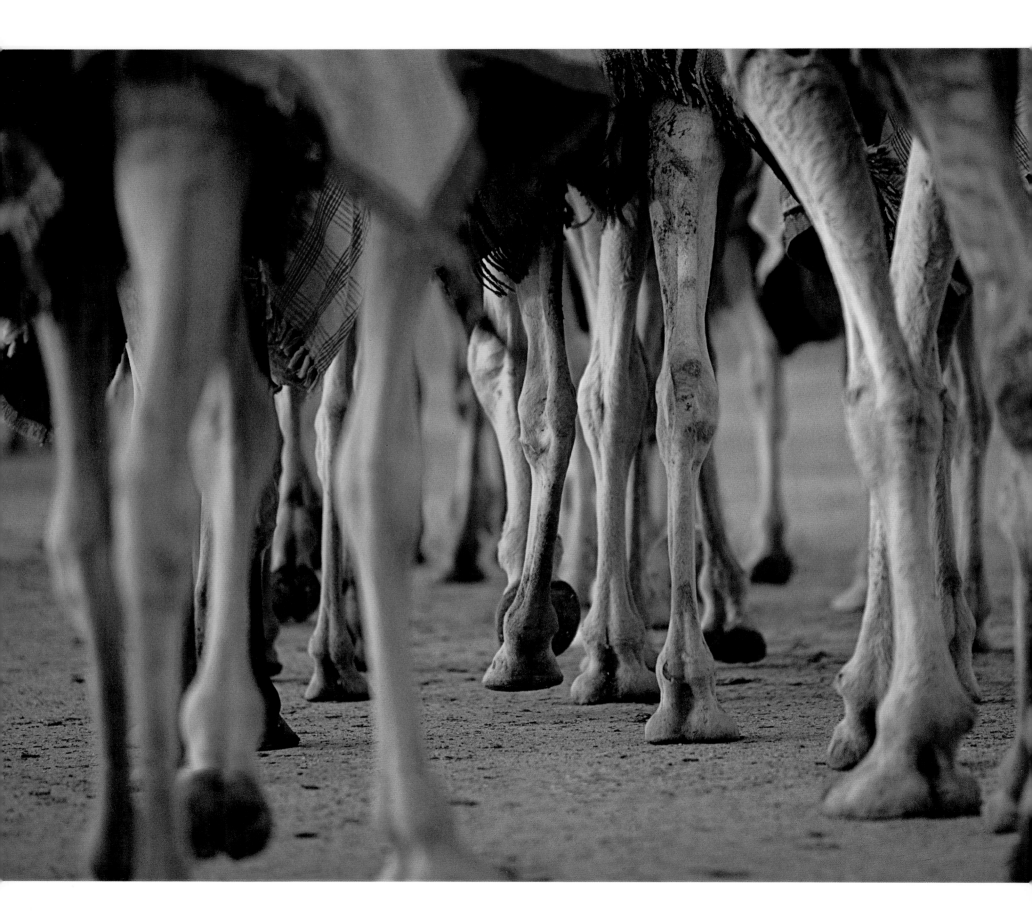

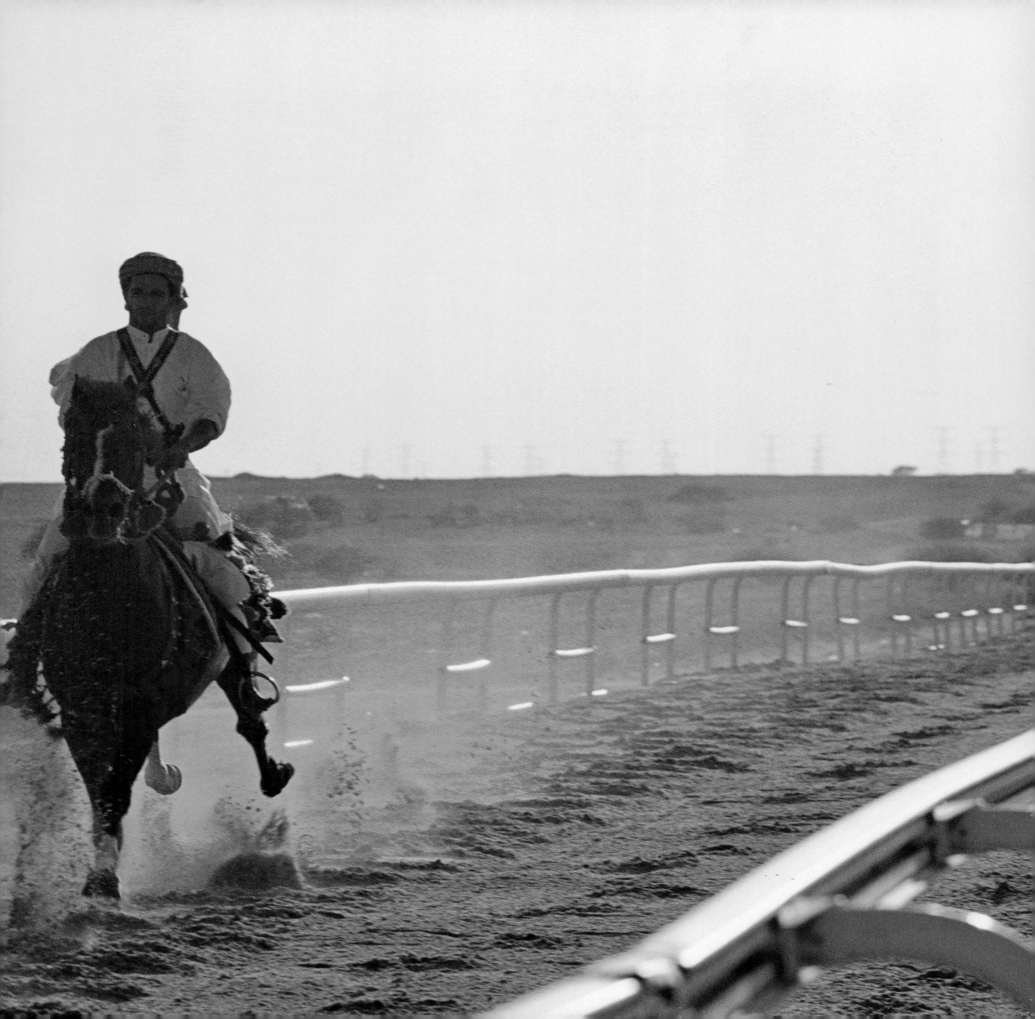

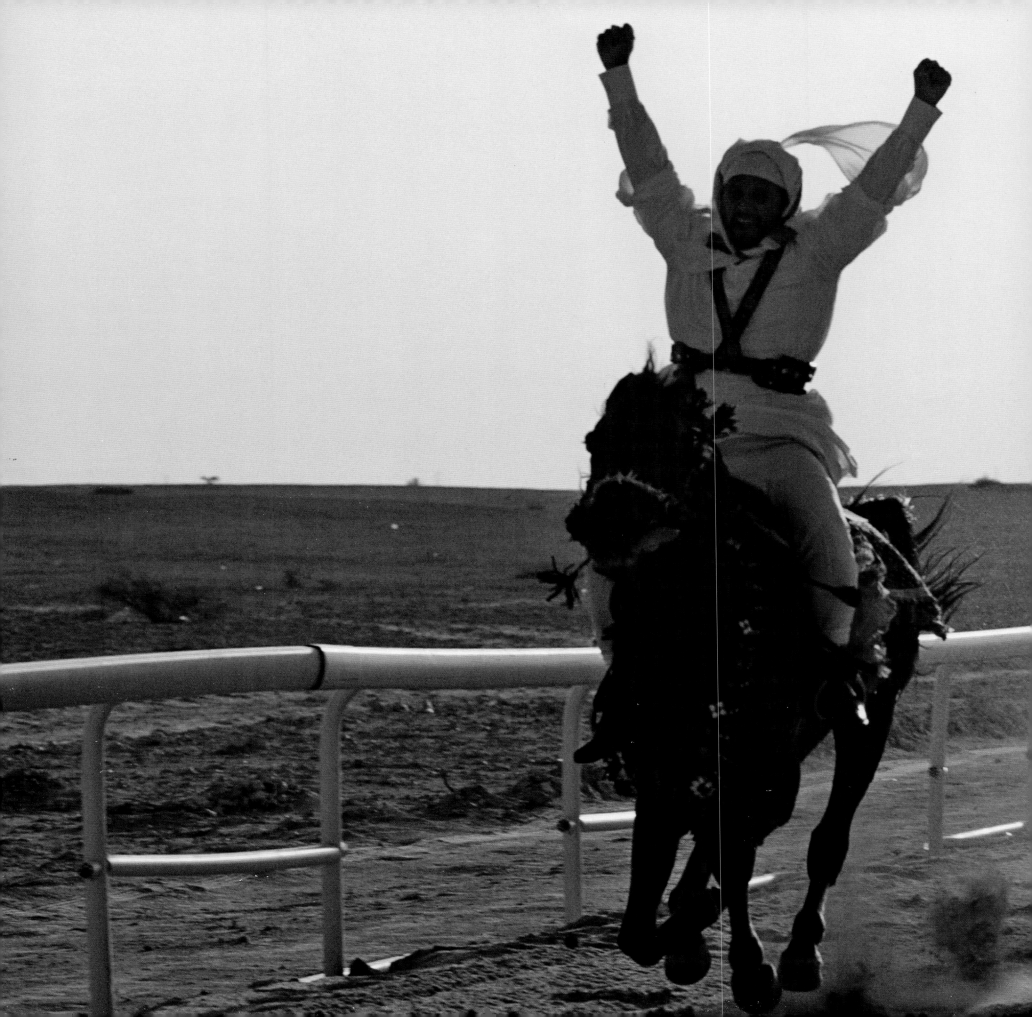

Speaking figuratively, there was a time after the influx of hydrocarbon wealth when it appeared that the self-sustaining skills of desert life might be washed away by a sea of luxuries. But Qatar is determined to reweave its ties to the past. There is a renewed interest in relating how parents and grandparents helped build the country, no matter how humble the contribution. It is a source of pride to speak of ancestors, not just of warriors but also of men who left their families to dive for pearls or to do hard labor in the oil fields and of women who held families together and whose handiwork contributed to sparse incomes.

Such things as historical docudramas for television and film, the restoration of historic buildings and neighborhoods, the resurgence of tribal sports like *maseela* (traditional horse races), and public exhibitions of archival photography fuel this interest in Qatari heritage. Original geographic and neighborhood names are being revived, and distinctly modern entities are given time-honored names. For example, the state-of-the-art sports medicine facility is called *Aspetar*, which is thought to be an early mispronunciation of the English word "hospital", and the public bus and taxi system is called Karwa, a historic word meaning transportation or "pay fee" in local Arabic dialect. Language is particularly important in a society imbued with oral tradition, and these administrative decisions encourage the remembrance of things past.

A modern Qatari may be defined by his or her job, education and possessions. But in the not-too-distant and impoverished past, people were known for their honor and pride, the sole aspects of life under their direct control. Personal dignity determined reputation and was maintained by upholding virtue, or *muru'ah,* including justice (which could be fierce) and hospitality (the more generous the better). Loyalty—to family, tribe and tribal alliances—was the guiding principle for both social and political life.

Until well into the nineteenth century, Qatar was a loose confederation of tribes with shifting alliances. Each tribe had a sheikh, or leader; most Qataris can still tell you who heads their tribe. Even as government has replaced many tribal functions, voting for the Municipal Council falls along tribal lines, and many neighborhoods and neighborhood schools are tribally delineated. Family and tribe comprise cohesive social units that regulate the behavior of their members. These units form a resilient foundation that helps Qataris withstand the upheaval brought on by the torrential change of recent decades.

Both Islam and tribal traditions are integral to being a Qatari. Traits necessary for survival in the pre-oil era metamorphose as a new generation takes command of a more complex society. The new society of modern systems and higher education lies within a familiar framework of family and Islam, and still requires hard work and perseverance. Both Islam, with its basis in tolerance and social justice, and the tribal structure carry the seeds of political self-governance, so there is a solid foundation for the future.

The traditional ways of the desert exert both a physical and spiritual force on Qataris. They are tied to the land by virtue of birth, and Islam encourages strict stewardship of resources. Long before nationhood, a small population and subsistence economy caused minimal environmental impact. Oil and its aftermath tipped that balance. Suddenly, there was a population explosion, industrial and household waste, overgrazing, overuse of groundwater, overfishing, and copious quantities of litter. Generations grew up with a consumption-based mentality and no public awareness of regulations and enforcement of the consequences.

113

Both Islam and tribal traditions are integral to being a Qatari. Traits necessary for survival in the pre-oil era metamorphose as a new generation takes command of a more complex society.

These barchan dunes are sculpted by wind into crescent shapes with the tips pointing downwind. A steep, slip face on the downwind arch tempts the adventurous to ease up to the edge in a vehicle and ride the mini avalanche down to the bottom, a thrill ride called "duning." The leeward side of the dune also provides excellent shelter for campsites, where nighttime campfires cast dancing shadows on the sleek surface of the dunes. Seif dunes (sword in Arabic) form undulating ridges parallel to the prevailing winds.

Sabkha are salt flats created when lagoons slowly fill, leaving behind gently sloped plains that flood during extreme high tides or after rains. Evaporating water creates salt crystals, making the sabkha look like fresh fallen snow, which the Bedouin collected for personal use and trade. They are treacherous to drive on. Even when sabkha appears as dry as the desert floor, it can crack under the weight of a vehicle, sinking it up to the axles.

Most of Qatar is strewn with the rocky detritus of ancient rivers and a fine dust that turns the sky a muddy brown during wind storms. The gritty dusk created by these storms can last for days. Immense limestone deposits are studded with vestiges of the sea: The fossils of sharks, dugongs, fish and fist-sized gastropod mollusks. In the southeast corner of Qatar, there are constantly shifting, knife-edged **dunes** that mark the edge of the endless *Rub al Khali*, or Empty Quarter, which stretches far into Saudi Arabia. Even with a GPS it is foolish to venture anywhere off-road in the desert without an experienced driver and plenty of water, because even the best four-wheel-drive is easily mired in sand or in the sticky salt flats called *sabkha*.

In town, the smallest gardens attract butterflies, and glittering green parakeets fill the trees. They are drawn to the presence of water, always water. Historically, forts and villages were built around a well or the occasional spring, as are most modern farms. The introduction of the pump by the oil exploration teams heralded the first water revolution in the late 1940s. The ability to extract large quantities of groundwater transformed its usage and led to a slow greening of small swaths of land. Though still on a limited scale, the cultivation of date palms and other crops was significantly easier than when water had to be hand-pulled from the ground. Pumps also heralded the beginning of a public water distribution system. As the pump slowly replaced donkey and human water carriers, the flow slaked the thirst of the labor force needed to build and operate everything from roads to drilling platforms and pipelines. At first locals filled the manual jobs, but were soon replaced by migrants. Gradually, the government realized that large-scale exploitation of groundwater was unsustainable, and water issues moved to the forefront of Qatar's development agenda.

The focus on conservation, distribution and high-tech solutions for protecting groundwater while still meeting the demands of a ballooning population is the purpose of the second, ongoing water revolution. Urban areas are chiefly served by municipal water systems, while many farms and camps rely on water tankers. At water distribution plants, it is common to see lines of trucks snaking for miles to fill up as consumers with dwindling reserves wait on the other end. To address this inefficiency, Qatar is devoting massive resources to expand the municipal distribution infrastructure. At the same time, research on desalination technology, including culling water from industrial sources such as the gas-to-liquids process, is a priority.

Recycled wastewater is used on many of the city esplanades and elaborately landscaped traffic circles. Picnickers and exercisers flock to the new city parks which fulfill a yearning for green, a relief from otherwise endless beige surroundings. Some areas are landscaped with indigenous plants that require much less water. Among these is the Qatar Foundation's Al Shaqab Stud, an immense equine facility housing the Emir's prize Arabian horses, a public riding school, and stadiums designed for international competitions. An emphasis on food security—both through investment in foreign agricultural areas and domestic production—spurs the most innovative farming techniques and the research and development of greenhouse, hydroponic, solar and other water-saving systems.

Both the accessibility of water and the development of public utilities played pivotal roles in societal change. In the drive to provide higher standards of living, the government encouraged Bedouin and villagers to settle in larger, centralized communities supplied by public electricity and water. These luxuries were a natural draw, as were the new public schools and health facilities. This urban migration, beginning slowly in the 1950s, kept pace with increased oil revenues, forever changing the pastoral patterns of Qatar.

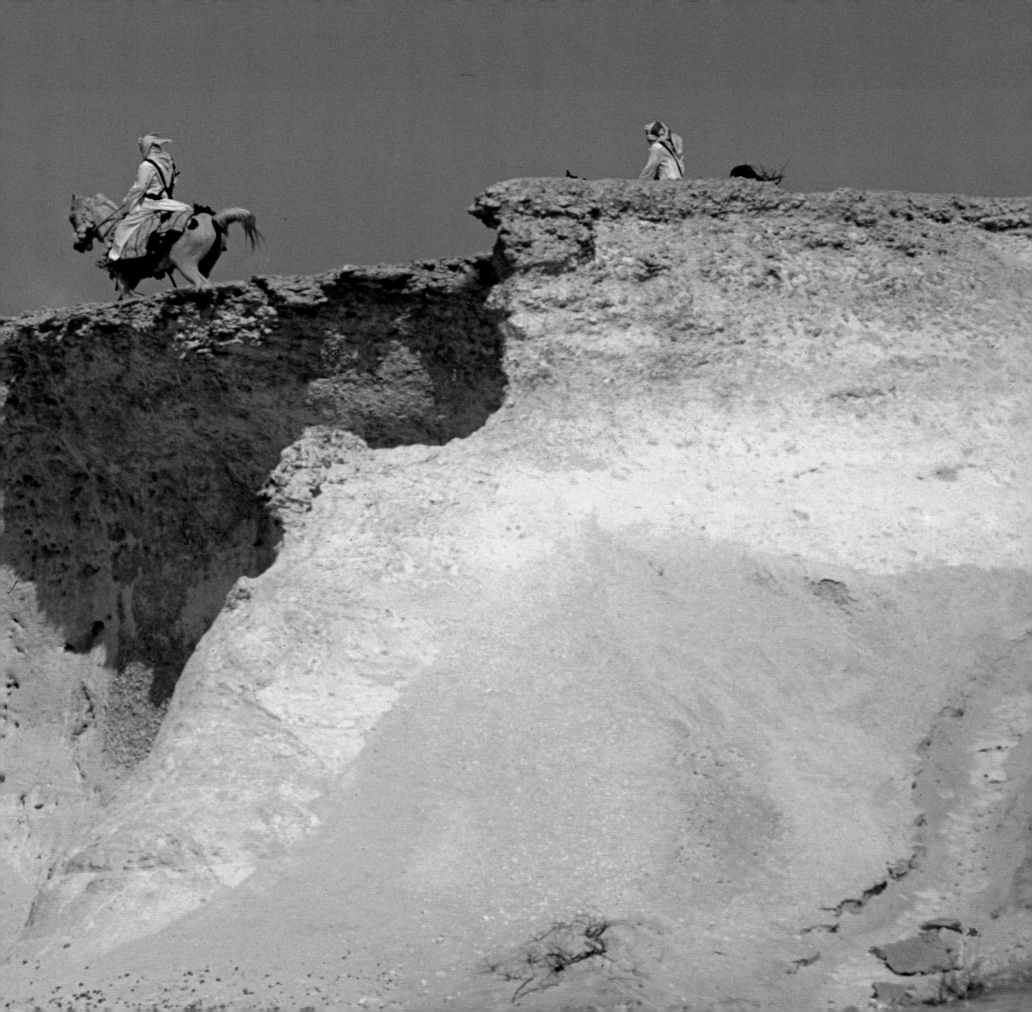

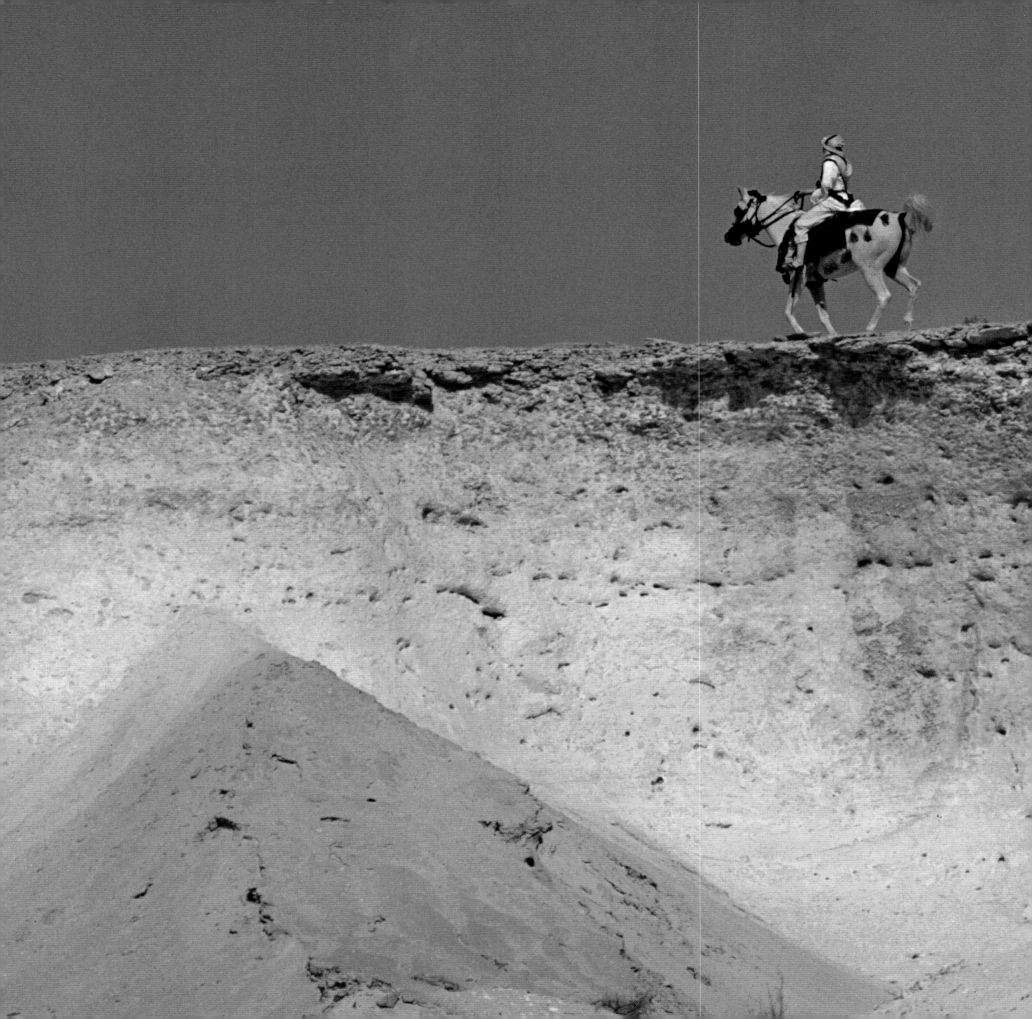

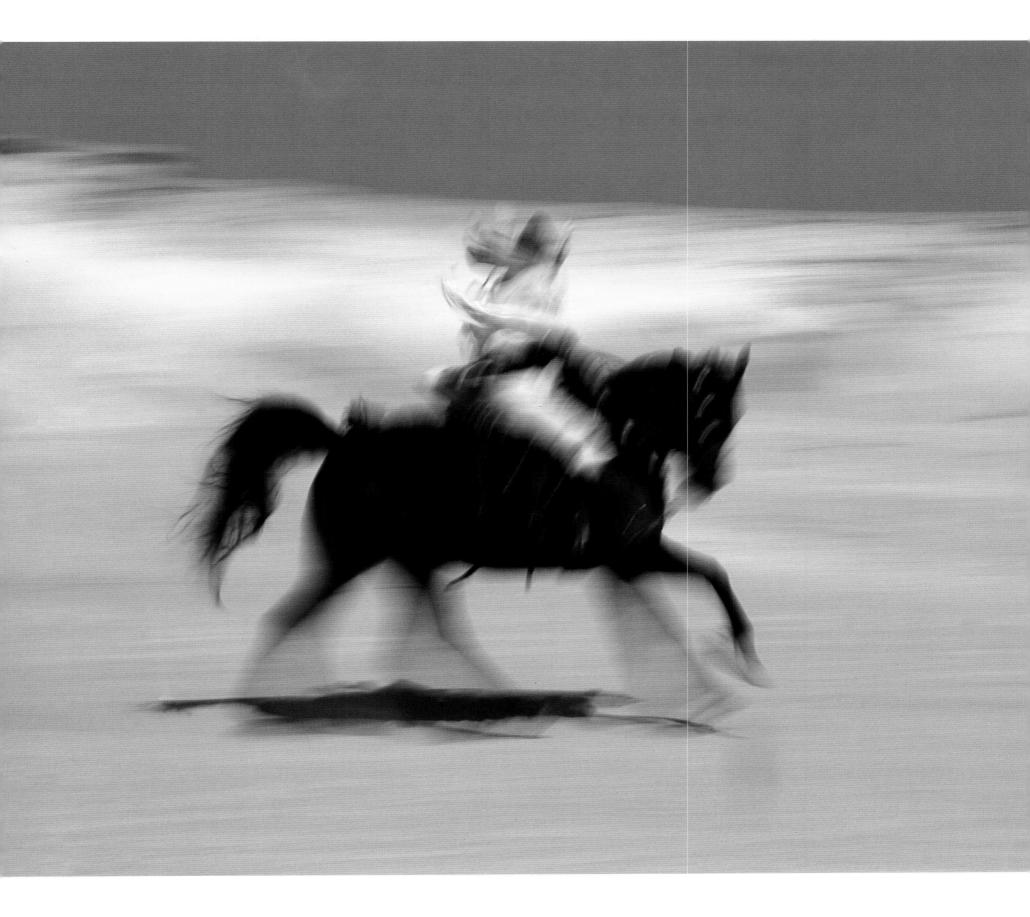

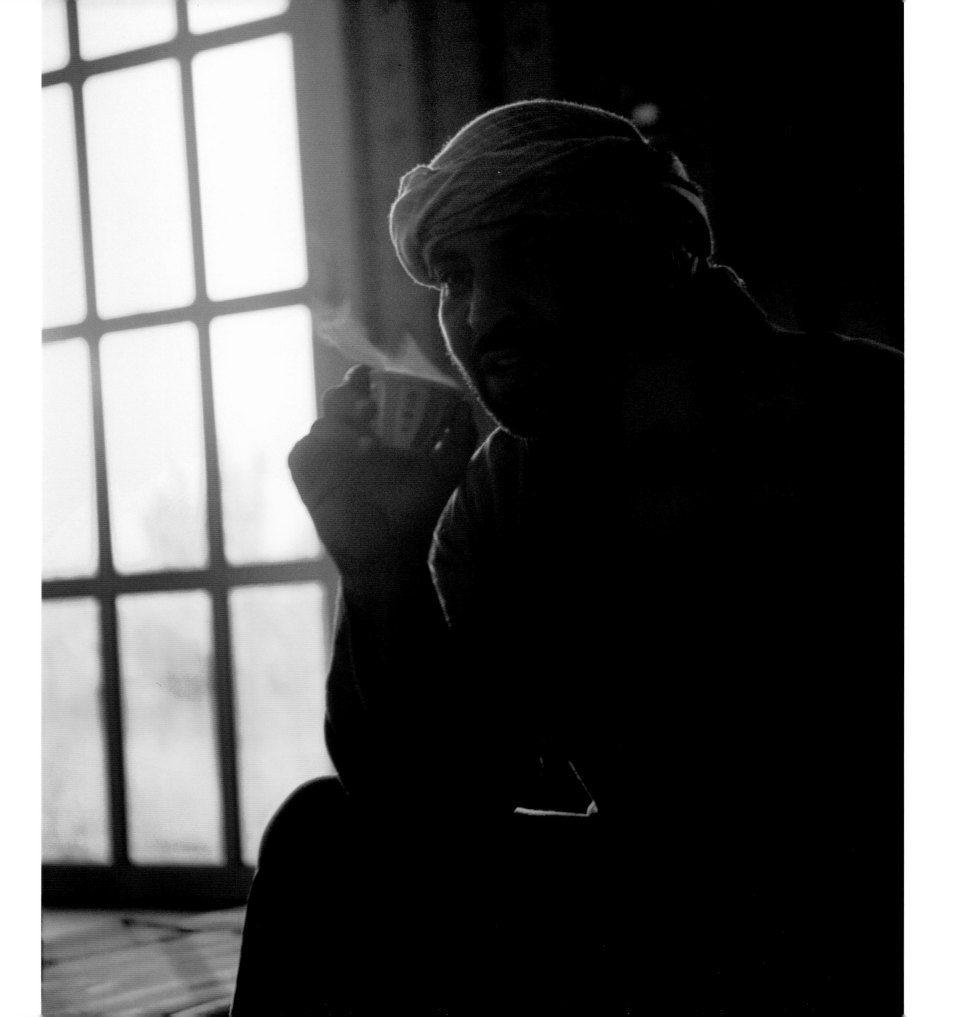

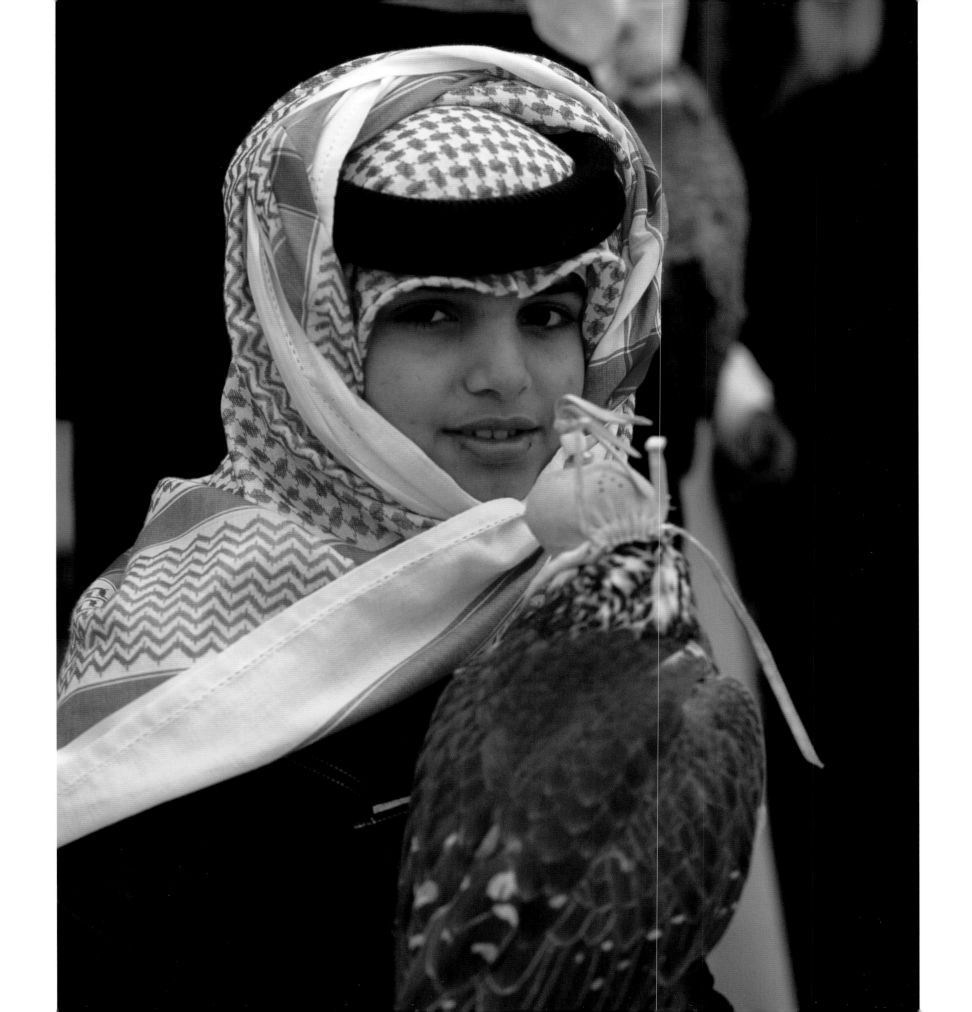

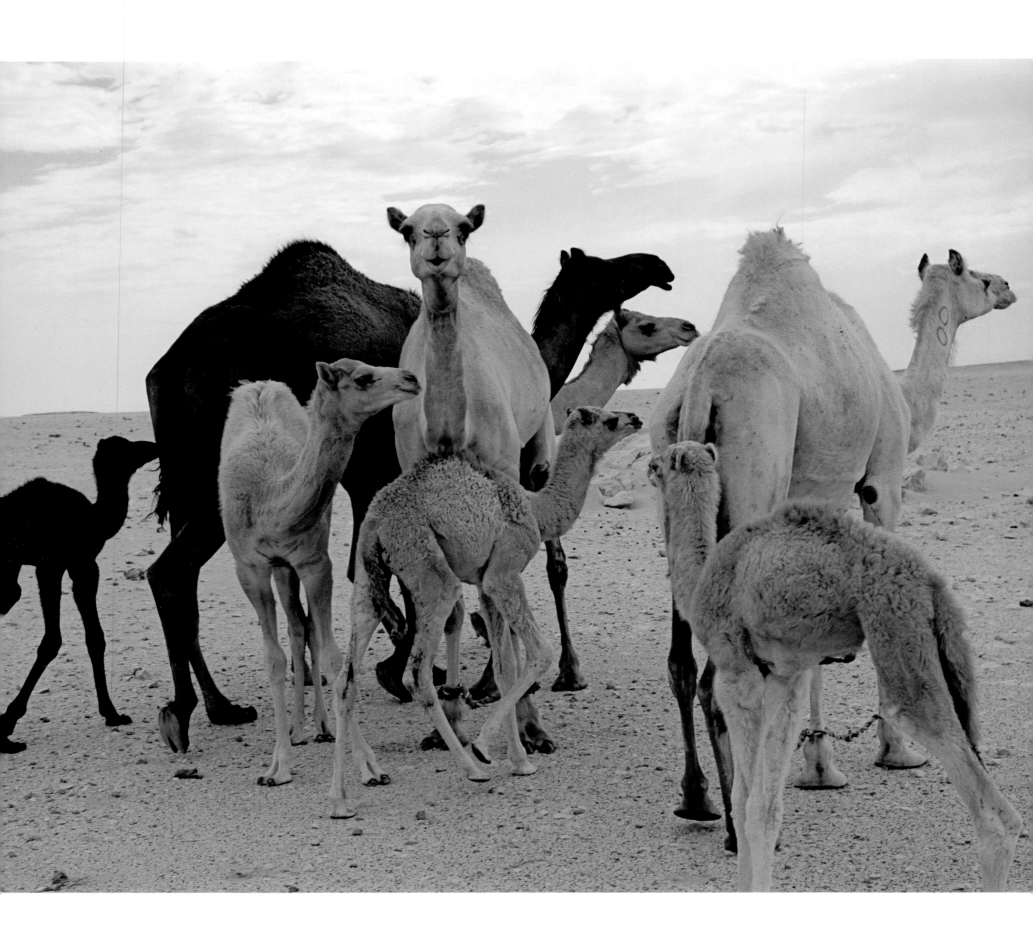

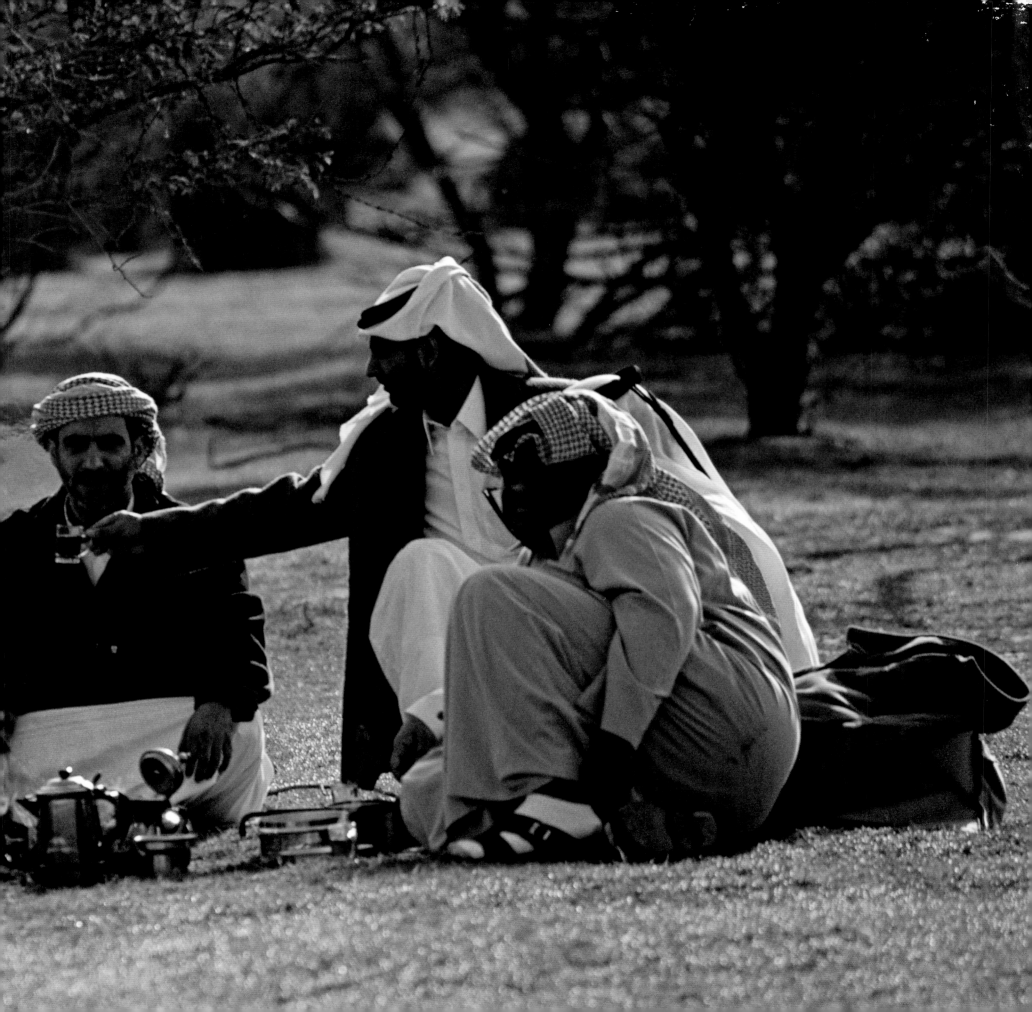

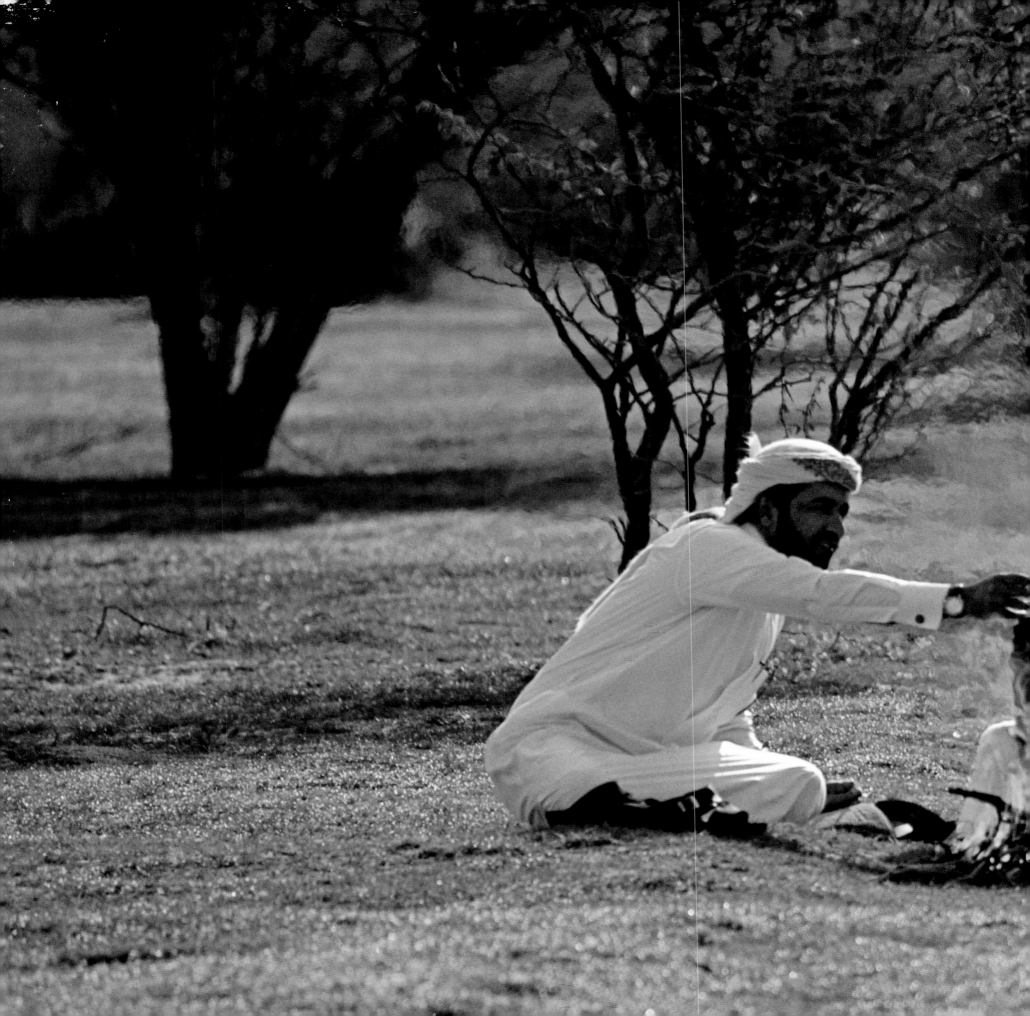

The modern migration to the desert in winter for recreation mirrors pre-oil days, when even some of the *hadher*—the "settled," or town-dwellers— enjoyed the cool winter in desert tents. During the summer, Bedouin moved from the desert toward urban centers to sign on for seasonal work aboard pearl fishing boats. Except for the cultivation of a few date palm trees, agriculture was impossible, so the Bedouin traded in the seaside towns for bulk rice, flour, grains, sugar and dates, as well as pots, pans, knives and the occasional bit of jewelry. In return, desert-born products like *al sedu* (woven goods), dried cheese, clarified butter, hides, herbal remedies and game entered urban areas. Camel's milk, thought to have medicinal qualities acquired from desert forage, was also sold at market. The Bedouin cared for the livestock of the *hadher* for added income. The economy was almost entirely credit-based, so that one year's products paid last year's bills, while the following year's supplies were acquired on credit. A few old shopkeepers in the *souqs*, the traditional markets, remember extending credit to families who now enjoy vast fortunes.

While Qataris trace their lineage primarily to either Bedouin or *hadher* roots, the lines are not hard and fast. Even well-established *hadher* families likely emerged from nomadic ancestors, since for millennia that had been the Arabian way. Some Bedouin lived on the fringes of sedentary areas in a semi-nomadic lifestyle while some villagers moved to the interior for the winter months. Particularly in northern Qatar, where herds of sheep and goats could number into the thousands, a few Bedouin maintained both simple mud-brick village houses and tent camps. Access to water was the preeminent concern, then and now.

The modern migration to the desert in winter for recreation mirrors pre-oil days, when even some of the *hadher*—the "settled," or town-dwellers— enjoyed the cool winter in desert tents.

After a rain, cool, glassy pools fill the depressions and slake the thirst of the cracked desert floor, promising emerald carpets of grass.

(opposite and following)

The desert responds to rain with flora that succors newborns like orxy and camels while attracting Qataris for leisure and sport

Water is found in wells or rain pools, shallow "lakes" formed by runoff in desert depressions. An expanse of apparently barren land relieved only by the meager shade of dusty *sidr* trees (*ziziphus spina-christi*) indicates groundwater deep beneath the scorched surface. After a rain, cool, glassy pools fill the depressions and slake the thirst of the cracked desert floor, promising emerald carpets of grass. In the months that follow, these rainfall-dependent oases called *rawdat* burgeon with life. *Sidr* blossoms attract bees, whose honey is valued for its rich flavor and healing properties. The flowers ripen into ruby berries, sweetly tart on the tongue. The spiny *sidr* branches harbor bird nests, while scorpions, snakes, *jerboa* (similar to kangaroo mice), and desert fox scuttle and scamper at the base. Sharp hoof prints show that gazelle grazed there at dusk or perhaps at first light.

Winter green *rawdat* attract Qataris for camping and weekend picnics. Almost all Qataris now live in the capital city of Doha or smaller urban areas, yet many have either a direct or a kinship link to land. Some own full-fledged farms with tree-lined avenues, swimming pools, soccer fields, date palms, vegetable gardens, horses, camels, sheep, goats, date palms and even exotic game. More common is the *ezbat,* a makeshift animal enclosure accompanied by buildings or tents for sitting and sleeping. Some Qataris pitch seasonal tents, either roomy canvas ones or the traditional wool and goat hair *bait al sha'ar*. The arrival of cool weather and blessed rain draws people to desert retreats. It is common for men to camp with their male friends one night and with their family another. Some young men commute to work from their tents all winter long. Groups of women and children often wade in rain pools, search for *faqa*, or relax on blankets in the shade of a *sidr* tree.

On these desert outings, Qatari men prove able cooks. As the fire is stoked, a neat canvas camping kit reveals its wares: pots; small handleless china cups for *qahwa* (coffee); glass cups for *chai* (tea, pronounced "shy" here); myriad bottles containing lightly roasted coffee; pungent spices like cardamom, ginger, saffron; date tree fiber to put in the spout of the *dallah* (coffeepot) to strain the *qahwa*; canned milk; sugar; and a selection of tea, loose or bagged. Occasionally a traditionalist roasts his own beans using the *mehmas*, a long-handled roasting pan, and then grinds them himself. It is said that in former days, the ringing sound of each man's mortar and pestle was unique and recognized, calling people to his fireside to enjoy fresh *qahwa*. The *dallah* is a universal symbol of hospitality in the Gulf.

A camp breakfast might include eggs, soft white cheese, olives, bread, and honey. Someone might fry a batch of *be'theeth*, a date crumble made from flour, dates or date syrup, and oil or clarified butter. *Be'theeth* suited the nomadic life because it could be transported for long periods without going stale like the unleavened bread made fresh in camp. Big meals feature chicken and lamb, kebabs or *machboos* (chicken or lamb with rice), flat bread, salad, hummus, or even *qouzi* (whole roasted lamb) presented on a platter of rice. A disposable plastic sheet protects carpets as the group gathers around a common dish.

The right hand scoops food into a ball that is deftly pushed into the mouth with the thumb, such that the fingers never come in contact with the mouth. Some moisten their rice with *leban* (buttermilk), which also holds the rice together. Delicate morsels may be placed on the rice in front of a guest, but food is never taken from in front of another person. Some camps and farms are quite formal with tables, chairs, china, silverware, and buffet tables laden with steaming chafing dishes.

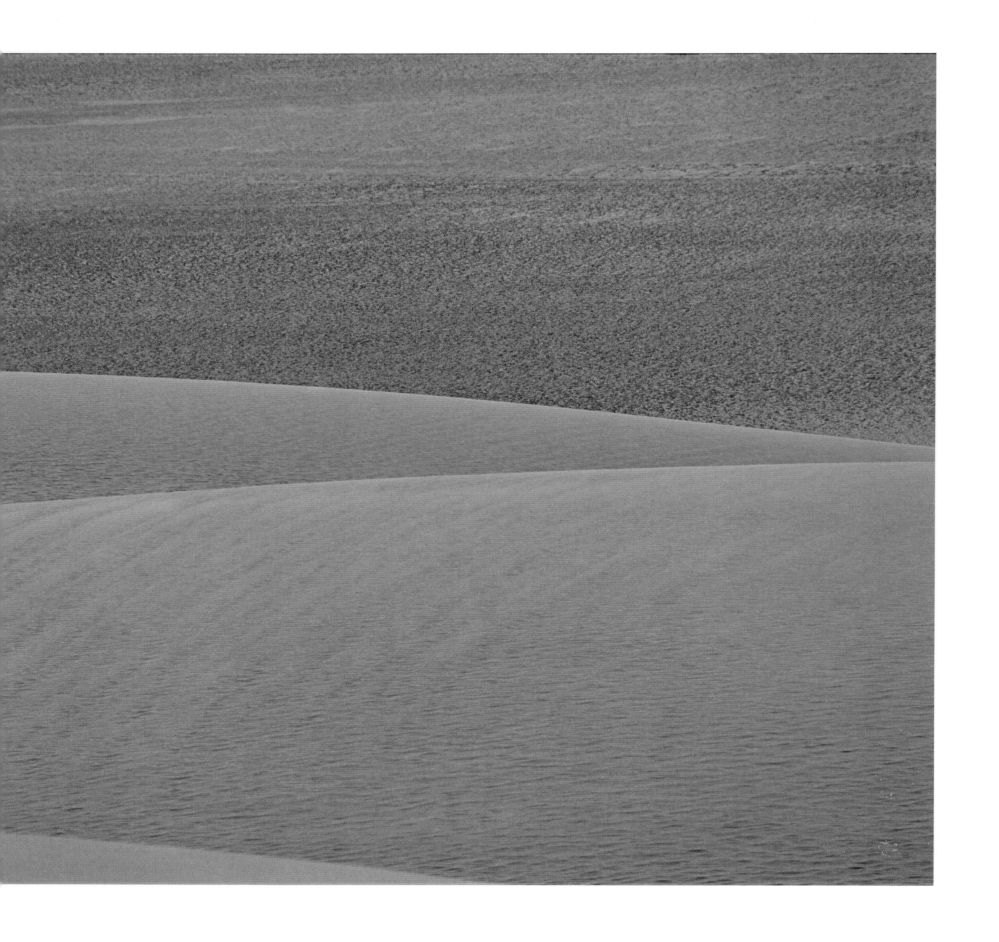

or visitors. While socializing was generally segregated in dedicated areas, if male family members were absent women welcomed guests with coffee and food in the men's section.

Water was austerely conserved, used and reused until it was finally offered to the camp dogs. If only brackish water was available, camels trekked to one of the sweet-water wells within the *dirah*, or tribal territory, to haul potable water in goatskin bags and later in automobile inner tubes. During the long, dry season, tribes migrated from well to well, each a tribal treasure. The draught of a thirsty camel exceeds twenty gallons in ten minutes, clearly too much to carry, so to supply an entire herd the Bedouin pulled water from stone-lined wells, many hundreds of feet deep, either by hand or using a donkey or camel. In the winter, when the livestock could absorb water from their forage, tribes ranged farther afield.

In Qatar as in all of Arabia, camels—the famed ships of the desert—formed the backbone of nomadic life. Camels provided all-important transportation, and their milk gave invaluable nutrition whether drunk fresh or made into yoghurt and cheese, which could be dried for long-term storage. Their fine hair made warm, soft cloth, their hides provided leather, and their dung fueled cooking fires. Female camels were sacrosanct because they produced the next generation, but excess bulls or injured animals were slaughtered for meat. A tender calf was provided to celebrate an honored guest. Whole baby camel served on a massive platter of spiced rice scattered with nuts is still a local delicacy; the lean tenderloin of the camel hump roasted under the mound of fat is deftly carved out using broad-bladed knives.

In this arid environment—receiving less than four inches of rain a year—nomads developed an enviable ecological intelligence and an intimacy with the natural world, from celestial navigation to the uses of desert plants. The Bedouin were known for their uncanny ability to remember landmarks, including distinctive vegetation, subtle variations in soil color, and patterns sculpted in the sand by prevailing winds, which together gave them a kind of innate GPS. Like many time-honored skills, the ability to read the land is a dying art, so both individuals and the government are working to pass traditional knowledge on to children through hands-on experience, research and oral histories.

Rain was (and is) a joyful time. When heaven's clouds let loose, the tribe led their herds to grass and scoured the land for greens, berries and *faqa*, mushroomy potato-textured desert truffles, to supplement their own scant diet. Nothing extraneous survived the constant packing and moving. Anything nonfunctional was jettisoned. Salukis, an ancient breed of sight hound, and *saqr,* or falcons, were revered for their beauty and stamina. They earned this esteemed position by capturing game that supplemented their masters' monotonous diet of milk, dates and bread. Meat—from the fleet *reem* (gazelle) to the wily *hubara* (bustard) and the shy *dhab* (a spiny-tailed lizard)—was a luxury.

The Arabian oryx, an antelope with a pair of long, straight, backward-pointing horns believed by some scholars to have inspired the mythical unicorn, and perhaps the ostrich, were the largest game hunted in Qatar. Both are now protected in preserves and have been released in limited numbers into the wild. Tribesmen also looked to their sheikhs to provide the occasional feast, a tradition that endures today with citywide meals provided to the needy during the Islamic holy days of Ramadan and Eid, as well as the everyday practice of distributing excess food to workers.

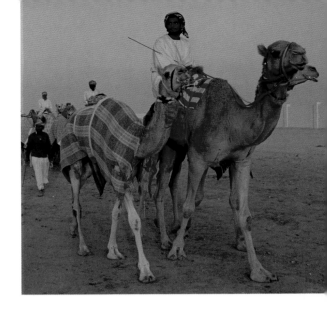

(above and following) Camels, a mainstay of Bedouin life, are still valued for racing, milk and meat; dune with fox tracks; domes of the State Mosque at Al Khuwair; moody sands of Khor Al Adaid

91

At times of scarcity, the Bedouin survived on camel's milk and dried dates, which they shared with their camels and horses if they were fortunate enough to own these valuable animals.

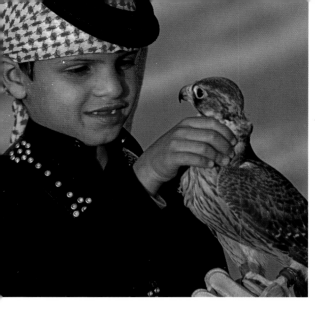

Chapter Two: Sand

In the desert, only water divides life from death. With air conditioning and running water, people can largely ignore their environment, but you cannot truly know Qatar without experiencing the beautiful and harsh realities of the land. Archeological evidence suggests that more rain fell in past times than in recent eras. Even so, for thousands of years Arab tribes migrated across barren expanses of desert seeking elusive forage for their livestock.

Though the terrain was stark and unforgiving, the Bedouin chose this lifestyle rather than joining settled communities. Necessity was a factor, since the modest villages could not support large groups or their all-important flocks. But the desert also appealed to the Bedouin. The empty wilderness that outsiders see was not a place of exile for the nomad but rather a land of freedom and independence, where fierce pride and self-reliance flourished.

It is reported that Islam was embraced in the Qatari area by Al Mundhir bin Sawa Al Tamimi when an emissary of the Prophet Mohammed, Ala Al Hadrami, visited in 628 C.E. The migration of the Prophet Mohammed and his Muslim followers from Mecca to Medina occurred in 622 C.E. The Hijra (migration) marks the beginning of the Islamic calendar, such that 628 C.E. would be 6 A.H. (after the Hijra). The Gulf countries, including Qatar, often use this Islamic or Hijri calendar, so it is usual to see newspapers and documents with a Hijri (A.H.) date alone or together with a Gregorian date. Since the Hijri calendar uses lunar months, there is a not a year-to-year correlation. Lunar years are about 11 days shorter than Gregorian years, so the further one moves from 0 A.H. the fewer the years separating the A.H. and CE.

Before Islam arrived in Qatar in **628 CE**, the Bedouin practiced a loosely-organized polytheism whose gods resided in stone idols or in wells and trees. Life focused on the here-and-now; there was no definite sense of an afterlife until Islam swept through Arabia. Perhaps submitting to the will of Allah was made easier by the promise of leaving behind a hard life on earth and attaining an afterlife abounding with good things like food and flowing water. There was a plan and a purpose to drought and famine, even if the human mind could not perceive it.

Especially during desperate periods, Allah and the ritual cycle of five daily prayers provided spiritual solace. At times of scarcity, the Bedouin survived on camel's milk and dried dates, which they shared with their camels and horses if they were fortunate enough to own these valuable animals. Tents, woven in stripes of ashy black, warm browns and beige, provided shelter. Remarkably adaptable, the sides could be raised for ventilation in the scorching heat, at times exceeding a steamy 120°F, and when wet, the fibers expanded to create a virtually waterproof material.

Women cleaned and spun the goat hair and sheep wool into thread and wove panels which they stitched together to form tent walls. They decorated the woolen partitions between the men's—or public—section and the women's section with elaborate patterns dyed with plant extracts. The edge facing the front of the tent was embellished with colored tassels and sometimes shells or beading. Displaying this prized handiwork was meant to symbolize the family's hospitality. The panels also functioned as room dividers, providing privacy for couples

السَّرُّمَلَ

SAND

It is He Who sendeth the Winds like heralds of glad tidings, going before His Mercy: when they have carried the heavy-laden clouds, We drive them to a land that is dead, make rain to descend thereon, and produce every kind of harvest therewith: thus shall We raise up the dead: perchance ye may remember.

– Qur'an 7:57, Surah al A'Araf